AMERICAN FASHION MENSWEAR

In memory of: Geoffrey Beene, Bill Blass, Brian Bubb, Oleg Cassini, Vicky Davis, Perry Ellis, Egon von Furstenberg, Roger Forsythe, Larry Kane, Nancy Knox, Roland Meledandri, Don Robbie, Bill Robinson, Willi Smith, Charles Suppon, John Weitz, and all the other great American menswear designers who are no longer with us.

Bill Robinson, ca. 1986 *Following page* In a decade dominated by uptight power suits, Bill Robinson stood out for his refreshingly casual approach to menswear, as seen in this elegantly rumpled ensemble.

© 2009 Assouline Publishing
601 West 26th Street, 18th floor
New York, NY 10001, USA
Tel.: 212 989-6810 Fax: 212 647-0005
www.assouline.com
Printed in China
ISBN: 978 275940 4094

ROBERT E. BRYAN

AMERICAN FASHION MENSWEAR

COUNCIL OF FASHION DESIGNERS OF AMERICA

ASSOULINE

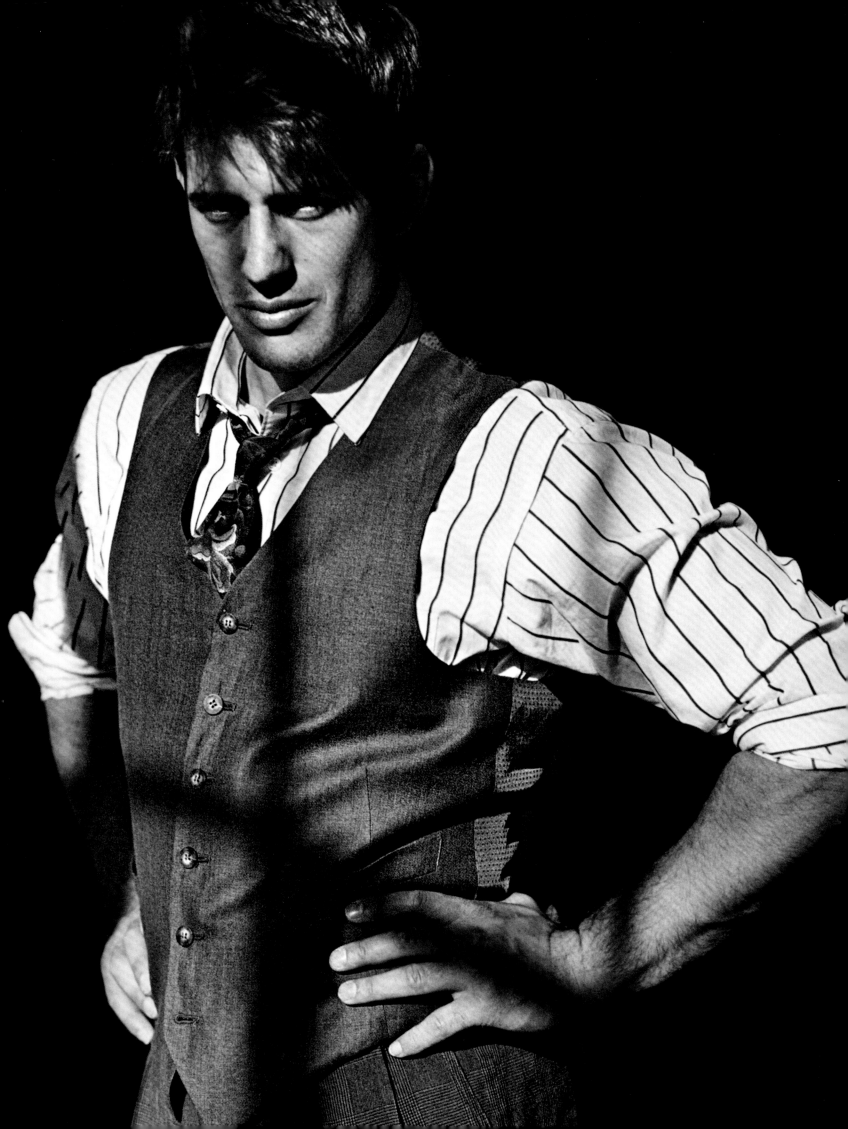

CONTENTS

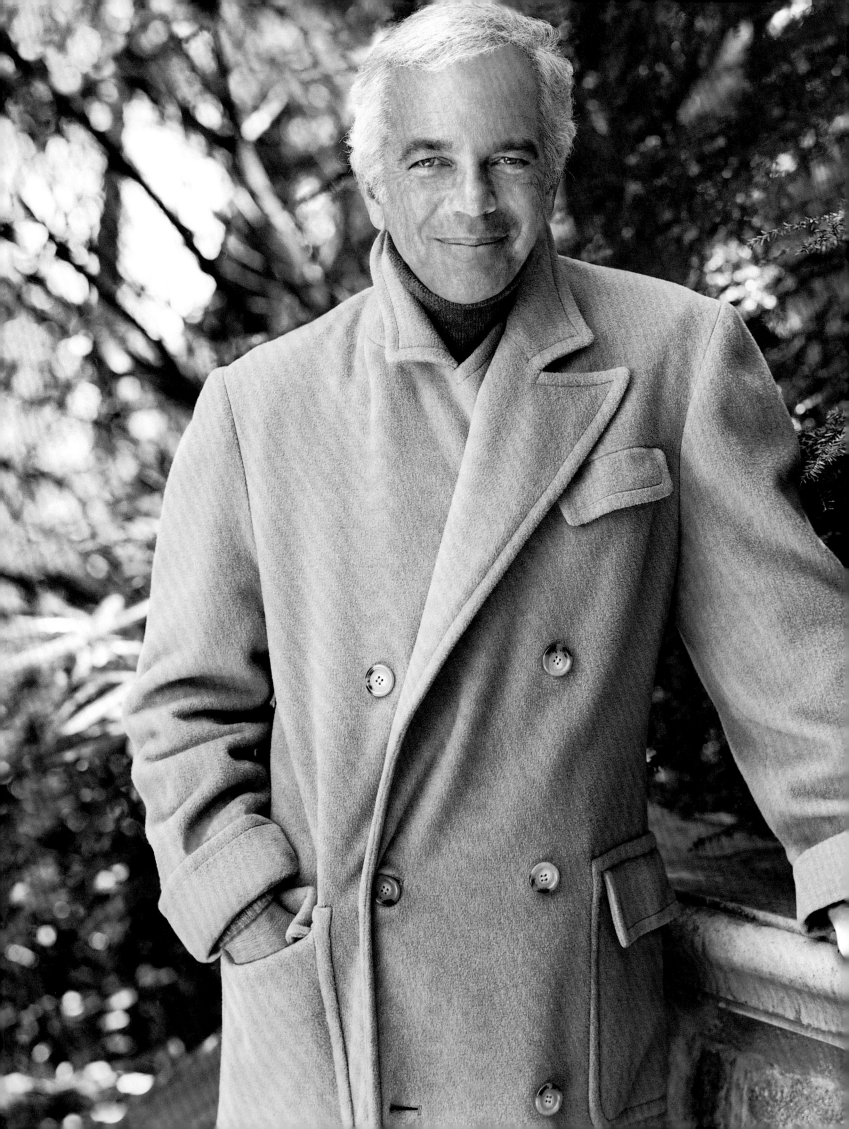

A LETTER FROM RALPH LAUREN

I have always been inspired by the dream of America—families in the country, a whitewashed barn, sailing off the coast of Maine, an old wood-paneled station wagon, a convertible filled with young college kids sporting crew cuts, sweatshirts, and frayed blue sneakers. America was my fashion school. Its heritage, myths, the land, its sports and movies, the professor I had in school who wore an old tweed jacket with patches on the elbows—these images of a timeless America became the living part of what I design.

I have been inspired by real people living their lives—the farmer, the cowboy, the athlete, the military man. When I was growing up in the Bronx, I would go with my brothers to army-navy stores and thrift shops searching for safari jackets, rugged military clothes, hand-knit ski sweaters, and varsity jackets. These were at the root of an American style made out of utility fabrics for real life and work. I loved the tradition and ease of the Ivy League look—the custom mood of navy blazers, school crests, rep ties, and flannels. And I have always looked back to the movies of Hollywood's golden age, to the legendary style of its strong characters—the rebel, the romantic, the dapper eccentric, the rugged hero. Out of this great vibrancy of American life and style evolved the richness and diversity of American menswear today.

I am honored to welcome you to *American Fashion Menswear*, the third volume in the Council of Fashion Designers of America's very distinguished American Fashion series, written with great insight and style by Robert Bryan. My personal journey designing American menswear during the past four decades is tied to many of the themes reflected throughout these pages. And just as *American Fashion Menswear* celebrates the unquestionable influence and innovative spirit of American menswear all over the world, so does the CFDA. I am proud to support its ongoing efforts in leading and fostering American fashion designers at every level and its special encouragement to young designers and fashion students everywhere. Fashion is about living. It's about living the best life you can—from what you wear, to the way you live, to the way you love.

Ralph Lauren, the dean of American menswear designers, has always had a deep appreciation for true American style.

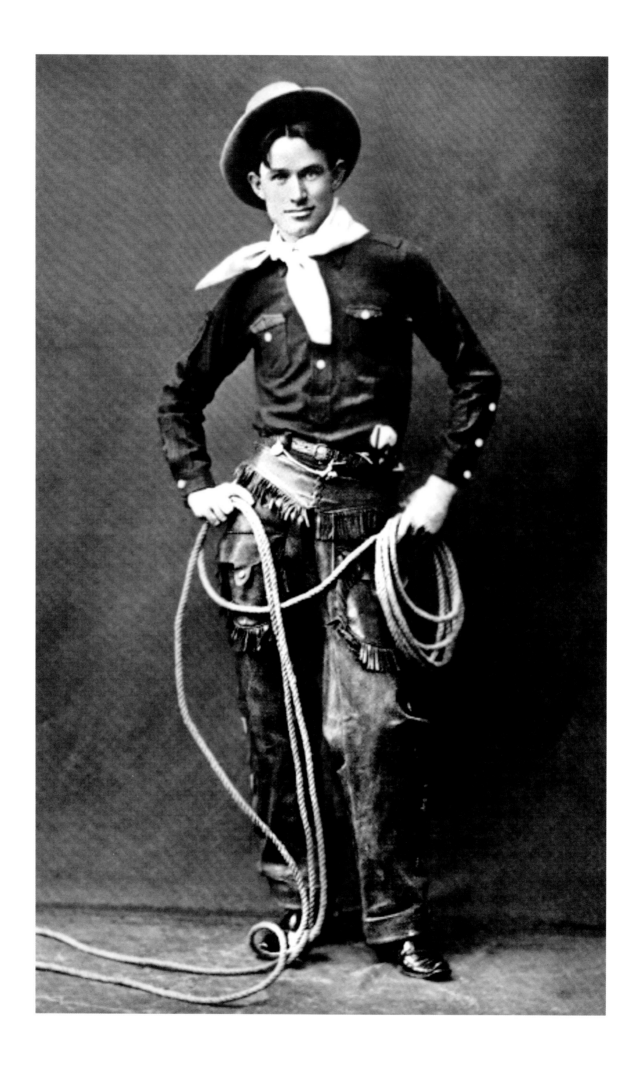

Introduction

{ *The story of men's fashion in America is intertwined with the history of our country.* }

AMERICAN ORIGINALS

In the history of American men's style, what matters most are the legends that have been its hallmarks. Levi Strauss jeans, Ivy League classics, Hollywood fashion plates, Brooks Brothers traditionalism, rock-and-roll rebels, and rough-riding cowboys—these quintessentially American icons are celebrated and emulated throughout the world of fashion. England may be the ancestral home of men's clothing, but it was American innovations in the twentieth century that pointed the way toward the casually eclectic style of dressing we enjoy today.

In 1900, suits were worn for most occasions except truly active sports and manual labor. But with each succeeding generation, more active-sports styles and utility garments were adapted and gradually incorporated into everyday wardrobes, resulting in what we now call sportswear. Most men today dress in jeans, khakis, polos, and sport shirts virtually all of the time, while suits, increasingly rare in offices, have taken the place of formalwear at weddings and funerals. In one hundred years, men's attire has shifted from tailoring to T-shirts.

The roots of this remarkable transformation are deeply embedded in our history. From the outset, America was settled by rugged individualists and adventurers who severed ties with the Old World to find their destiny in an unknown land. This separation from Europe opened the way for a new beginning in a less stratified society that was readily accepting of change. These early explorers' lives were dramatically different from those lived in Europe or in colonial cities. To survive the social and geographical challenges of the new environment, these men needed garments that were functional and well designed—qualities that continue to endure at the very heart of American menswear.

These hardy frontiersmen were the first to develop an indigenous American style, best exemplified by the adventurer Daniel Boone, who became a mythical figure both here and in

Will Rogers, ca. 1900 *Previous page* The great American humorist, commentator, and cowboy Will Rogers parlayed his authentic western roots into a career in vaudeville. He went on to star in the *Ziegfeld Follies* and in 71 films. By the time of his death, in a 1935 plane crash, he was the most popular man in America.

Europe. His practical clothing, based on Native American garb, consisted of buckskin leggings; loose-fitting fringed animal-skin shirts; and a broad-brimmed beaver felt hat—not, as legend would have it, a coonskin cap. To the civilized world, this was an entirely new way of dressing, and European intellectuals were fascinated. They saw in Boone the personification of their ideal, the "natural man" (a close cousin of the noble savage), a concept they continued to apply to certain Americans right on through to that national symbol of masculinity, the cowboy.

While a more romanticized figure (as embodied in Marlboro Man advertisements), the cowboy has much in common with his frontiersman forebear, including a reputation for being a straight shooter and having a taste for fringed buckskin. He thrived during the cattle drives of the late nineteenth century along the fabled Chisholm Trail, but his legend has only grown in the years since, first in rodeos and Wild West shows such as those staged by "Wild Bill" Cody, and then in the movies with stars such as Tom Mix and later John Wayne. As fanciful as it may appear, the true cowboy's garb is strictly functional, from his ten-gallon Stetson hat to block the sun to his high-heeled boot to hold the stirrup. In between, he wears a utilitarian bandanna, a plaid flannel shirt, a hand-tooled leather belt, rugged chaps, and durable denim dungarees, all requisite for his cattle-punching duties. There is also a less functional and far more theatrical incarnation known as the rhinestone cowboy, epitomized by the crystal-studded gold lamé and embroidered satin designs of Nudie's Rodeo Tailors, who created elaborate costumes for entertainers ranging from westerners like Roy Rogers and Johnny Cash to rockers like Elvis Presley and John Lennon. The cowboy look comes and goes in fashion, but unfortunately for city slickers, it rings true only on real buckaroos in a genuine western setting.

While the West is tamer these days, the ideal of the American individualist still resonates. In sports, finance, the arts, and all around us there are daredevils whose audacity is reflected by their clothes. At the same time, menswear is governed by long-standing traditions, so that even these fearless fellows dress under some restriction. And these customs can affect all aspects of clothing, from fit to fabric to color and cuffs. Such rules may at times confine, but they can also facilitate the creation of a unique persona, making it possible for men to sharply define themselves according to which styles and customs they accept or reject. If a man wants to portray himself as a serious business executive, a dedicated follower of trendy fashion, a robust athlete, or a dapper dandy, it's relatively easy to do just that. Because menswear is so precise, the smallest selections, such as a bow tie, work boots, round glasses, or a fedora, can speak volumes about the character of the man who wears them.

These menswear traditions are not frozen in time, nor do they exist in a vacuum; they are constantly evolving under the influence of broader historical and sociological changes. At the start of the last century, the American businessman was in a powerful position, poised to rule the world of commerce and industry. These imposing industrialists and their associates needed a comfortable new work uniform to replace the overly formal morning suit with its long jacket, double-breasted waistcoat, and striped trousers. The lounge suit, with its matching jacket and trousers, soft shoulder, and easy fit, was the solution, the template for suits as we know them today. Through the decades, the suit's shape shifted, moving from the sophisticated, full English drape-cut in the 1930s, to the Brooks Brothers' youthful, Ivy League, natural-shoulder cut of the 1950s, and back once again to a 1940s broad-shouldered silhouette for Wall Street power brokers in the 1980s. Despite the suit's ability to adapt, it gradually lost its required-uniform status, first during leisure time and then in the workplace, though it still holds a meaningful place in most men's wardrobes.

Two world wars, each followed by periods of prosperity and liberation, freed up menswear, thereby contributing to the growth of more informal apparel. During the Roaring Twenties, men began to experiment with new forms of dress, from soft one-piece shirt collars (instead of detachable starched styles) to sporty knickers and voluminous Oxford bag trousers, all the while incorporating active sports and utility styles into their daily wardrobes. Ironically, the Great Depression of the 1930s would see a brilliant renaissance in men's fashion. The same escapist mentality that found its expression in glamorous Hollywood movies also gave us dashing fashion plates like Fred Astaire, Gary Cooper, and Cary Grant.

Sportswear came into its own in the postwar period of the 1940s and 1950s. As men moved from city centers to the more casual atmosphere of suburbia, their leisure- and weekend-clothing needs shifted. This was the era of safe, traditional clothing, when the colorful, all-American style that prevailed at elite Ivy League universities became democratized. At the same time, in the midst of the conformist culture of the Eisenhower years, there was a growing breed of disillusioned misfits ranging from bikers to beatniks to so-called juvenile delinquents. The appearance of these rebel tribes combined with the emergence of rock and roll and the unifying force of television to create a generation of budding revolutionaries. Mirroring this movement, movies like *The Wild One* (1953) concisely defined the antihero as a brooding rebel who rejected society's rules; this was dressing as a form of social protest, not aspiration. Black leather jackets, jeans, and T-shirts were his preferences, and they created a model of nonconformity still followed today.

By the 1960s, the children of the postwar baby boom had reached adolescence. Sociological forces, including rejection of fifties white-bread culture, the unpopular Vietnam War, the Beatles, psychedelic rock music, and drugs, were paving the way for what became a full-fledged social revolution. Dress codes fell by the wayside almost overnight. Jeans became the essential foundation for the new, long-haired, masculine peacock look—just add a paisley printed shirt, a fringed vest, beads, sandals, and an army-surplus camouflage jacket. This youthful freedom spread to society at large by the 1970s, as even newscasters grew long sideburns and wore polyester leisure suits. By the end of the decade, hippie regalia were replaced by white disco suits, Studio 54 glamour, and most significantly, the new menswear designer names that would soon usurp the old dependable brands. The prosperous but conservative Reagan era of the 1980s brought a return to suits and power dressing, epitomized by the 1987 film *Wall Street*. At the same time, punk music, which began in the late seventies and evolved into new wave in the eighties, became a strong countercultural movement, flooding the streets with pierced young rebels wearing black leather, safety pins, ripped T-shirts, and jeans.

Jeans, America's single greatest contribution to fashion, were themselves originally developed for strictly functional purposes, with their double seams, metal rivets, and sturdy fabrication. Utility wear of all kinds has, like jeans, become fashion in its own right, while remaining a constant source of inspiration for designers. Encompassing rugged outdoors apparel for hunters and lumberjacks, durable canvas workwear for farm and factory, and superbly designed garments for the military, these sensible, functional clothes have been adapted to uses far beyond their original intent.

The evolution of menswear during the past hundred years reflects powerful sociological, scientific, and political influences, including war, social upheaval, technological advances, and financial depression and prosperity, in a world populated by a changing cast of players that ranges from matinee idols, rock stars, and dandies to captains of industry and factory workers. Rather than follow a strictly chronological approach, this book is divided into seven categories, focusing on those currents that continue to influence the way men dress today.

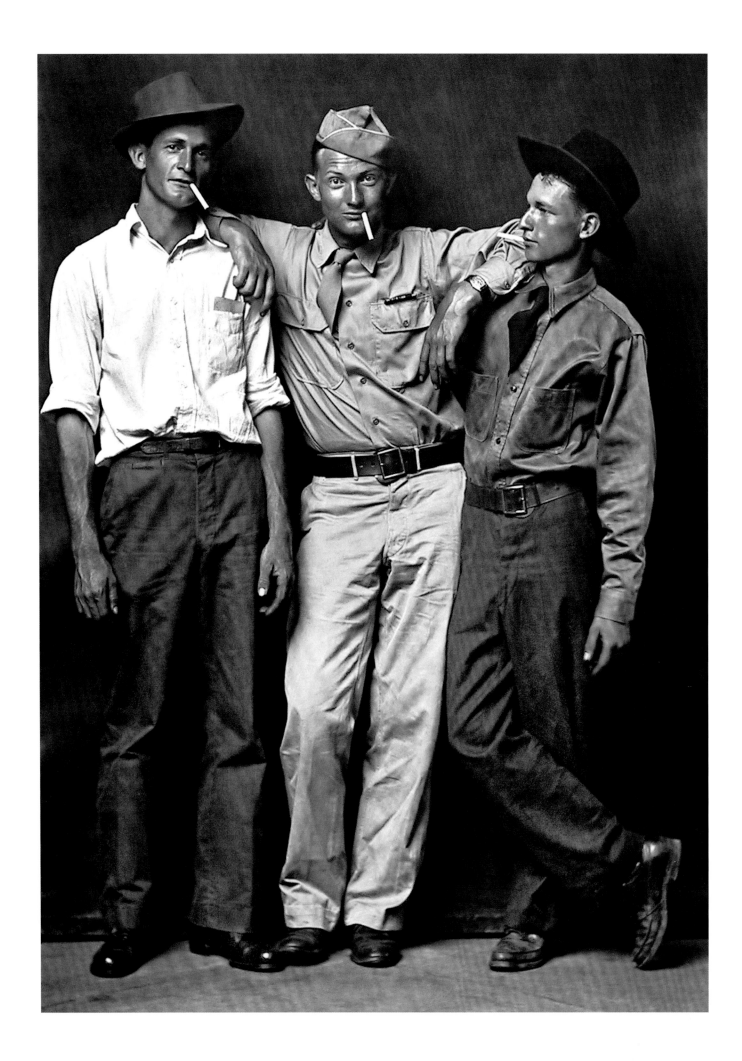

Utility

Function
equals
fashion
in the
evolution
of menswear
in
America.

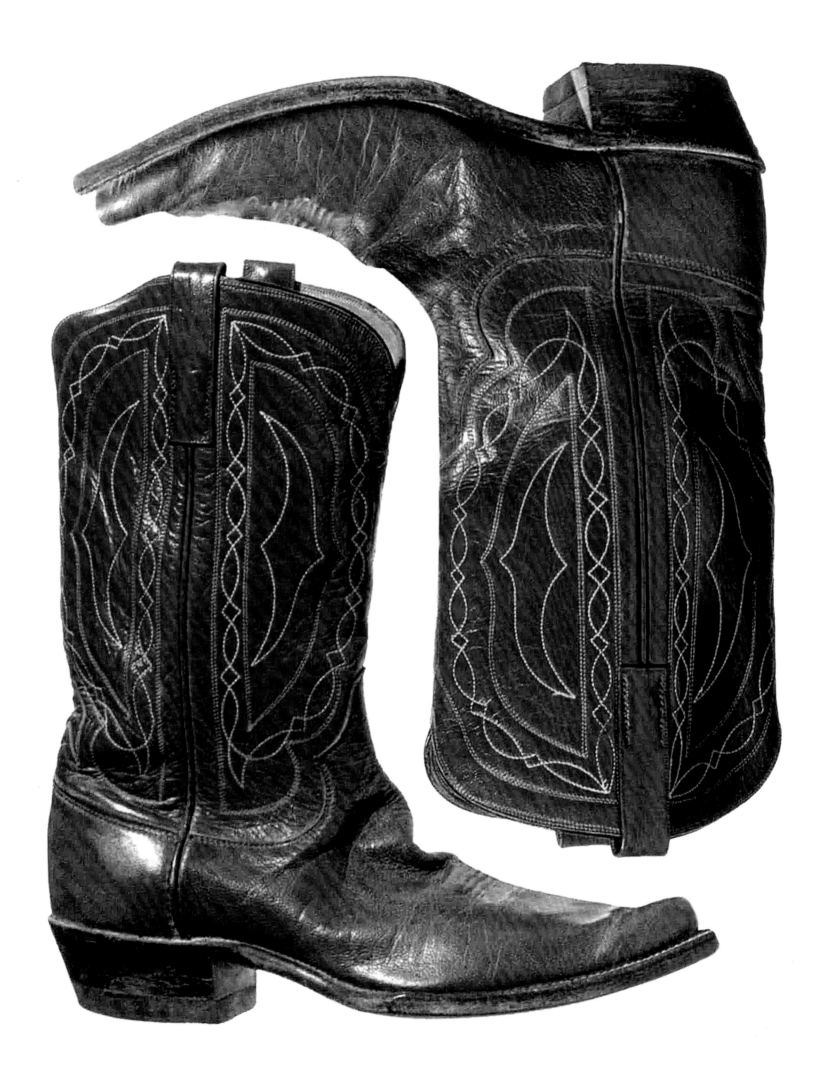

DESIGNED FOR WORK

The denim jean is without doubt one of America's greatest contributions to world fashion, a style whose origin as basic workwear for gold rush miners is as far removed from the designer world as possible. Even beyond Levi Strauss's historic dungarees, many of our most important achievements in menswear have emerged from a long-standing utilitarian tradition that includes not only workwear but also military and great outdoors apparel. In a way, this is entirely fitting and appropriate, as their functional attributes reflect many of the ideals of the American people—strength, authenticity, integrity of purpose, and a total lack of pretense. Through the years, designers have borrowed from this storehouse of sound design, while the man in the street has regularly incorporated elements into his everyday apparel. Now more than ever, these utilitarian classics are enjoying a renaissance at all levels of fashion.

The evolution of blue jeans from pure function to fashion phenomenon is the ultimate success story. In 1873, the immigrant entrepreneur Levi Strauss and the inventor Jacob Davis patented a metal rivet pant, then called a waist overall, which they manufactured in San Francisco. By the 1890s, its popularity had spread from lowly miners to that greatest icon of American masculinity, the cowboy. This positive association steadily grew in the public's mind and by the 1930s was confirmed by a surfeit of Western movies starring the likes of Gene Autry, the Singing Cowboy, and the legendary John Wayne, clad in what were then called blue dungarees. At the same time, "dude" ranches came into vogue for tenderfoot easterners who wanted a taste of everything connected with the Old West, including Stetson hats, yoked snap-front shirts, hand-tooled leather belts and boots, and, most important, Wrangler or Levi's jeans. Many tourists, enamored of their jeans' comfort, practicality, and aura of strength, took them home as prized possessions, spreading the word to friends and neighbors back East.

Before long, teenage bobby-soxers and their boyfriends had taken rolled-up jeans into their leisure wardrobes to wear with saddle shoes and penny loafers at the local malt shop. But this

Cowboy boots *Opposite* There are few accessories as American as cowboy boots. A perfect blend of fashion and function, they were designed to fit the stirrup but are often decorated with elaborate contrast stitching. **Heber Springs, Arkansas, 1945** *Previous pages* The small-town photographer Mike Disfarmer captured the camaraderie and unpretentious style of his friends and neighbors. "Homer Eakers, Loy Neighbors, and Julius Eakers, Brothers-in-law" demonstrates the casual comfort of basic workwear and military uniforms in a civilian setting.

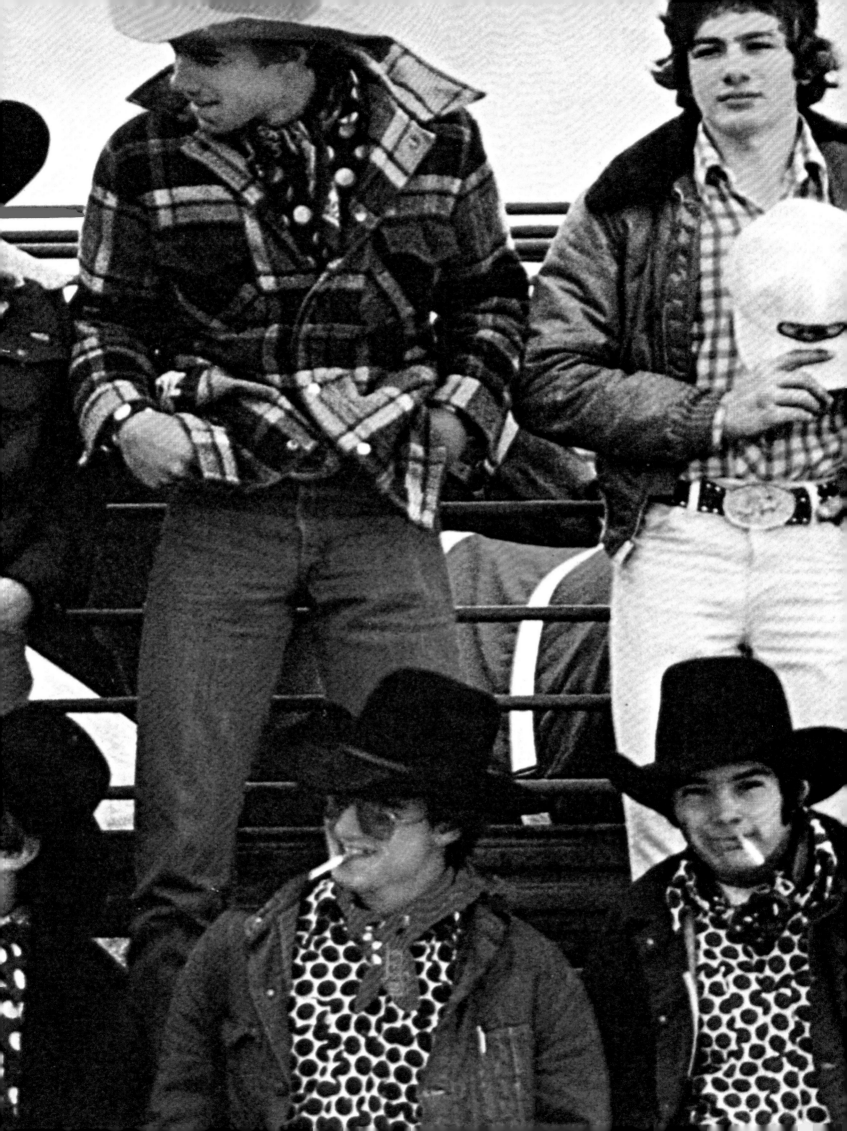

wholesome beginning had already turned sour by the mid-1950s, when jeans became associated more with T-shirted juvenile delinquents than the all-American cowboy television star Roy Rogers. To many adults living in the fifties, rock and roll was the devil's music, and Levi's 501 jeans were his pants. Having seen films like *Rebel Without a Cause* and *Blackboard Jungle* (both 1955), they believed that jeans were synonymous with hot rod drag racing and switchblade fights. When jeans were banned from schools, their popularity only increased among young people, setting the stage for a denim revolution in the decade ahead.

In the 1960s, jeans (now bell-bottomed) became an antiestablishment political statement, and therefore an essential part of the countercultural uniform worn by everyone from Haight-Ashbury hippies to Chicago Yippies. By 1970, the revolution had achieved at least partial success—the United States was still in Vietnam, but jeans accounted for nearly half of all pants sales. Tellingly, as the disco decade rolled in, it was polyester flares that put a momentary halt to the jeans explosion. But Calvin Klein soon came to the rescue with the first significant American designer-jeans line, promoted by a controversial 1980 ad campaign featuring fifteen-year-old Brooke Shields seductively purring, "Nothing comes between me and my Calvins." (Klein worked the same successful advertising provocation again in the early 1990s with an underwear-clad Mark Wahlberg in his rapper Marky Mark persona, confirming that, no matter the gender, sex always sells.) Bringing the concept up to 2008, Tom Ford introduced the ne plus ultra designer-jeans line, boasting eighteen-karat gold-plated buttons and silk-lined pockets for the bargain price of $990 a pair.

Nearly 140 years after their invention, jeans are the most popular and democratic form of fashion in the world, worn by people of all ages and types for every occasion. With the advent of casual Fridays (and more informal workplace attire in general), regular guys wear them to work with sport jackets while more adventurous souls, like Ralph Lauren and Kenneth Cole, combine them with tuxedo jackets for formal events. They are an integral part of fashion and music, and styles and fits abound—from low-slung baggy cuts favored by rappers to skinny black jeans for downtown rockers. There's even a "senior fit" comfort-stretch model for former flower children since gone to seed.

While jeans are undoubtedly the most successful offspring of the workwear family, other styles have earned considerable respect for their intrinsic value, durability, and form-follows-function styling. In fact, both David Neville of Rag & Bone and Richard Chai have cited workwear as a significant inspiration for their collections. Companies like Carhartt (est. 1889)

Western wear, 1976 *Previous pages* Europeans have always had a special appreciation for hard-core American style. Here, Italian photographer Oliviero Toscani's take on Western wear for *L'Uomo Vogue*, featuring the then-trendy U.S. jeans brand UFO.
Work wear, 1946 *Opposite* J. C. Leyendecker was one of the foremost illustrators of American menswear in the first half of the twentieth century. Here, he turns his attention from elegantly suited gentlemen and collegiate Arrow Collar Men to a rugged construction worker, appropriately dressed in overalls and a work shirt for the Labor Day issue of *The American Weekly* magazine.

THE American WEEKLY

Greatest Circulation in the World

"The Nation's Reading Habit"
Magazine Section—Boston Advertiser
Copyright, 1946, by American Weekly, Inc.
All Rights Reserved.

Week of Sept. 1, 1946

LABOR DAY

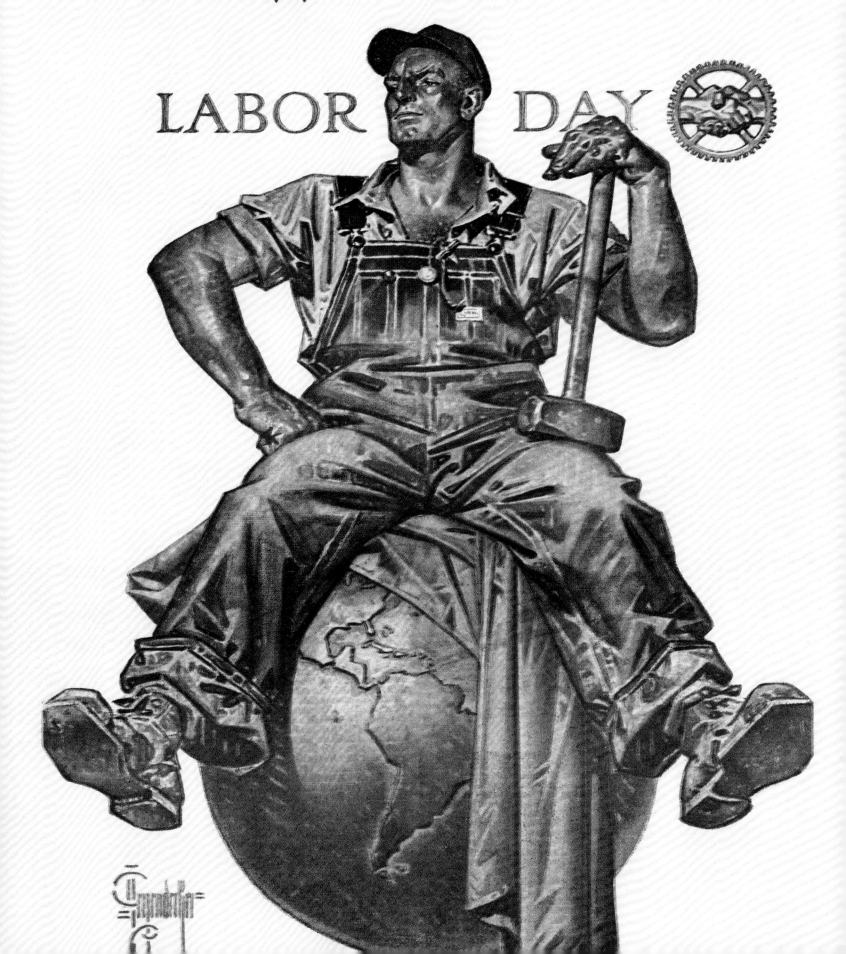

and Williamson-Dickie (est. 1922) continue to turn out utilitarian clothes for farm, factory, and more recently "blue-collar chic" street wear. For instance, Dickies hoodies, shirts, and pants have in recent years been worn uniform-style by skateboarders and rappers who value their straightforward styling and macho attitude—confirmed by Da Band's Elliot Ness in the song "Do You Know": "Philly spitters rock Dickies and boots." Meanwhile, rapper Nas sang the praises of the competition—"I'm a braveheart in Carhartt and Champion hoodies"—adding a plug for the legendary activewear maker Champion. With their multiple pockets and loops, painter's pants have always been appreciated for their functional attributes, but on occasion they've crossed the line into fashion. In the late 1970s, trendy young men started wearing them in natural white canvas and later with the kind of paint splatters that would have pleased Jackson Pollock. Fashion companies soon jumped on the utilitarian bandwagon, offering their versions in a rainbow of colors, which effectively killed the trend until the natural hue popped up again for an early-nineties moment in the spotlight. The coverall (a jumpsuit for factory work) was adapted for numerous runway presentations in 2008, while its close cousin, the overall, remains as classic today as in Grant Wood's 1930 painting *American Gothic*. It seems everyone loves the authentic style of a chambray work shirt too, from mainstream retailers Banana Republic and J. Crew to former president Jimmy Carter and blue-collar multimillionaire Bruce Springsteen—who established his working-class bona fides early on, wearing jeans and a white T-shirt on the cover of his 1984 album, *Born in the U.S.A.*

There are few items in men's apparel whose potent, manly aura equals that of the work boot; hence its recurring appeal to gay men, punks, goths, and fashion designers everywhere. Somehow they keep popping up on runways, combined with everything from women's evening dresses to men's sportswear and tailored clothing (think Thom Browne, Gilded Age, and John Bartlett). The fashion leader Justin Timberlake wore his distressed boots with a dinner jacket and a tie as the image man of Givenchy cologne in 2008—one way to inject a strong dose of machismo into even the most effete outfit. Finally, on a more down-to-earth level, the vintage work boot–maker Red Wing (founded 1905) is selling its shoes at J. Crew to satisfy those would-be construction workers who just can't seem to make it to an army-navy store.

Though it is more often pleasure than business, hunting can be work, too. Rugged outdoors catalog retailer L. L. Bean's leather-top, rubber-bottom "Bean Boot" is specifically designed for hunting in rough terrain but equally functional anywhere the weather turns inclement. Endorsing the historic boot, the catalog once offered readers a tongue-in-cheek warning:

"You cannot expect success hunting deer or moose if your feet are not properly dressed." (L. L. Bean would later be endorsed by *The Official Preppy Handbook* in 1980 and enjoy a whopping 42 percent increase in sales.)

However, outdoor clothing makers were popular on campus long before the preppy revival of the 1980s. As early as the 1920s, college students were wearing wool plaid outerwear intended for rugged sports, Mackinaws and Hudson's Bay coats made by companies like Woolrich and Pendleton Woolen Mills. In the early 1990s, Seattle-based grunge rock brought outdoorsy plaids back into fashion, and the inimitable Marc Jacobs introduced the look to the New York runway in his collections for Perry Ellis. For Fall 2009, Michael Bastian based his menswear collection on a nostalgic, heavily layered grunge aesthetic, right down to the signature plaid shirt wrapped at the waist. Woolrich has also explored its innate fashion potential, launching a European-designed but American-made collection that perfectly recaptures the rugged charm of its outdoor clothing line circa 1930. (Sadly, the "Pennsylvania Tuxedo," a matching red-and-black plaid hunting coat and snow pant, has not been revived.) Likewise, Sal Cesarani, David Chu, Joseph Abboud, and a host of other archaeologically minded designers have used vintage outdoor styles as inspiration while continually updating fits and fabrics. The result of all this able-bodied outdoor activity was a major return to bold and brawny plaids on Fall 2008 runways; it went by the unusually robust fashion name "the Lumberjack look."

If there is any man who can surpass the all-around machismo of the hunter, it is the soldier. While army uniforms were created purely for function, military designers knew well how to flatter a man's physique. Thankfully, many of their innovations have carried over into civilian life, perhaps the sole silver lining in the clouds of war of the past century. Commercial fashion designers have always understood that there's something special about the look of a man in a uniform, but beyond looks, practicality and comfort have been primary concerns for the armed forces. Doughboys returning home after World War I, for instance, found it impossible to go back to wearing starched, detachable high collars after experiencing the comfort of army shirts with soft, one-piece collar construction. Likewise, who needed a pocket watch (or a vest, for that matter) when it was so much more convenient to wear one of those newfangled military-style wristwatches?

But the most significant fashion to emerge from World War I was the aptly named trench coat, developed by Thomas Burberry for English troops fighting in France. Its civilian popularity grew after the war, accompanied by an air of masculine adventure that reached its apogee in the

1942 film *Casablanca*. Consequently, when most men think of the trench coat, it's often the one worn by Humphrey Bogart saying farewell to Ingrid Bergman on a rain-soaked runway. And it wasn't worn only by Bogie; it became requisite attire for detectives prowling the dark and shiny streets of 1940s film noir, not to mention the comic-book detective Dick Tracy. Today, the trench retains its virile authority in the real world, but streamlined, with fewer attachments and in shorter lengths.

The casual post–World War II environment made it easy for army gear to make the transition from military to civilian apparel. Soldiers brought back their uniforms from active duty and found garments such as the khaki pant and the short battle jacket—better known as the Ike jacket, nicknamed for General Eisenhower—a perfect fit for suburban living. Another army staple that entered the mainstream was the CPO, or Chief Petty Officer's jacket, a heavy wool shirt with two breast pockets, most often seen in plaid, which became popular with collegians in the 1960s and grunge rockers in the 1990s. And the leather bomber jacket, notable for its oversize pile collar, was designed to keep fliers warm at high altitudes but worked equally well for students at college campuses in northern latitudes.

During the Vietnam years, protests at home introduced a new reason to wear military surplus. It was no longer simply about practicality or even looking fashionable. Military garments, such as olive drab field jackets, camouflage fatigue pants, and army boots were appropriated by protesters from the establishment. Having mixed these battle-tested garments with their jeans and hippie regalia, they were now ready to fight the enemy on their own terms. Of course, the fact that this surplus gear was highly functional and cheaply priced at the local army-navy store didn't discourage the trend. Whether there is a war to protest or not, army surplus–inspired styles— from the leather bomber jacket to camouflage prints—continue to turn up regularly on fashion runways everywhere. For instance, designers introduced cargo pocket pants and shorts into their lines in the late 1990s and, remarkably, they have stayed far longer than any normal trend cycle should allow. Those highly functional pockets are so popular with men that the cargo pant seems to have joined the ranks of classic menswear styles that will always be in stock.

In a world fraught with challenges of all sorts, it's no wonder there's a newfound appreciation for the authentic, back-to-basics aesthetic of utilitarian clothing emphasizing practicality, strength, and an inherent masculinity. These are qualities every man can appreciate—from designers and avid followers of fashion to everyday guys who simply want to look good.

John Bartlett, 2008 *Opposite* John Bartlett's utilitarian, masculine designs demonstrate military and workwear influences. Here he takes a minimalist approach to a short-sleeve leather shirt for his Spring-Summer 2008 collection. **S.S. Leviathan, 1918** *Following pages* A J. C. Leyendecker illustration of military personnel in the well-tailored uniforms of the various services as they sail aboard the *S. S. Leviathan* for the European front.

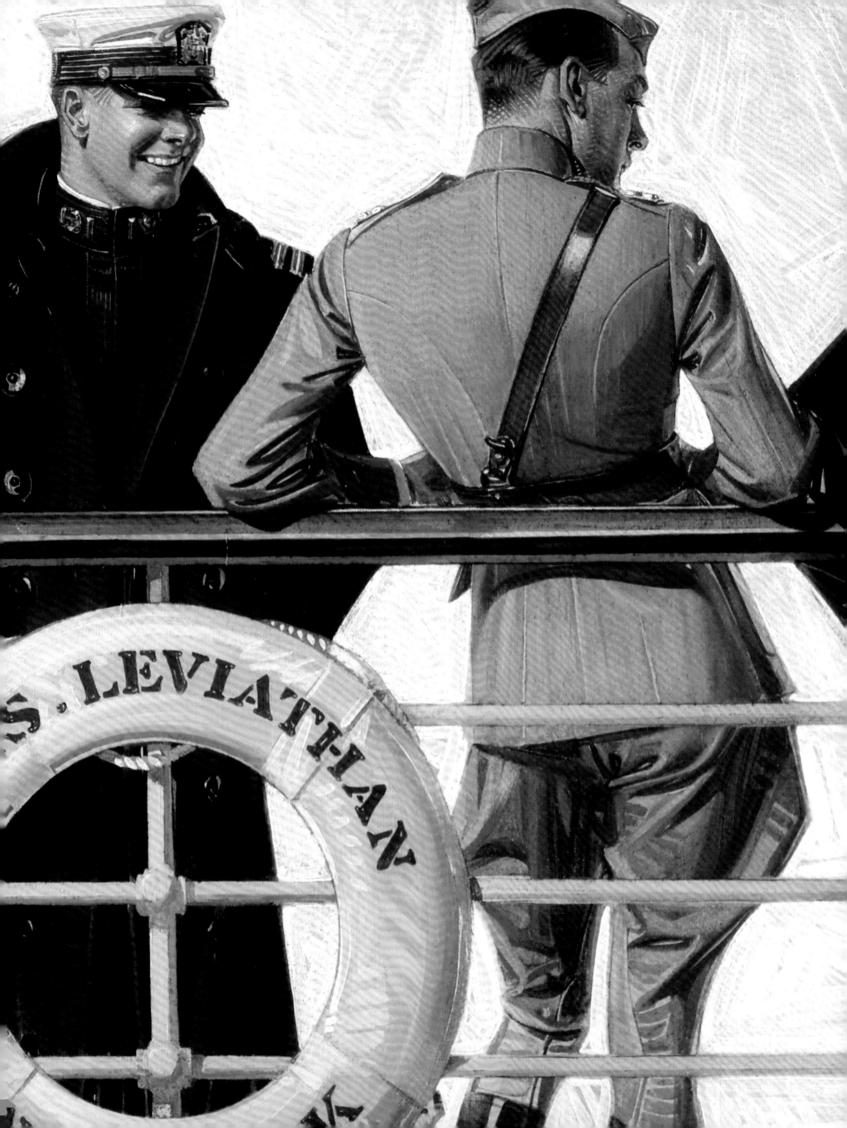

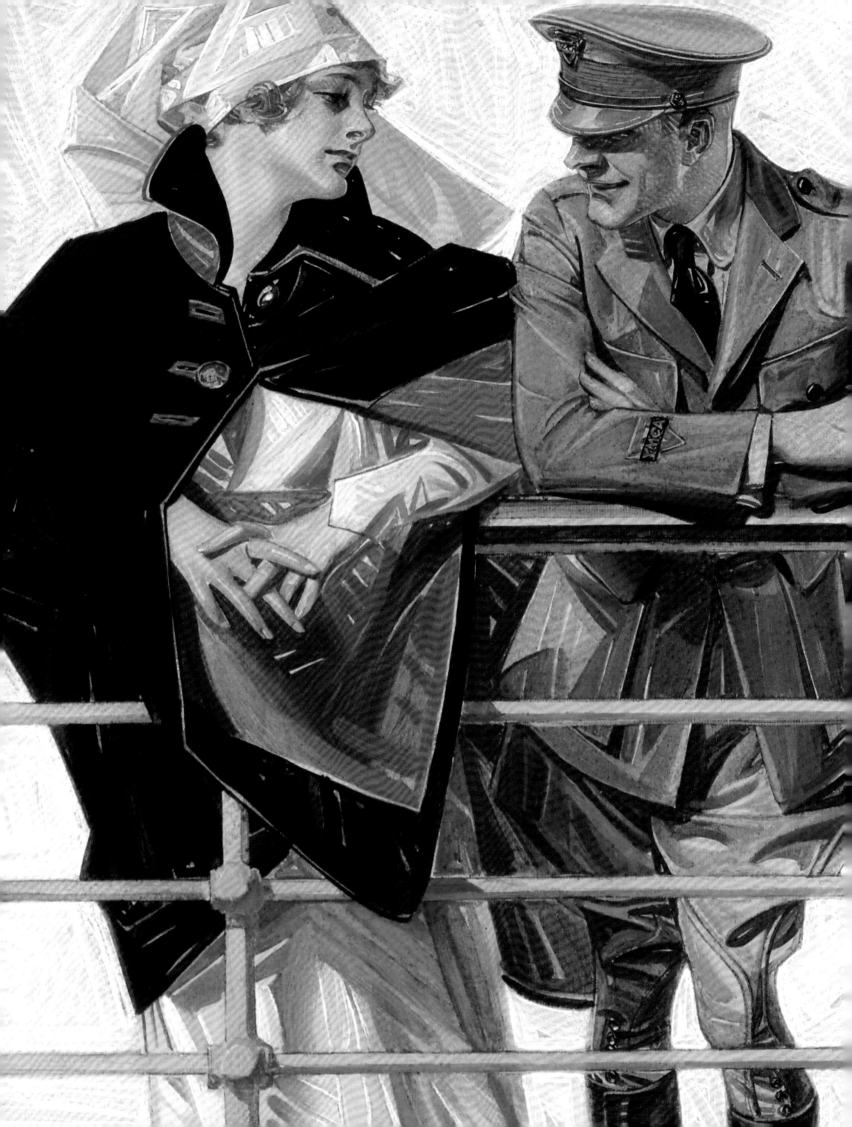

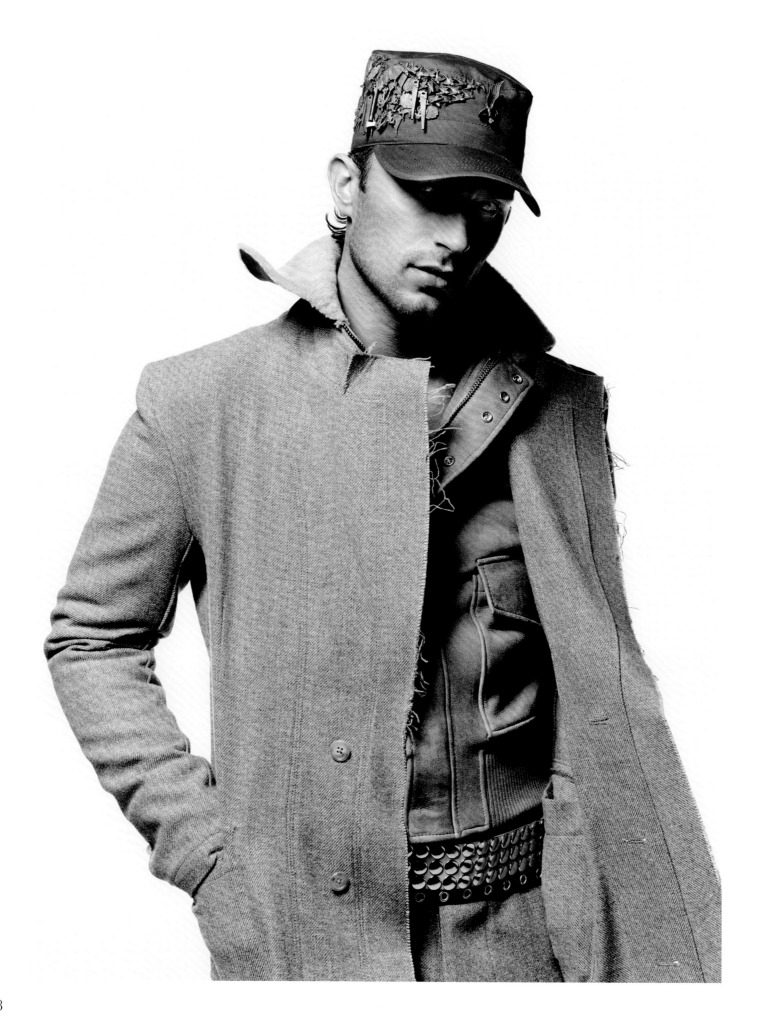

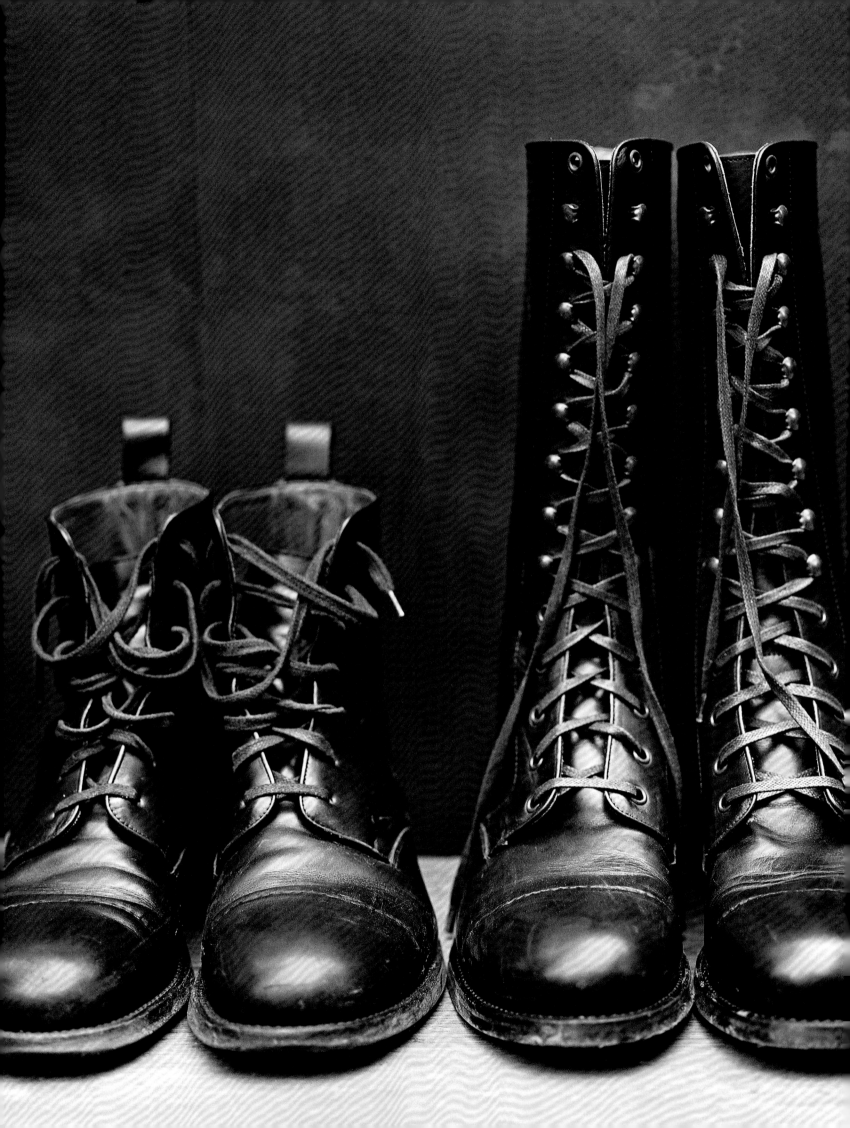

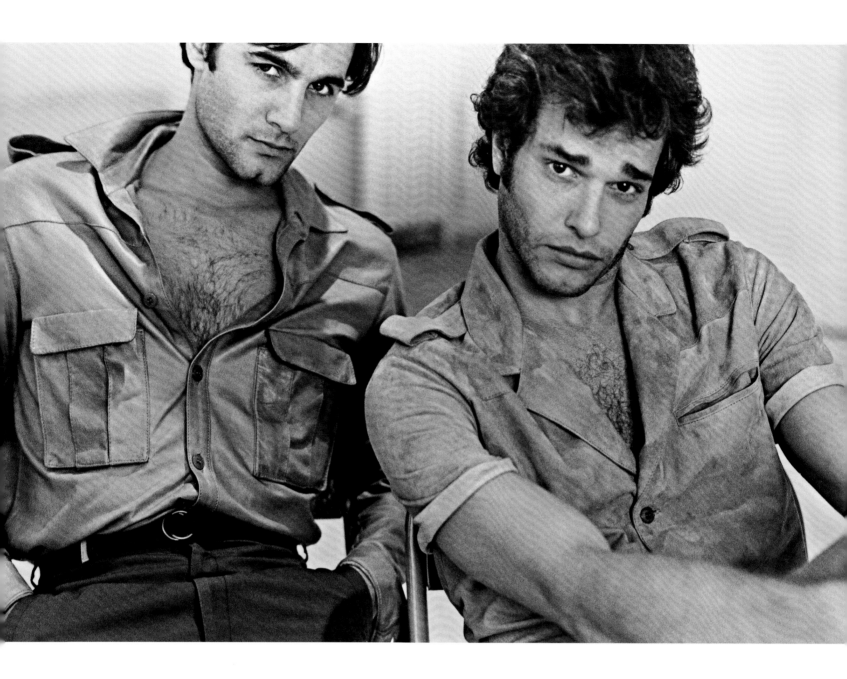

Bill Kaiserman for Rafael, 1979

Above Dubbed the American Armani in the 1980s, Bill Kaiserman was also influenced by military apparel, as is aptly demonstrated by these olive- and caramel-colored shirts adorned with epaulets and bellows pockets for his Rafael line.

James Dean, 1955

Opposite The iconic actor, dressed in a Western shirt and jeans, poses for the camera in front of his Airstream dressing-room trailer during the making of his last film, director George Stevens's *Giant*.

Subversive Jewelry by Justin Giunta, 2004

Previous pages, left Military uniforms, the epitome of good design, have often inspired civilian designers. Here, a military-style "Arsenale" cap by Justin Giunta.

John Varvatos, 2002

Previous pages, right From goth to grunge, combat boots can be as fashionable as they are functional.

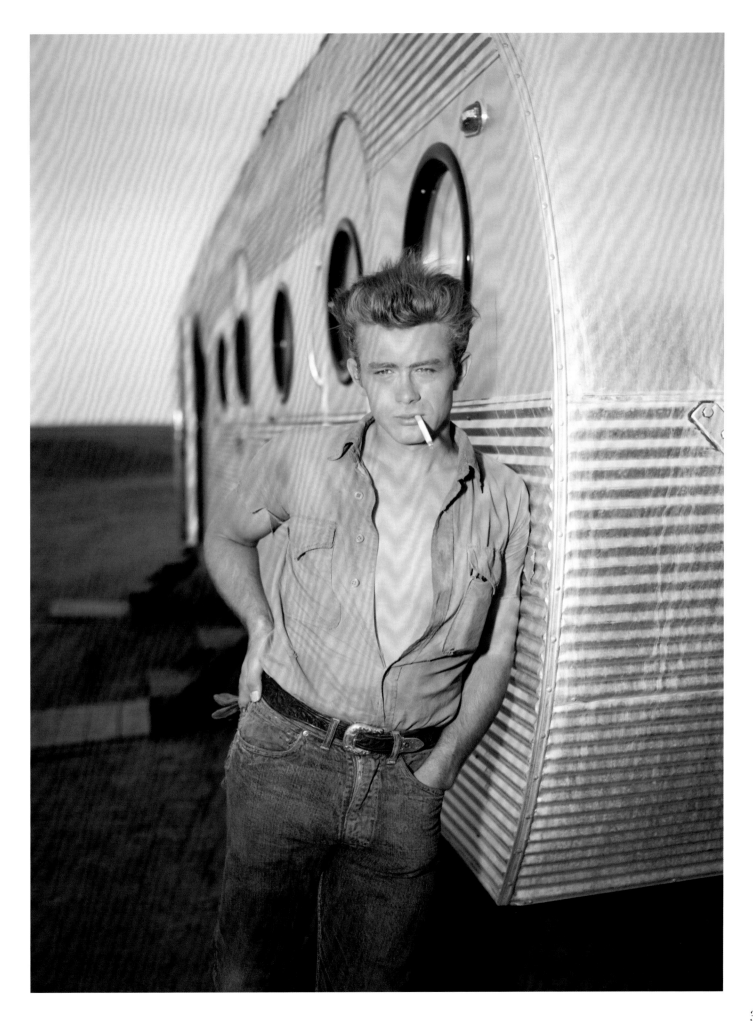

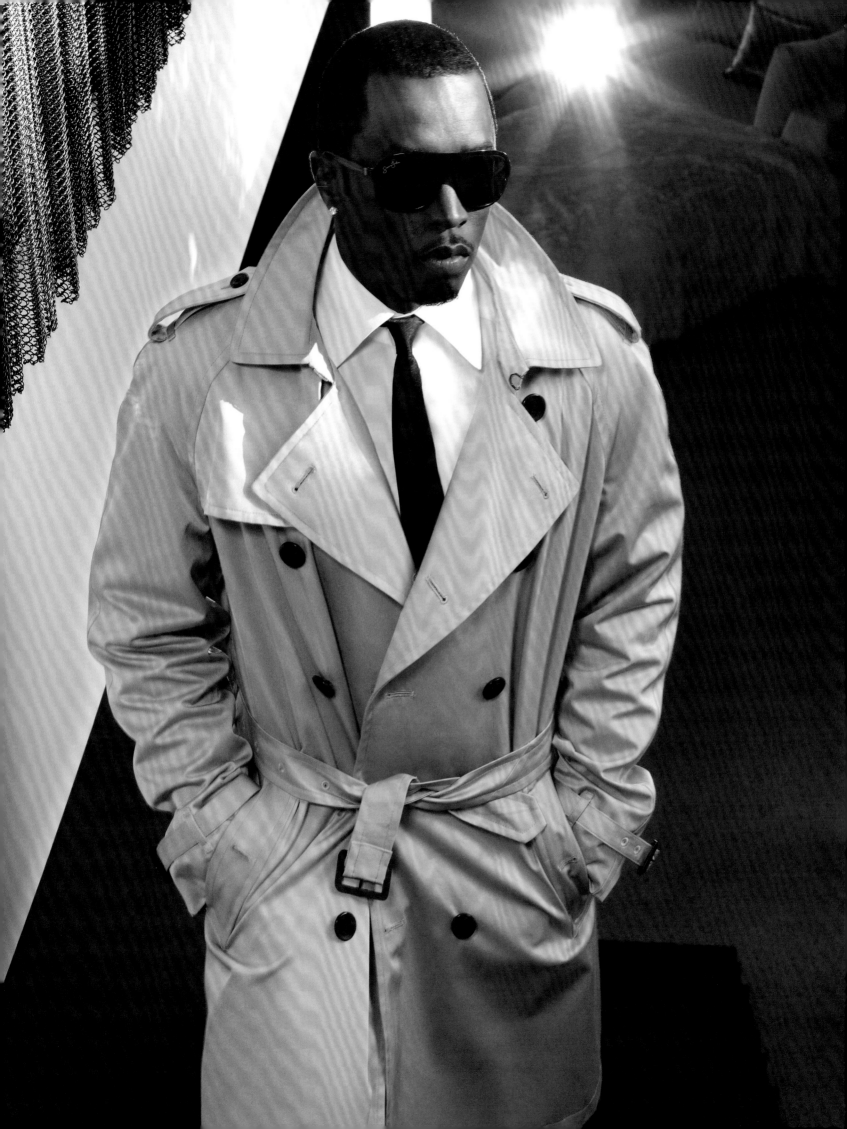

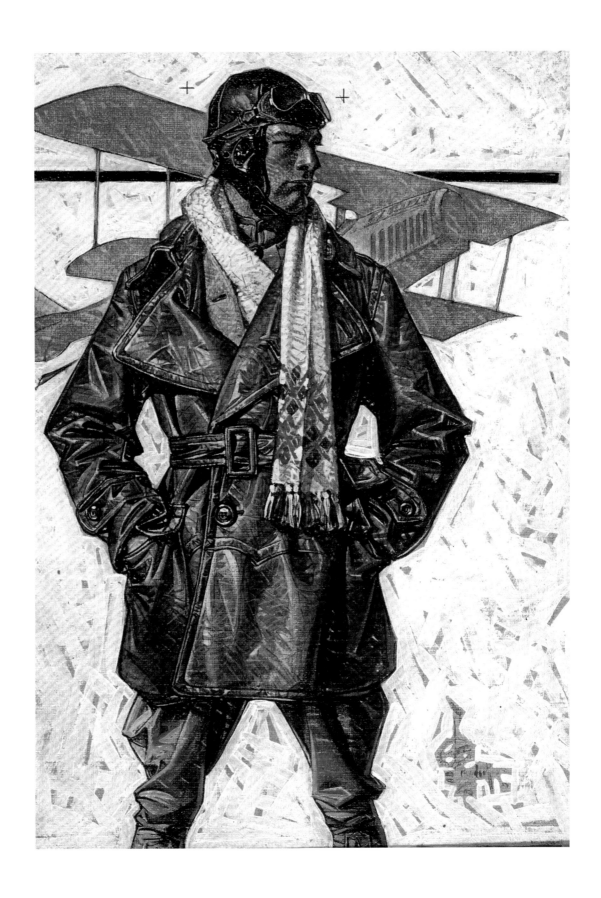

Air Force Pilot, 1917

Above Illustrator J. C. Leyendecker glorifies the World War I
American aviator, clad in a leather flying helmet and leather coat.

Sean John, 2008

Opposite Hip-hop impresario and designer Sean "Diddy" Combs
models a trench coat of his own design.

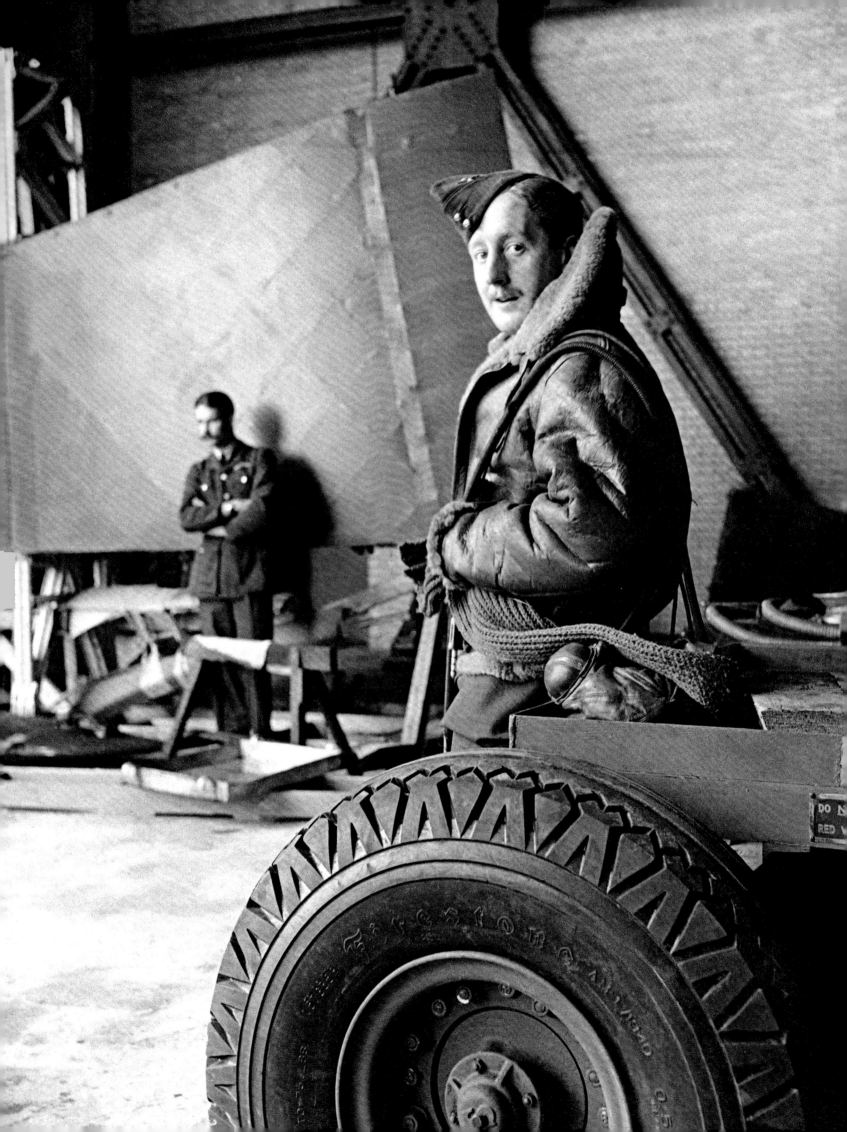

Reed Krakoff for Coach, 2008

Above Designer Reed Krakoff's adaptation of the aviator coat.

British aviator, 1941

Opposite The noted fashion photographer Cecil Beaton was commissioned by the British military to document the troops at war. In this portrait, a pilot wears a shearling leather coat designed to keep him warm while flying at high altitudes.

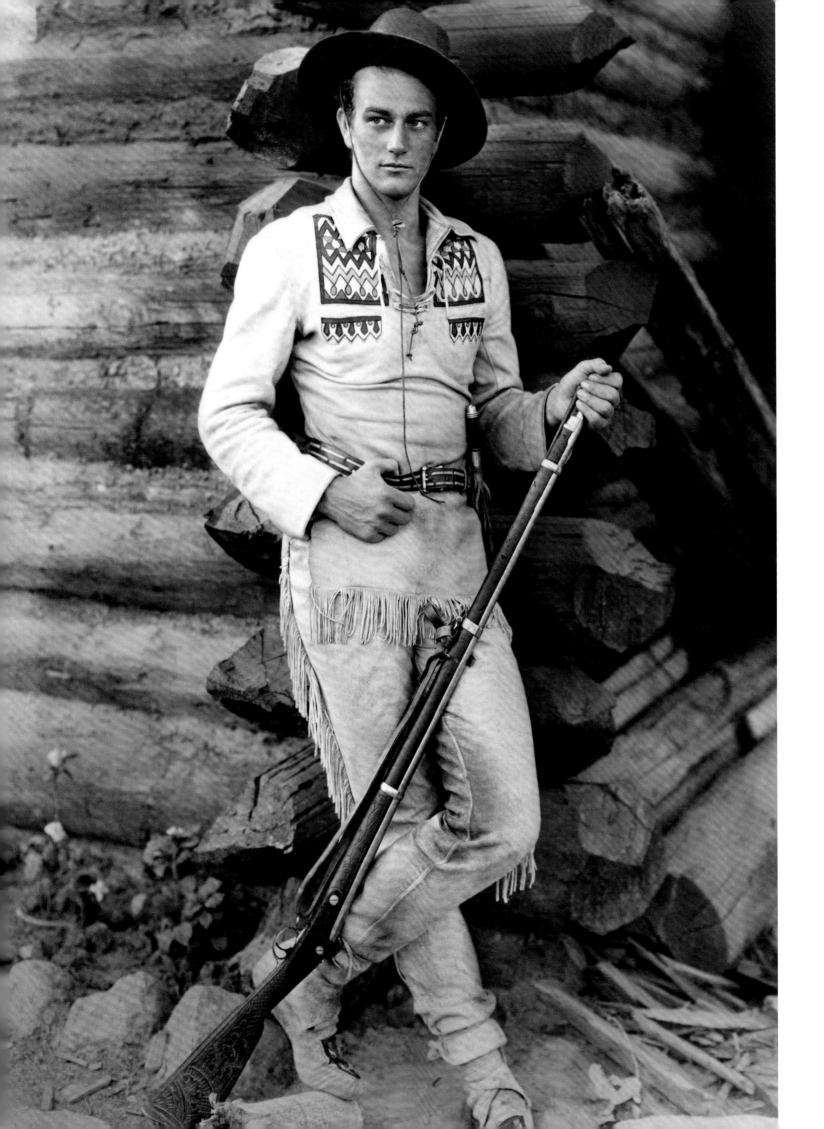

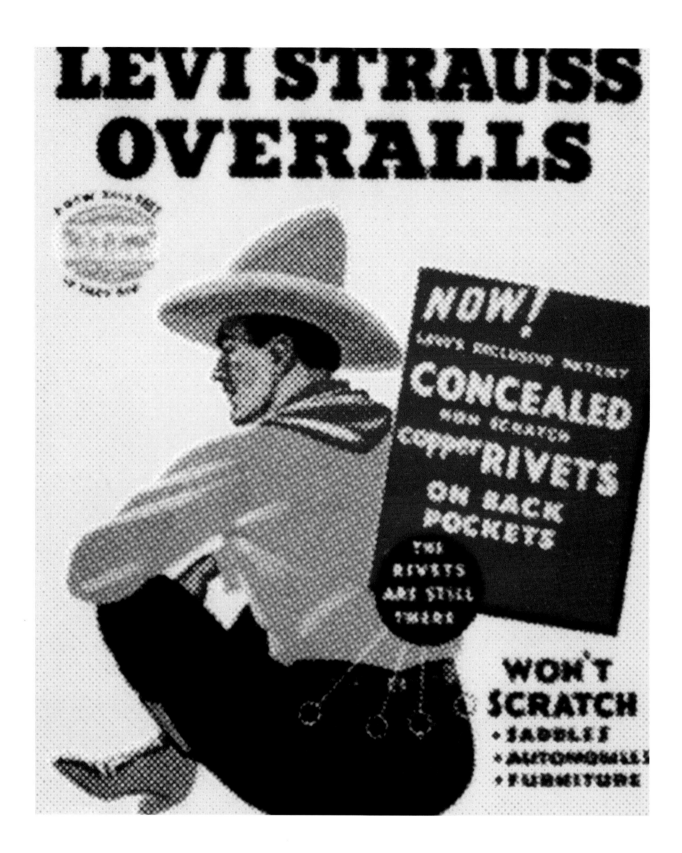

Levi Strauss advertisement, 1937

Above Levi Strauss, the company that invented denim jeans and pioneered Western wear, promoted the quality make and all-round practicality of its clothing.

Jeffrey Lubell in True Religion, 2008

Opposite A leader in the premium-denim field, True Religion founder and CEO Jeffrey Lubell models a Western denim shirt and jeans.

John Wayne in the film *The Big Trail*, 1930

Previous pages, left For his starring role in *The Big Trail*, directed by Raoul Walsh, the 23-year-old Wayne wore beaded and fringed buckskin, more in keeping with Native American dress (or at least with Daniel Boone) than typical cowboy style.

Henry Jacobson, 2006

Previous pages, right A contemporary approach to Western wear that is just as sexy on the runway as at a rodeo.

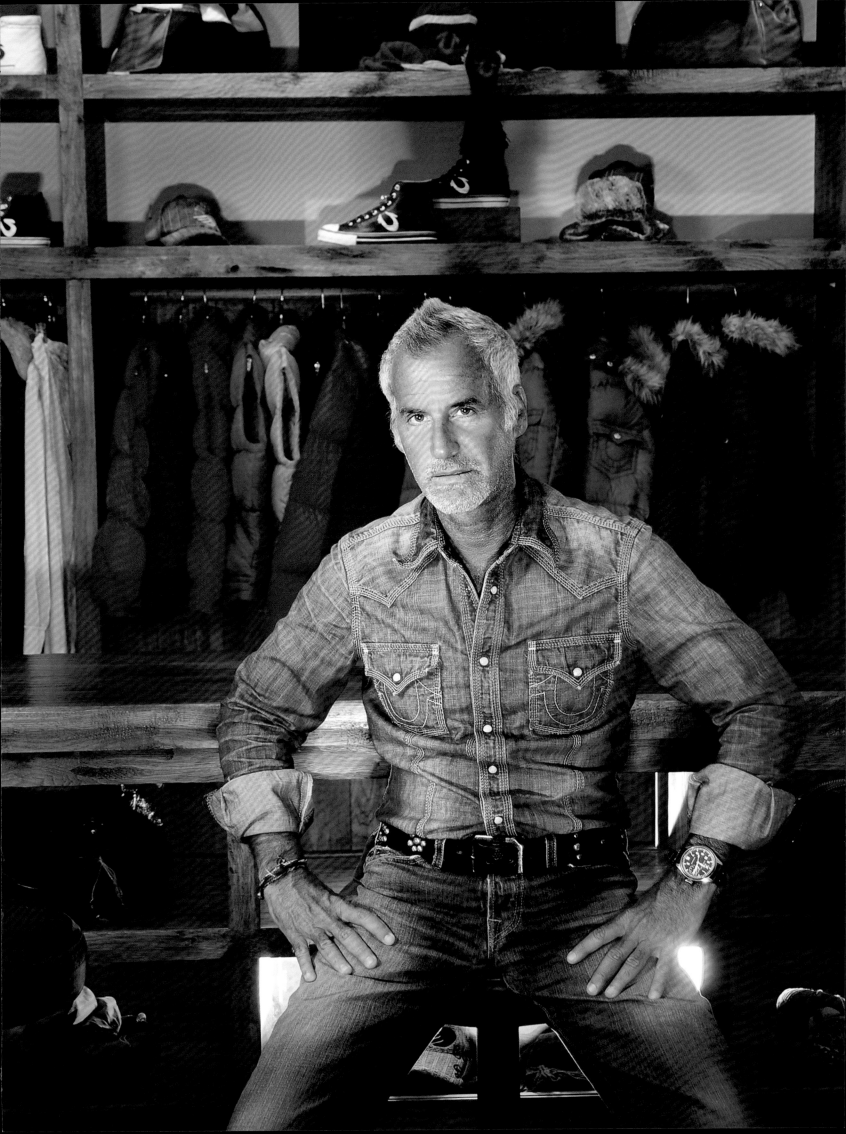

Tony Melillo, 2008

Left Activewear-influenced designer Tony Melillo sent this dressy leather jacket and pants down the runway at his Fall 2008 show.

John Bartlett and Banana Republic, 1997

Opposite The all-American combination of a snap-front, Western-inspired John Bartlett jean jacket and Banana Republic cotton khakis was showcased in the spring edition of *The New York Times Magazine*'s *Men's Fashions of the Times*.

***The Lineman,* 1949**

Following pages, left The quintessential American illustrator Norman Rockwell, known for poignantly capturing scenes from everyday life, created a series of advertisements for AT&T featuring men at work.

Denim overalls, 1948

Following pages, right North Carolina tobacco farmer Roger Ferguson shows off the versatility of overalls by dressing them up with a shirt and a tie for a Sunday go-to-meetin'.

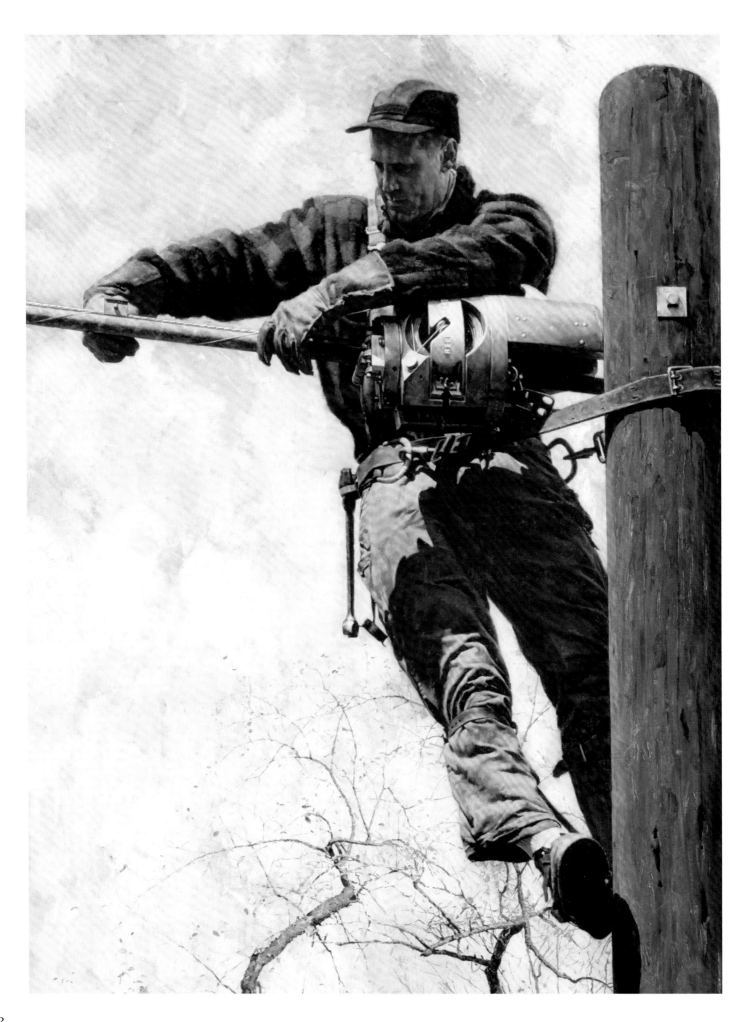

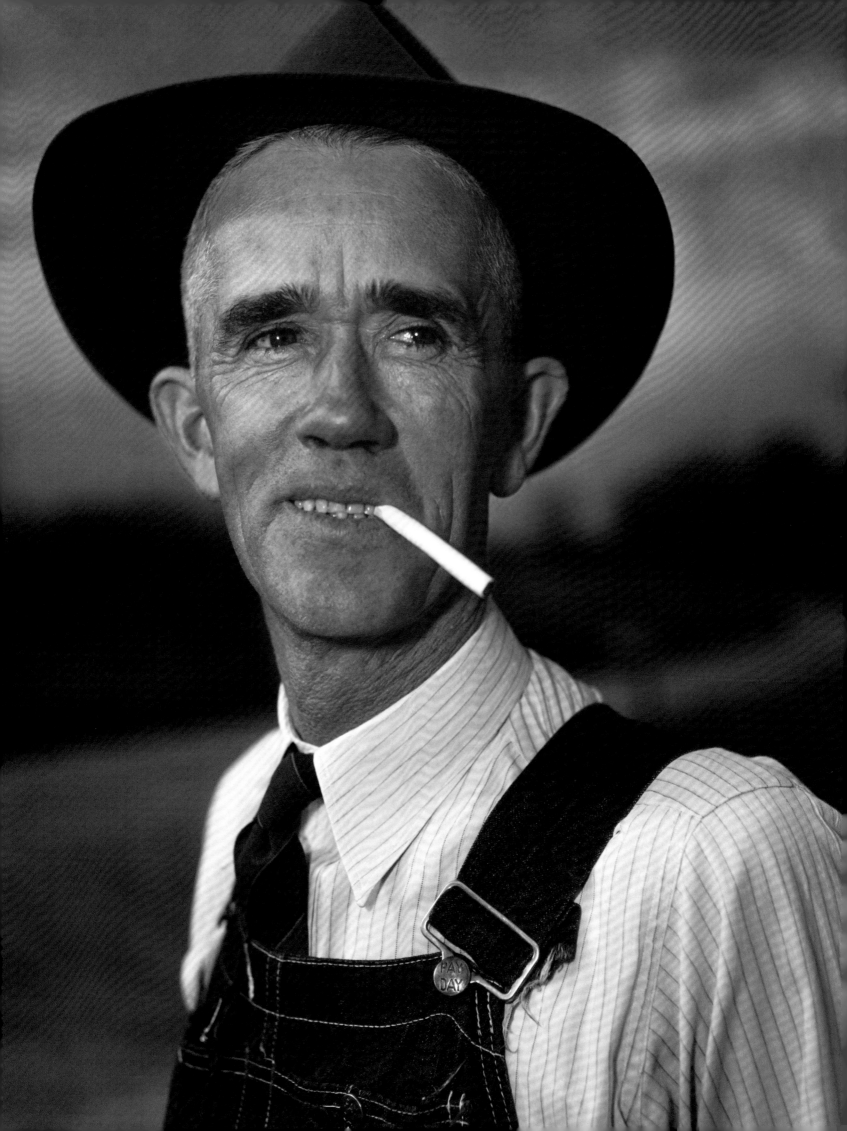

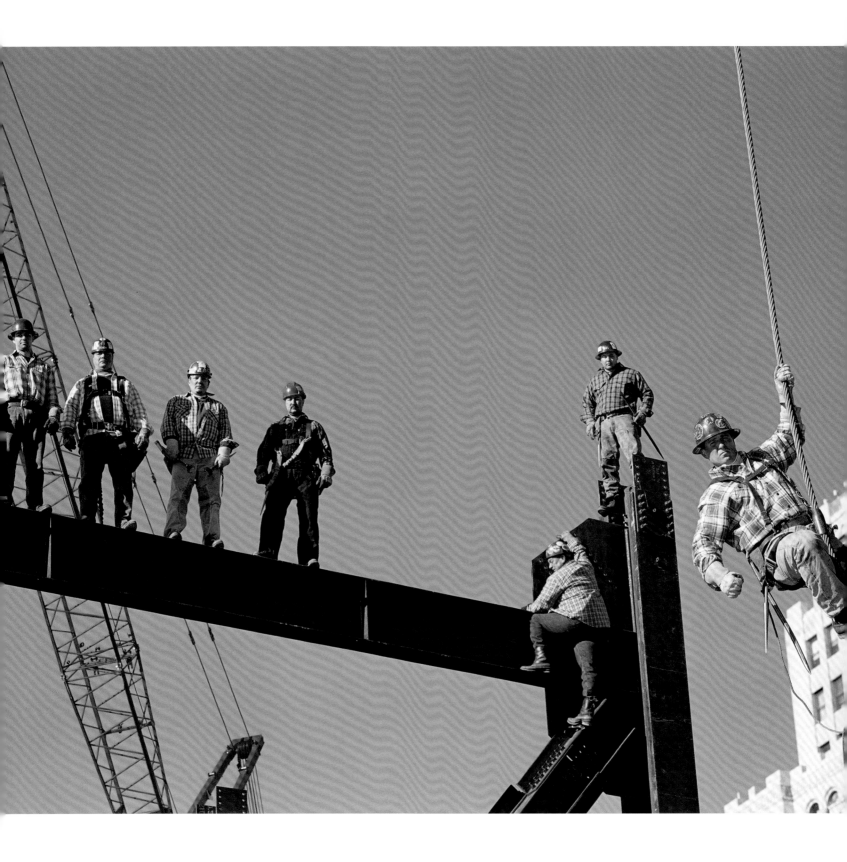

Tommy Hilfiger, Lands' End, J. Crew, Filson, and Ralph Lauren, 2003

Above In line with their dangerous profession, construction workers wear practical, no-nonsense clothing such as plaid shirts and jeans. From left to right, these model employees have on Tommy Hilfiger, Lands' End, J. Crew, J. Crew, Lands' End, Filson, and RRL Ralph Lauren. Photograph by Laura Wilson for *GQ*.

Billy Reid, 2008

Opposite Louisiana-based designer and retailer Billy Reid's well-dressed outdoorsman look: a double-breasted wool jacket, a turtleneck sweater, and fashionably cuffed dark denim jeans.

Daiki Suzuki for Woolrich Woolen Mills, 2008

Above A field jacket in a shadow buffalo plaid designed by Daiki
Suzuki for one of America's oldest rugged-wear companies,
Woolrich Woolen Mills.

Andrew Fezza, 1992

Opposite Actor Liam Neeson models a wool plaid field jacket
by designer Andrew Fezza.

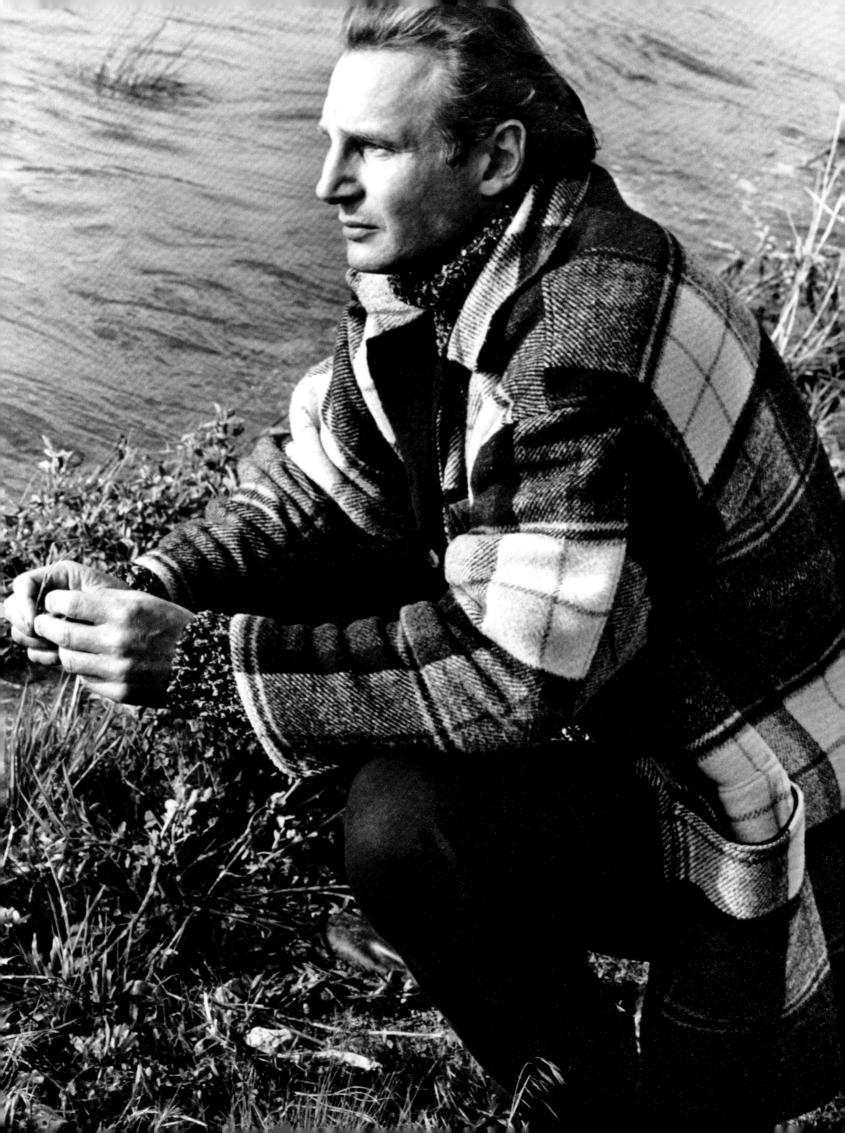

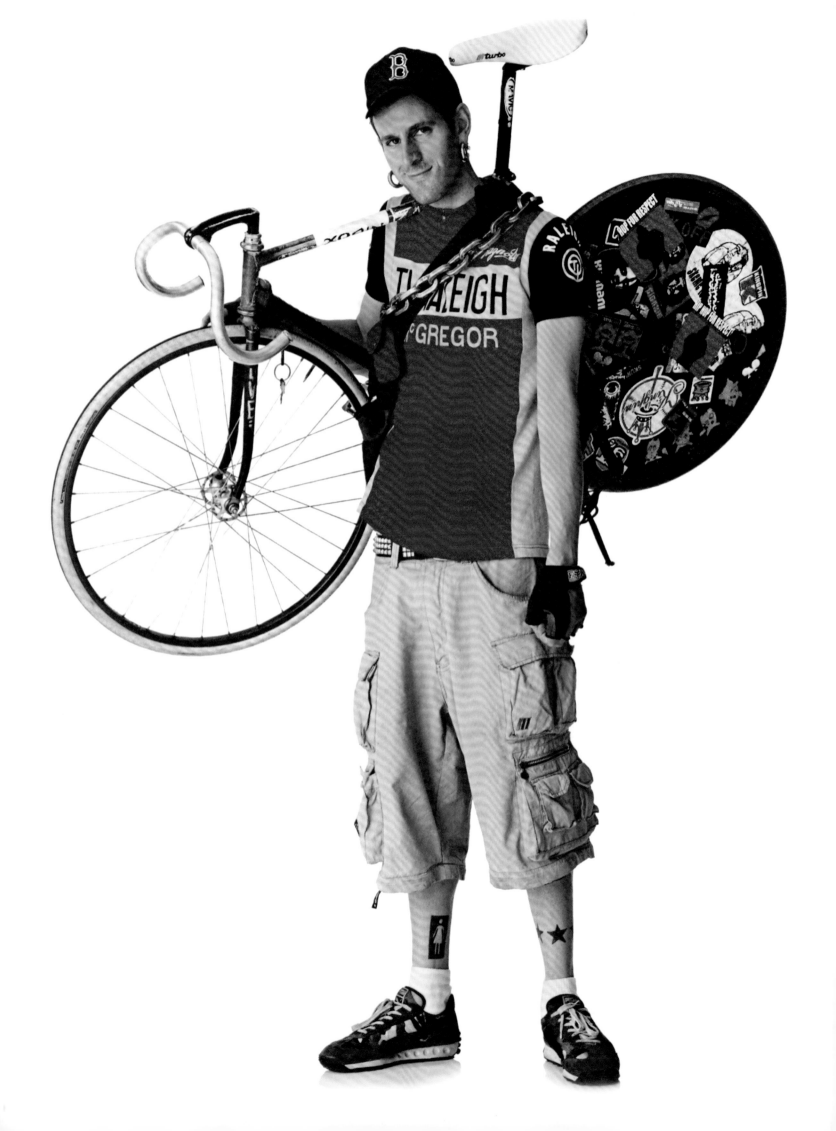

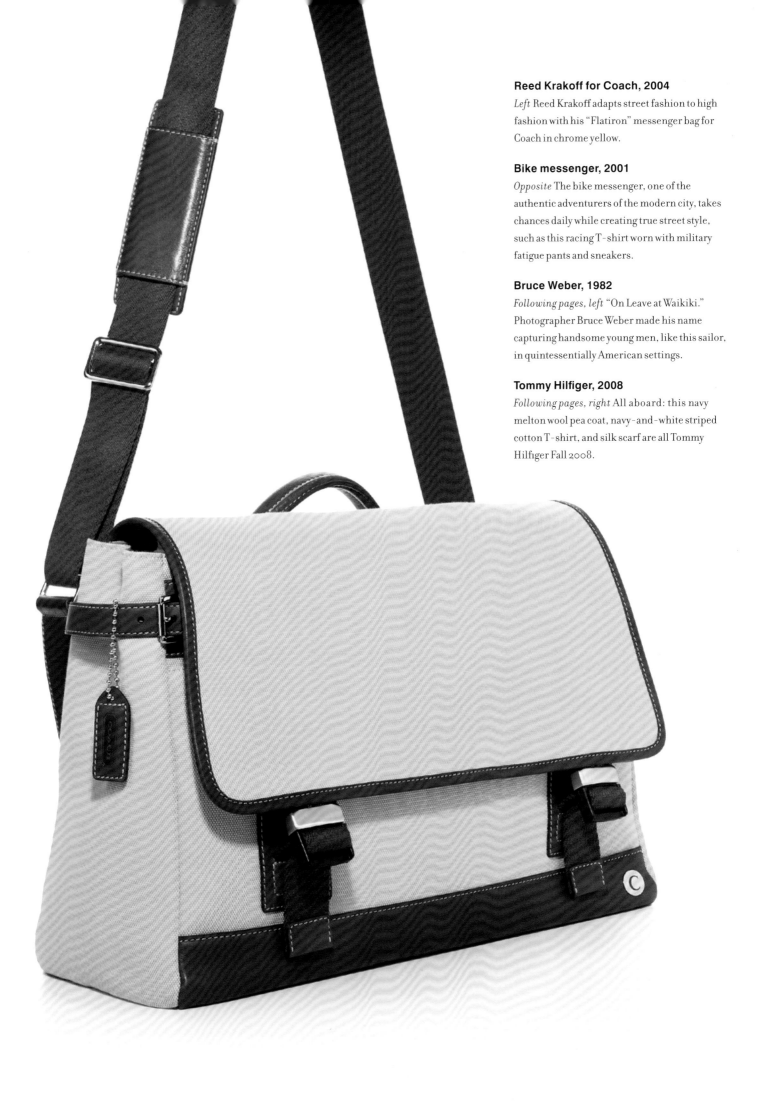

Reed Krakoff for Coach, 2004

Left Reed Krakoff adapts street fashion to high fashion with his "Flatiron" messenger bag for Coach in chrome yellow.

Bike messenger, 2001

Opposite The bike messenger, one of the authentic adventurers of the modern city, takes chances daily while creating true street style, such as this racing T-shirt worn with military fatigue pants and sneakers.

Bruce Weber, 1982

Following pages, left "On Leave at Waikiki." Photographer Bruce Weber made his name capturing handsome young men, like this sailor, in quintessentially American settings.

Tommy Hilfiger, 2008

Following pages, right All aboard: this navy melton wool pea coat, navy-and-white striped cotton T-shirt, and silk scarf are all Tommy Hilfiger Fall 2008.

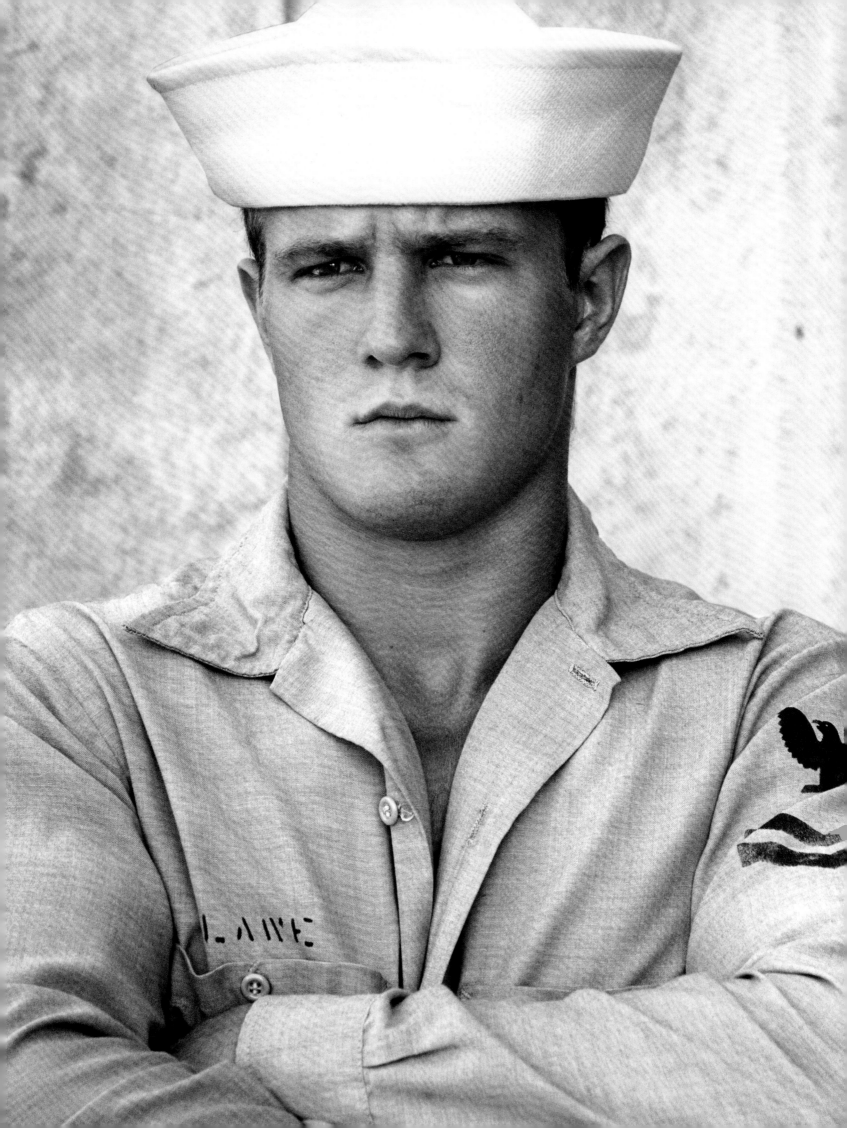

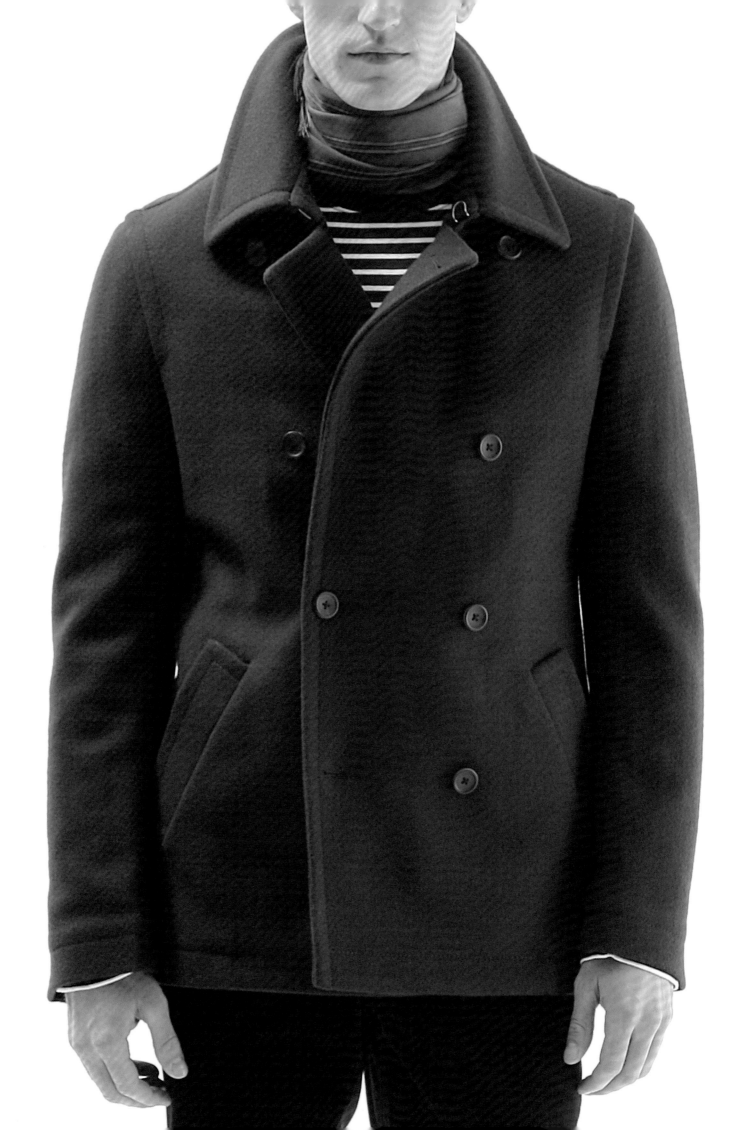

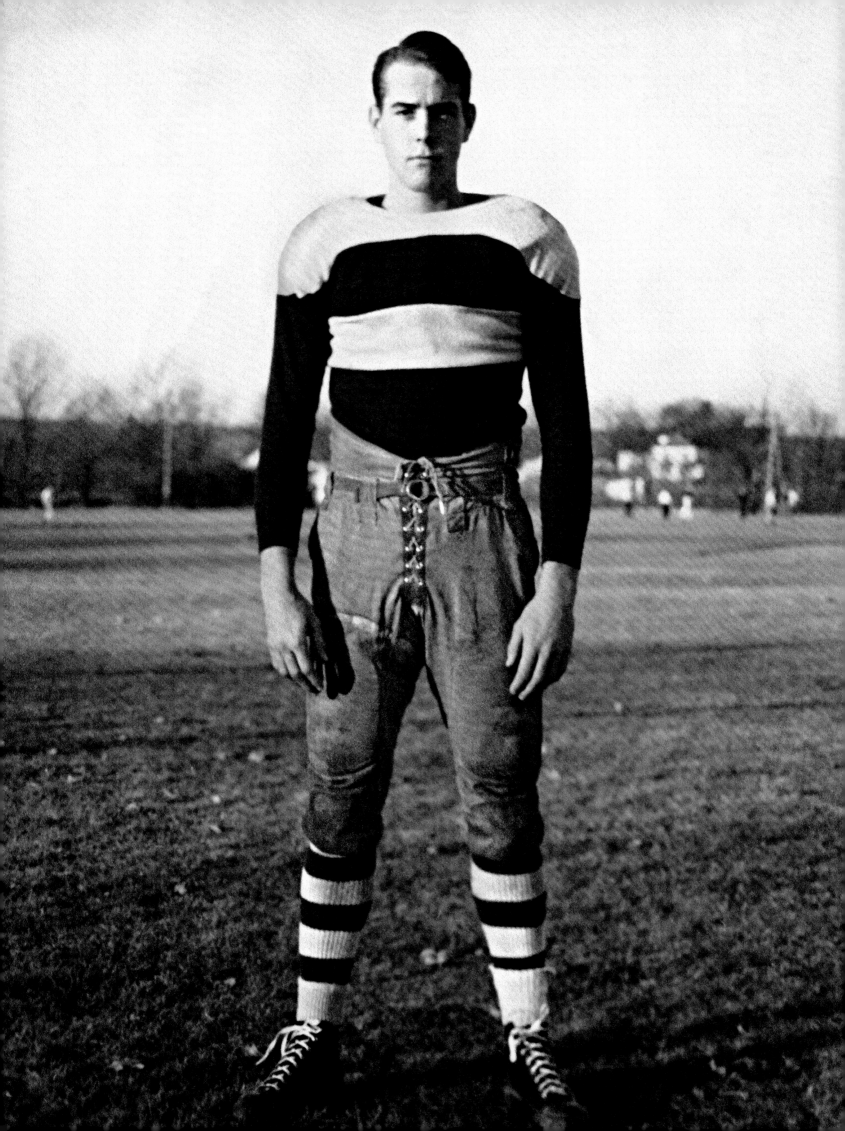

The Ivy Road

{ *From rep ties to Shetland sweaters, the legacy of collegiate attire dates back more than a century.*

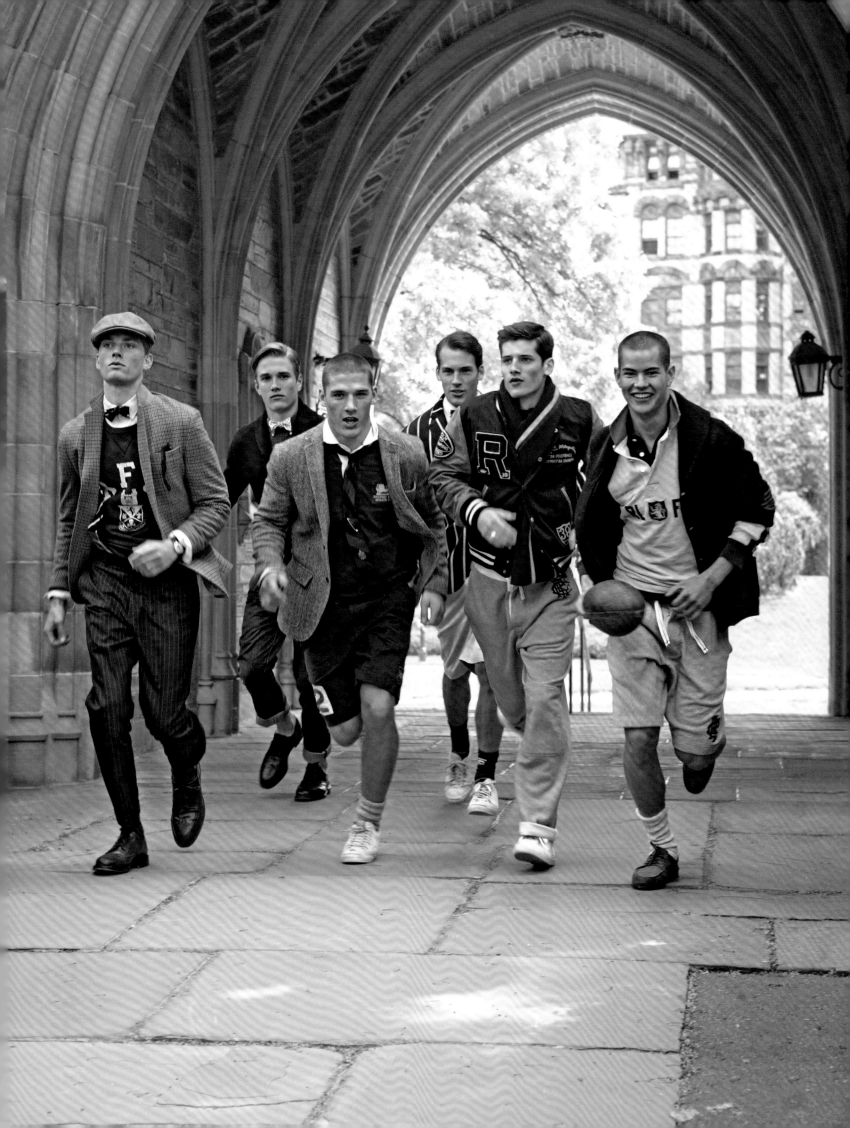

FASHION ON CAMPUS

"A preppy is someone who dresses perfectly without trying to— and who appears to do everything well without trying to."

ERICH SEGAL, AUTHOR OF *LOVE STORY*, 1970

The boom years following World War II witnessed the popularity of the most inherently American style of all: the Ivy League look. Even after all the changes in fashion during the past fifty years, America still remains faithful to this indigenous style as interpreted by companies such as Ralph Lauren, J. Crew, and Brooks Brothers.

To understand how collegiate styles spread from eastern campuses to the rest of the nation, let's take a closer look at the roots of the Ivy League look at the dawn of the twentieth century. In 1896, Brooks Brothers introduced what would become the look's ultimate symbol: the sporty oxford-cloth button-down collar shirt, adapted from shirts worn by English polo players who didn't want their collars flapping in their faces. From then until 1930, Brooks Brothers introduced items that became core components of the Ivy League look, such as the polo coat (also borrowed from equestrian England), Shetland sweaters, seersucker suits (a longtime staple of the British Empire), the rep tie (based on British regimental club designs), Indian madras leisurewear, a three-button, natural-shoulder sack coat, and a new button-down collar shirt in Brooks' legendary shade of pink.

Besides Brooks Brothers, it was the privileged sons of the elite attending Harvard, Yale, and Princeton who really defined the latest menswear trends. While the term "Ivy League" was not coined until the mid-thirties, in reference to the eight schools comprising the Ivy League Athletic Conference, the schools already had a reputation as closely watched fashion centers. It was on these New England campuses that the taste developed for three-button suits and natural-shoulder sport coats, raccoon and polo coats, Harris Tweed and Norfolk jackets, and gold-buttoned blazers.

Ralph Lauren, 2008 *Opposite* These students may be late for class, but at least they're dressed in perfect preppy clothes from Rugby Ralph Lauren's Fall 2008 collection. **Football player, 1940** *Previous page* The goal of every red-blooded American boy? To make the school's football team, like the young hero in this photograph, strikingly clad in lace-up pants, a striped athletic jersey, and striped socks.

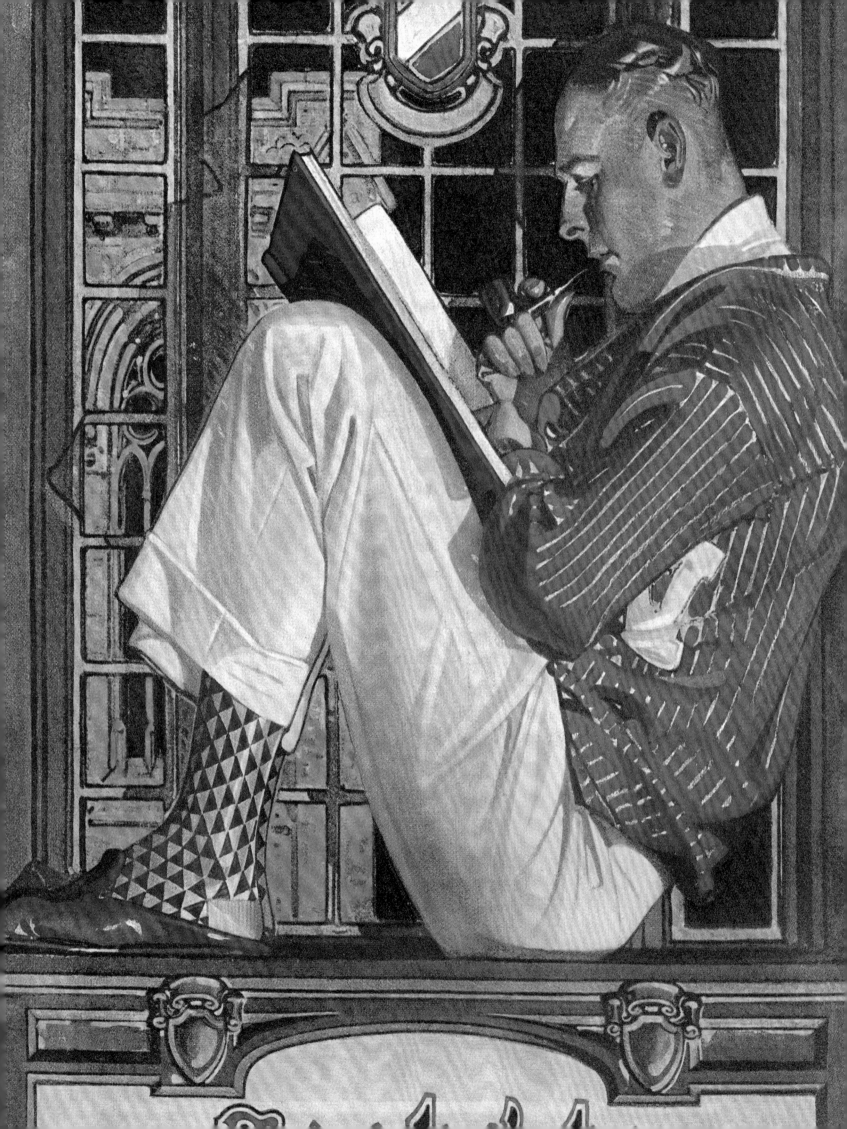

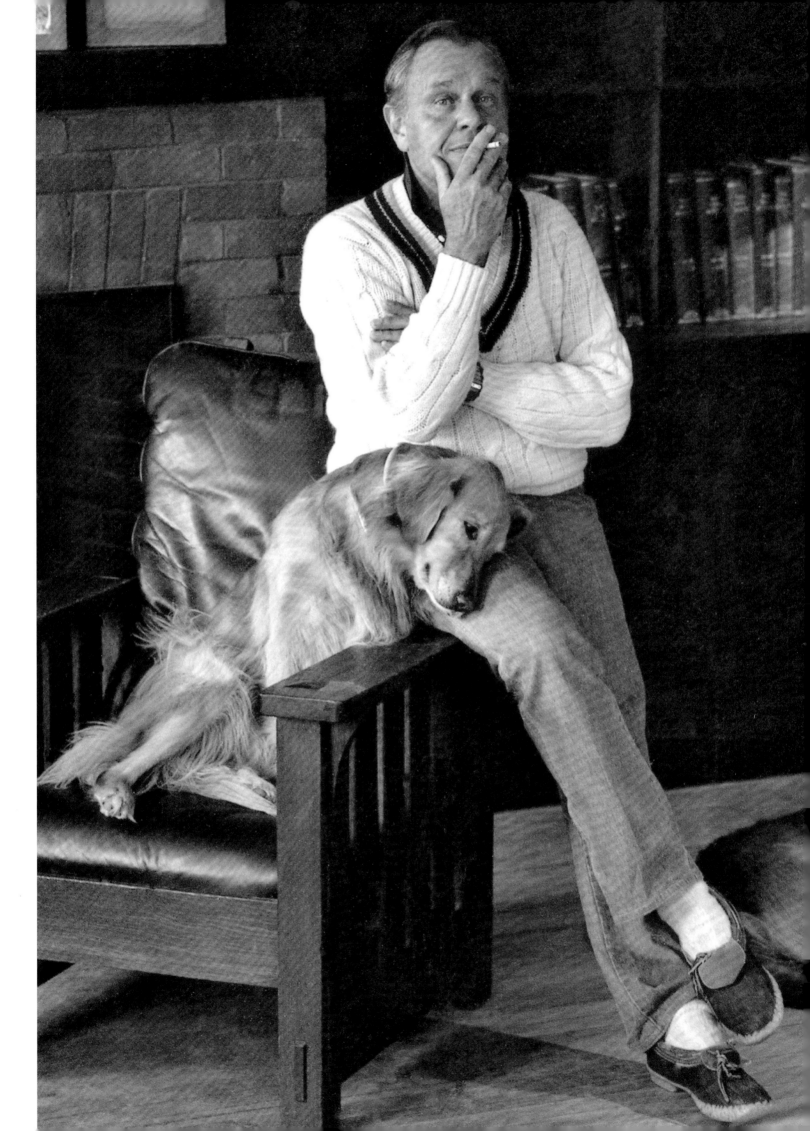

Sports were a huge influence on the Ivy League look, as *Men's Wear* magazine reported in 1928: "College men cannot be expected to be dressed in their Sunday best at all times, so it is little wonder that they are outfitted a good deal of the time as if they were about to venture forth upon the golf course."

Throughout the 1930s, college students continued to jump on the latest trends, such as the newly minted Bass Weejun moccasin (also known as the penny loafer) in 1936, or, the following year, English hunting jackets worn as raincoats. By the 1950s, the look really started to solidify. In an article entitled "American Informal," *Esquire* pronounced that "naturalness is the answer—no frills, nothing superficial." It was the students at northeastern colleges who became the poster boys for this new "old school" look, while southern universities such as Duke, Wake Forest, and the University of Virginia followed their lead. In keeping with this old-money New England aesthetic, the new resorts of choice were Nantucket, Cape Cod, and Martha's Vineyard, though their influence was not as great as that of prewar destinations such as Palm Beach and the French Riviera.

At the fashion forefront was the sack sport coat (now with slimmer lapels) as rendered by old-line clothing makers such as Haspel, Southwick, and J. Press. It was typically worn with trim, plain-front chinos adorned with a buckled strap on the back and with Weejuns (often with argyle socks, and later no socks at all). Patterned Bermuda shorts also became part of the look, with *Men's Wear* exclaiming, "Shorts are sensational!" and announcing that they had "taken Princeton and Yale by storm."

By 1954, the Ivy League look was both popular and hip. Jazz great Miles Davis, as recounted by Christian M. Chensvold in an article for *RL Magazine*, started getting his clothes at the Andover Shop in Cambridge, Massachusetts. Davis went for everything from tweed and madras soft-shouldered jackets to button-down collar shirts and rep-stripe ties. When Miles wore a seersucker jacket, a white club-collar shirt, and a bow tie at the 1955 Newport Jazz Festival, other jazz greats such as Stan Getz and Chet Baker also began adopting the Ivy League look.

In 1960, the youthful Harvard grad and Massachusetts native John F. Kennedy brought the Ivy League look to the White House. His nonchalant style continues to inspire designers today, with Michael Kors saying that Kennedy's "unstudied sense of style is a constant touchstone

Ivy League style, ca. 1929 *Previous pages, left* A student wears the epitome of college fashion—a shawl-collared letter sweater and cream flannels—in this advertisement for Interwoven socks by J. C. Leyendecker. **Bill Blass, 1982** *Previous pages, right* Posing in a classic tennis sweater with one of his beloved golden retrievers, the legendary Bill Blass was one of the first designer names in menswear in the mid-1960s.

when I design my men's collections." Whether sailing in a faded polo shirt, rolled chinos, and Sperry Top-Siders or at the White House in a relaxed suit, Kennedy helped define a new age of American style.

The popularity of the Ivy League look went into rapid decline with the rise of mods and hippies in the 1960s and disco and punk in the 1970s. But by 1980, many young men, tired of polyester flamboyance, were ready for something fresh and clean. The result was a renaissance of classic American style, this time going by the name "preppy." In 1980, Lisa Birnbach hit the best-seller list with her tongue-in-cheek send-up of the lifestyle, *The Official Preppy Handbook*. Once again, blue blazers, polo shirts (now by Lacoste), khakis, argyle sweaters, L. L. Bean parkas, and Top-Siders ruled the day.

The preppy trend was long gone by the dawn of the 1990s, but a quirk of fashion extended it into an entirely new and unexpected market: hip-hop. Urban youths, attracted to the aura of affluence cast by traditional styles and brands, began buying items by Tommy Hilfiger and Ralph Lauren, but in extra-large sizes. When this mini revival ended, sportswear at large turned to grunge, and then, for the duration of the nineties, shifted into a minimalist phase led by Calvin Klein.

Today, the legacy of the Ivy League and preppy looks can be seen in mainstream retailers like J. Crew and The Gap, as well as in designer collections such as Billy Reid, Michael Bastian, and Trovata. And Ralph Lauren recently launched Rugby, a new collection of collegiate style updated for the twenty-first century. But in many ways, these reincarnated Ivy League styles are different, transformed and modernized through fit, design twists, and, most important, an aggressive mix-and-match concept of dressing based on the premise that opposites attract—formal with active, vintage with new, and designer with workwear.

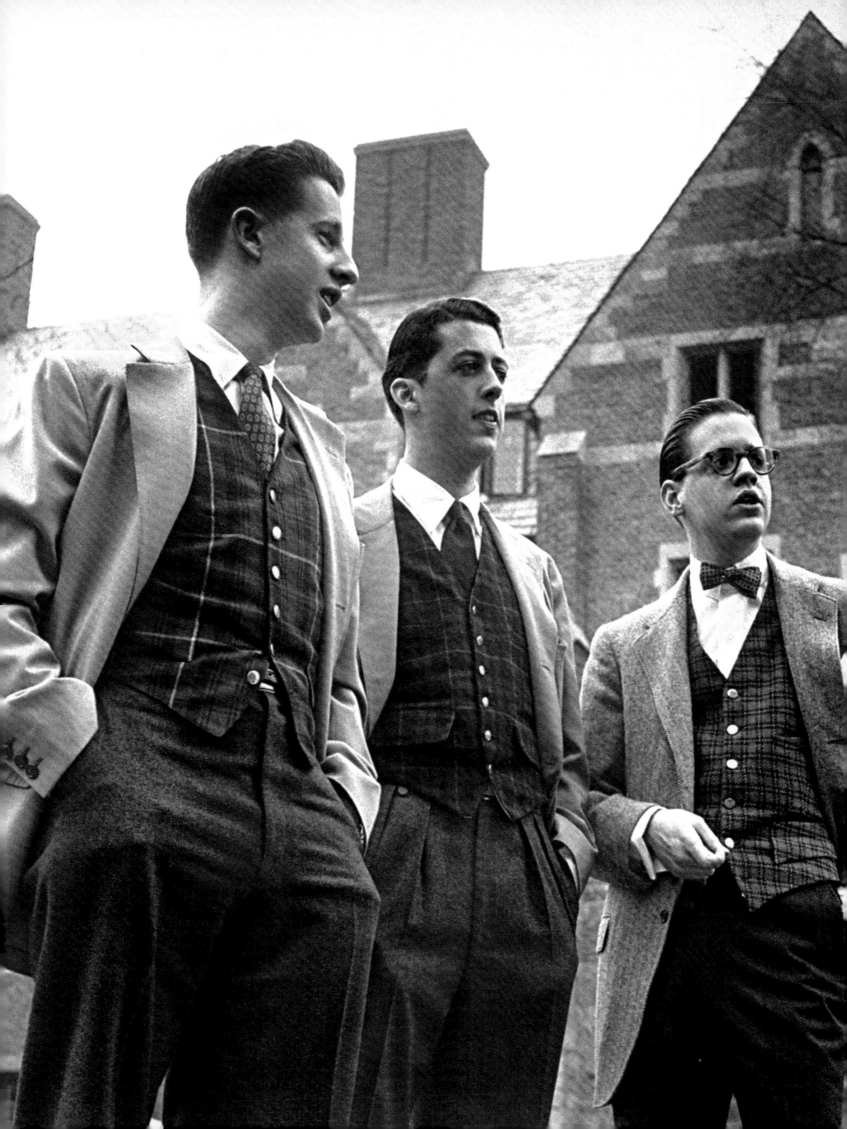

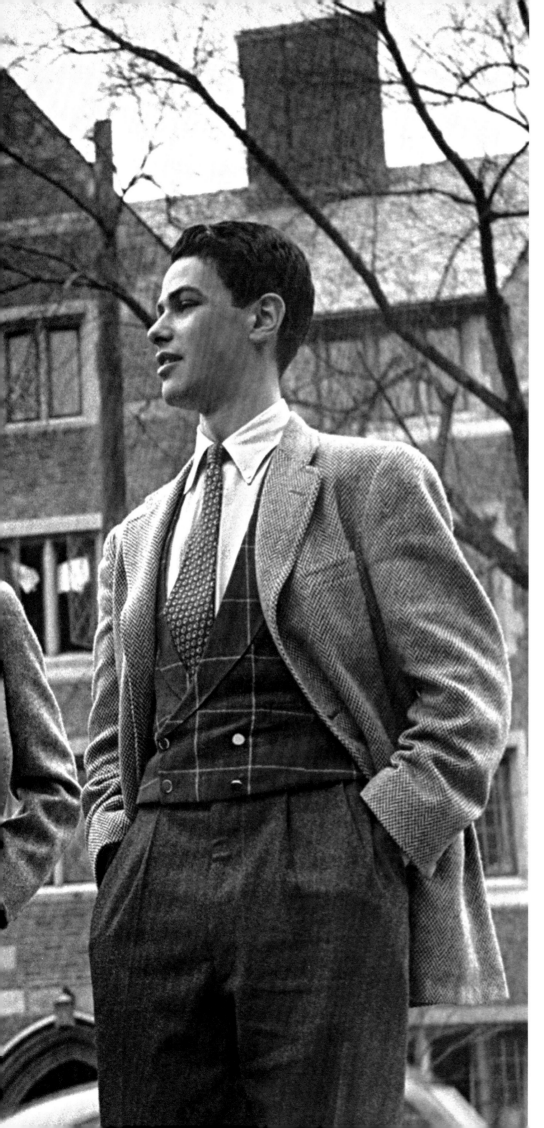

Ivy Leaguers, 1950

Opposite During the golden age of the Ivy League look, college students—like the nattily dressed Yale undergrads captured on campus in this photograph—set the fashion trends, from tartan to tweed.

Libertine, 2008

Following pages, left Libertine's Johnson Hartig and Cindy Greene started their label on the premise of creating one-of-a-kind pieces out of their vintage finds. This wool plaid jacket is evidence of the fact that tartan, a traditional menswear staple, is always in fashion.

Unis, 2008

Following pages, right 21st-century sportswear rejuvenates the classics with cooler cuts and materials—from skinny jeans to softer jerseys. Designer Eunice Lee, of the NoLIta–based indie label Unis, has attracted a cult following with her downtown-preppy aesthetic.

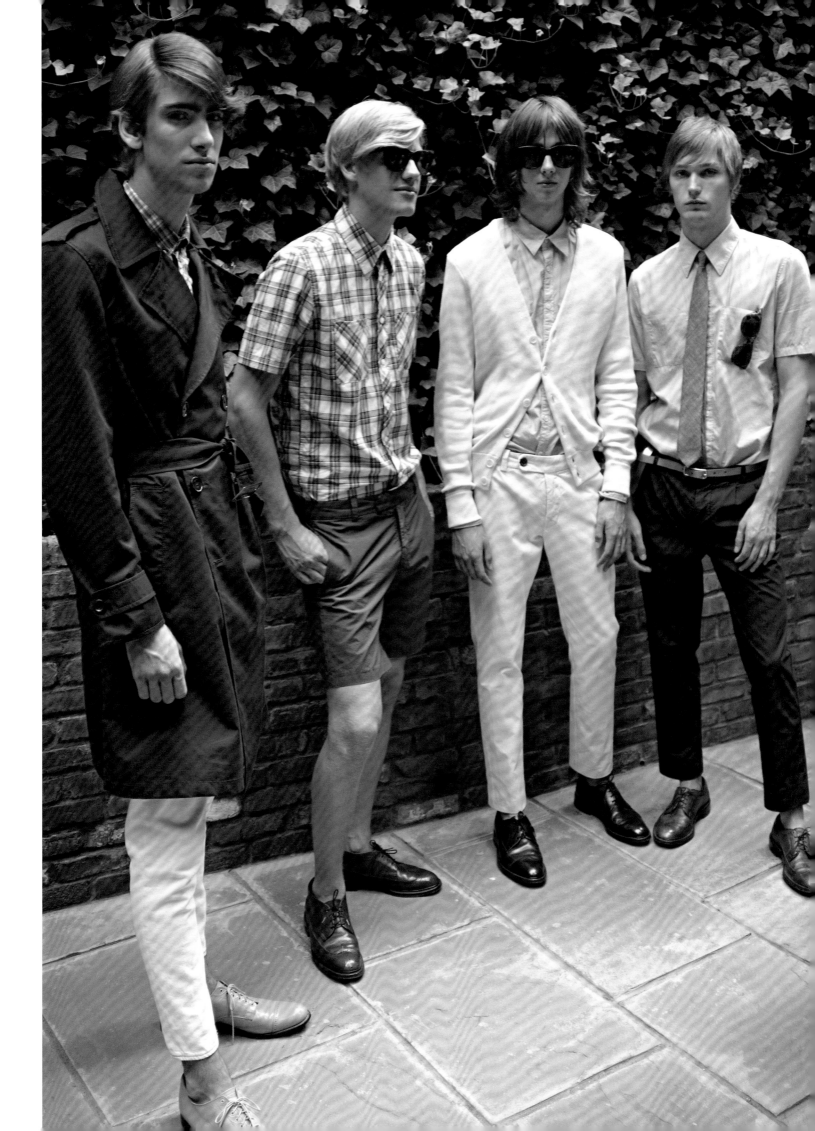

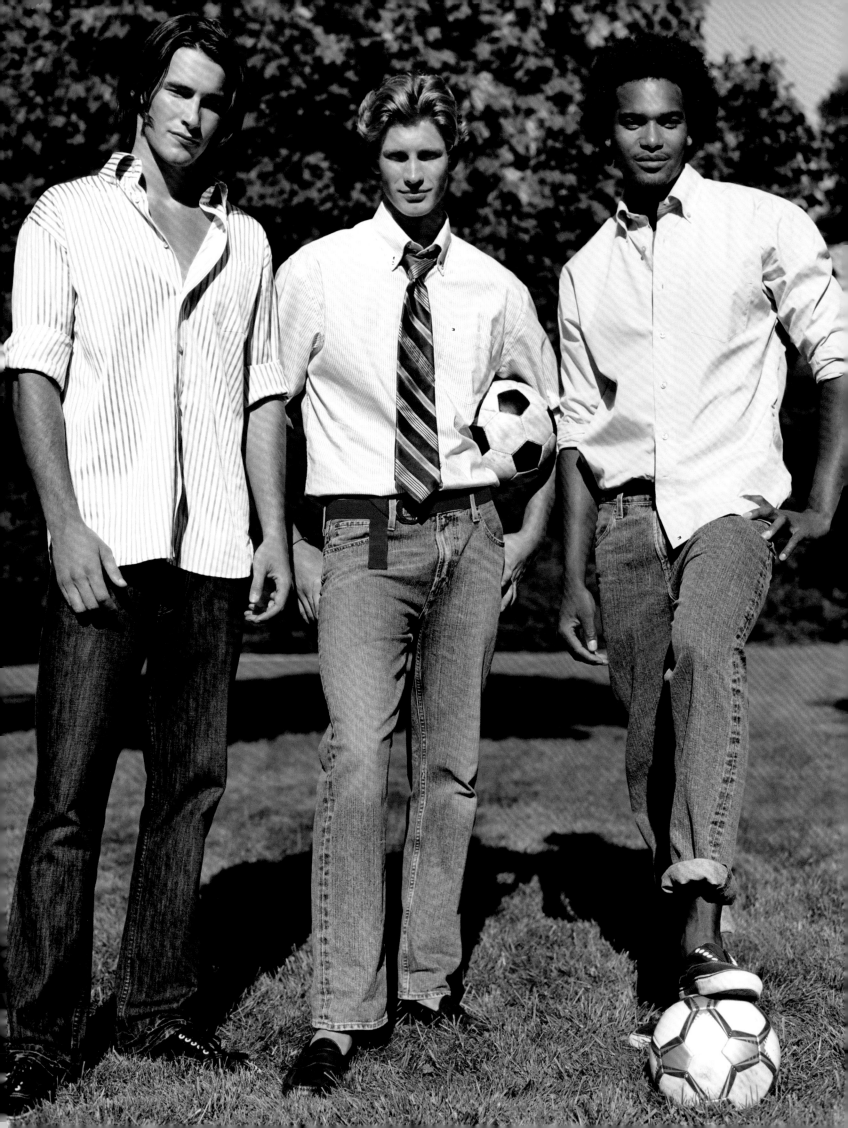

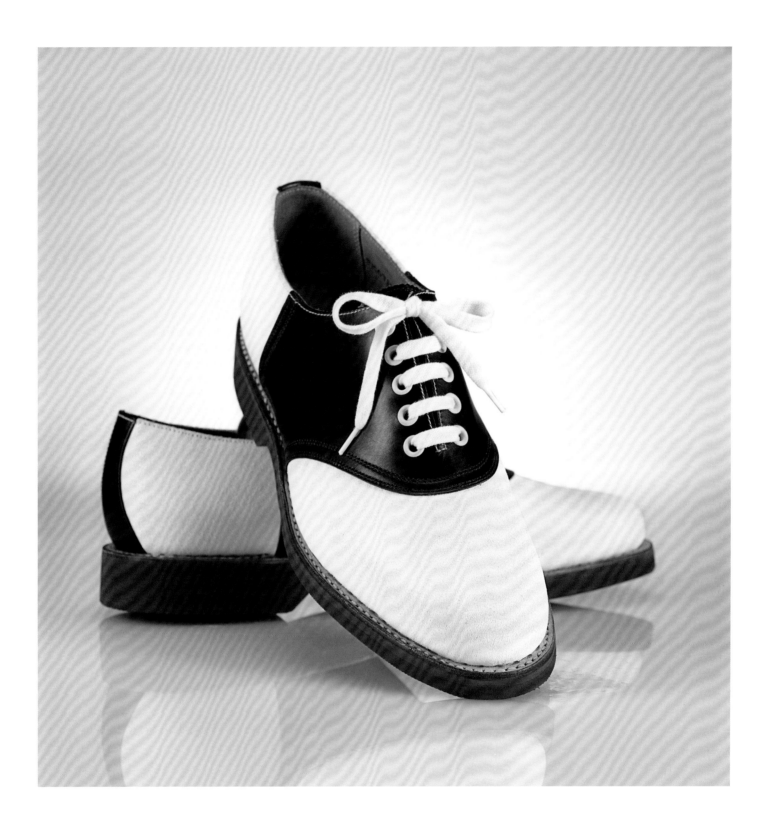

Ralph Lauren, 2008

Above A favorite of high school and college students from the 1920s through the '50s, the saddle shoe (named for the contrasting center section that sits across the shoe like a saddle) is enjoying a 21st-century fashion revival.

Tommy Hilfiger, 2005

Opposite It looks like a beautiful day in the Hamptons, and it is: Tommy Hilfiger oxford shirts, jeans, and footwear are welcome at any garden party.

Trovata, 2007

Previous pages Newport Beach, California–based Trovata is known for its whimsical, slightly disheveled approach to preppy fashion.

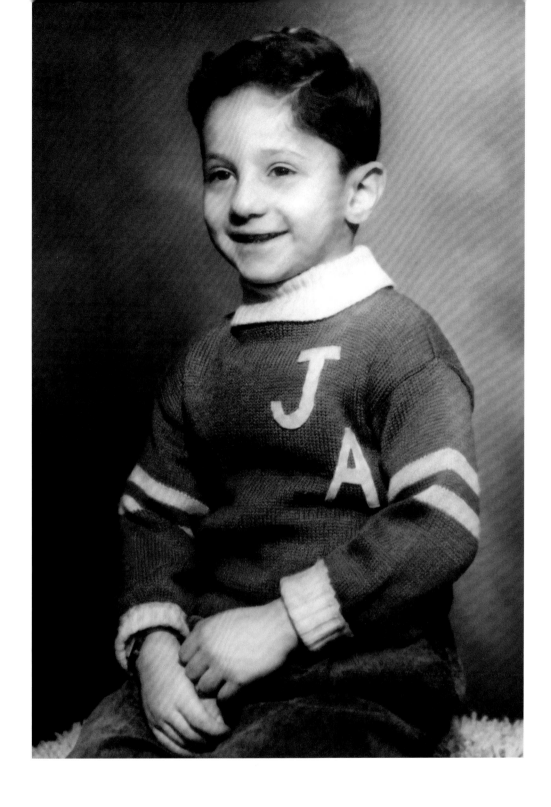

Joseph Abboud, ca. 1954

Above Designer Joseph Abboud, with his striped, monogrammed letter sweater, was collegiate even as a child.

Ralph Lauren, 1995

Opposite Recapturing the spirit of 1920s college style, this photograph in the May 15, 1995, issue of the *Daily News Record* features a tweed suit, Fair Isle sweater, shirt, and bow tie from Polo Ralph Lauren.

Ben Kahn, Tommy Hilfiger, Robert Massimo Freda, and Cole Haan, 1995

Following pages, left The 1920s campus craze for raccoon coats, argyle sweaters, and full-cut Oxford bag trousers is reimagined in a fashion shoot for the *Daily News Record*, featuring a Ben Kahn coat, a Tommy Hilfiger sweater, tweed trousers by Robert Massimo Freda, and saddle shoes by Cole Haan.

Trovata, 2007

Following pages, right Trovata's interpretation of the quirky college student was the subject of the label's Fall 2007 collection advertising campaign.

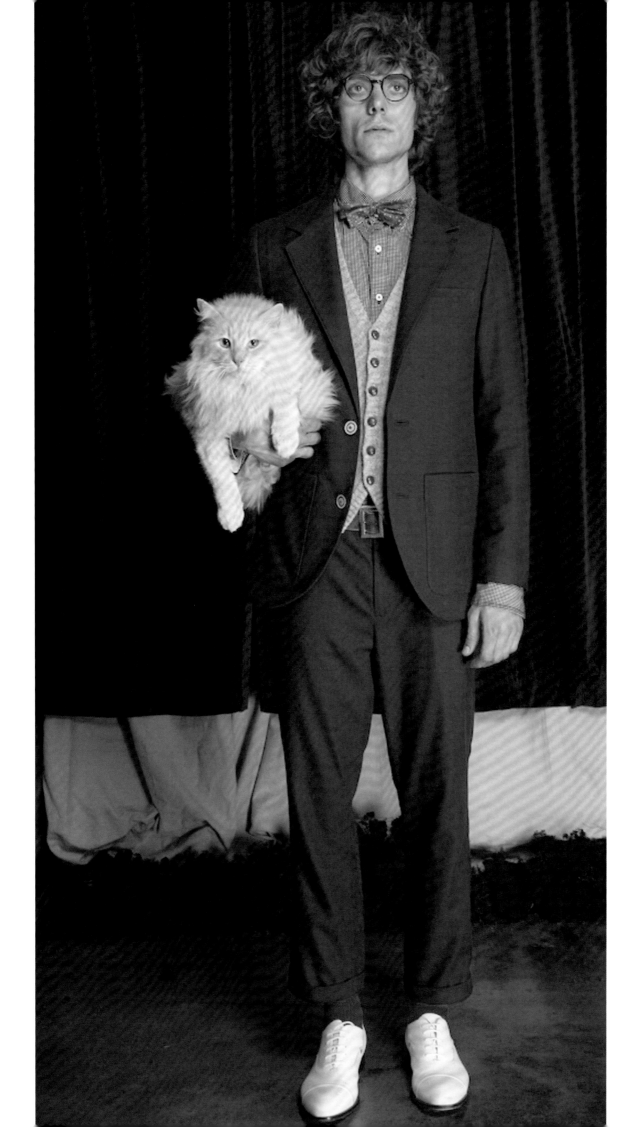

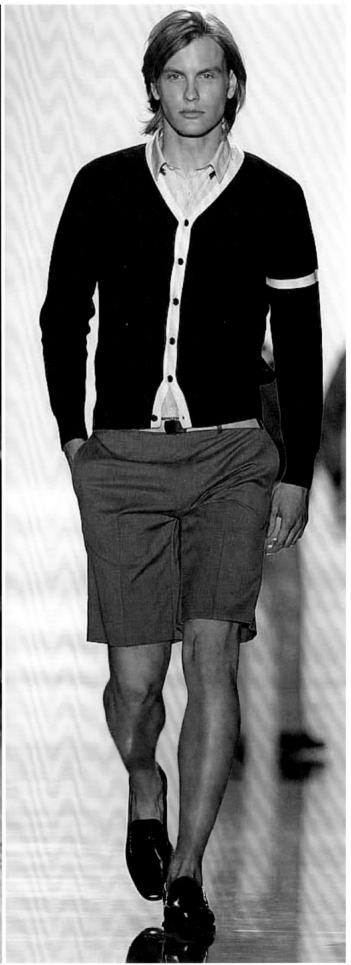

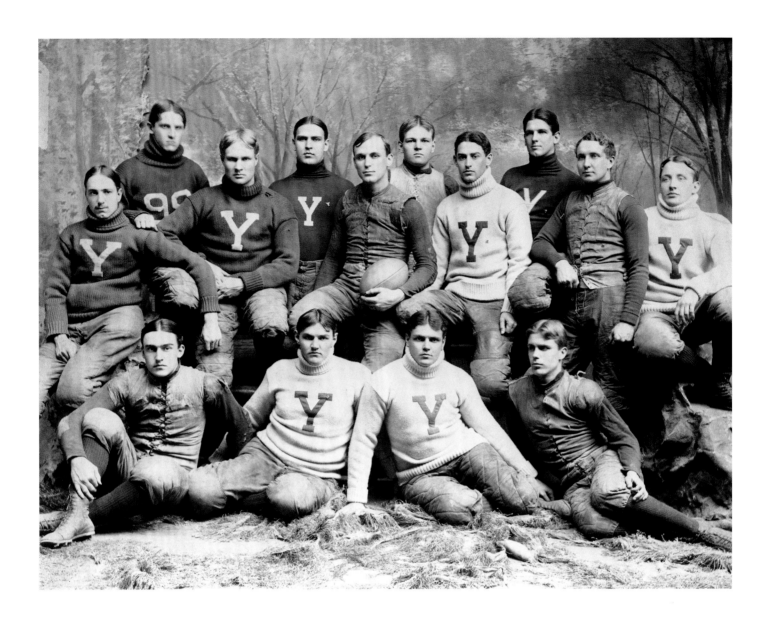

Yale football team, ca. 1910

Above A vintage photograph of a robust Yale football team,
proudly sporting their beefy turtleneck letter sweaters.

Gap, 2009

Opposite The polo shirt for Spring-Summer 2009, with stripes
layered over stripes.

Marc Jacobs, 2005

Previous pages, far left and center left Two requisite college looks
from the trendsetting Marc by Marc Jacobs line: the ubiquitous
hoodie sweatshirt (worn under practically everything) and the
ever-popular baseball jacket (right), updated with a skinny tie.

Yigal Azrouël, 2008

Previous pages, center right Designer Yigal Azrouël's Paddington
duffle coat worn over a henley and denim jeans, with Yigal for
K-Swiss sneakers.

Gant Limited Edition by Richard Bengtsson, 2009

Previous pages, far right A cardigan with shorts and loafers is a
foolproof way to look cool on campus.

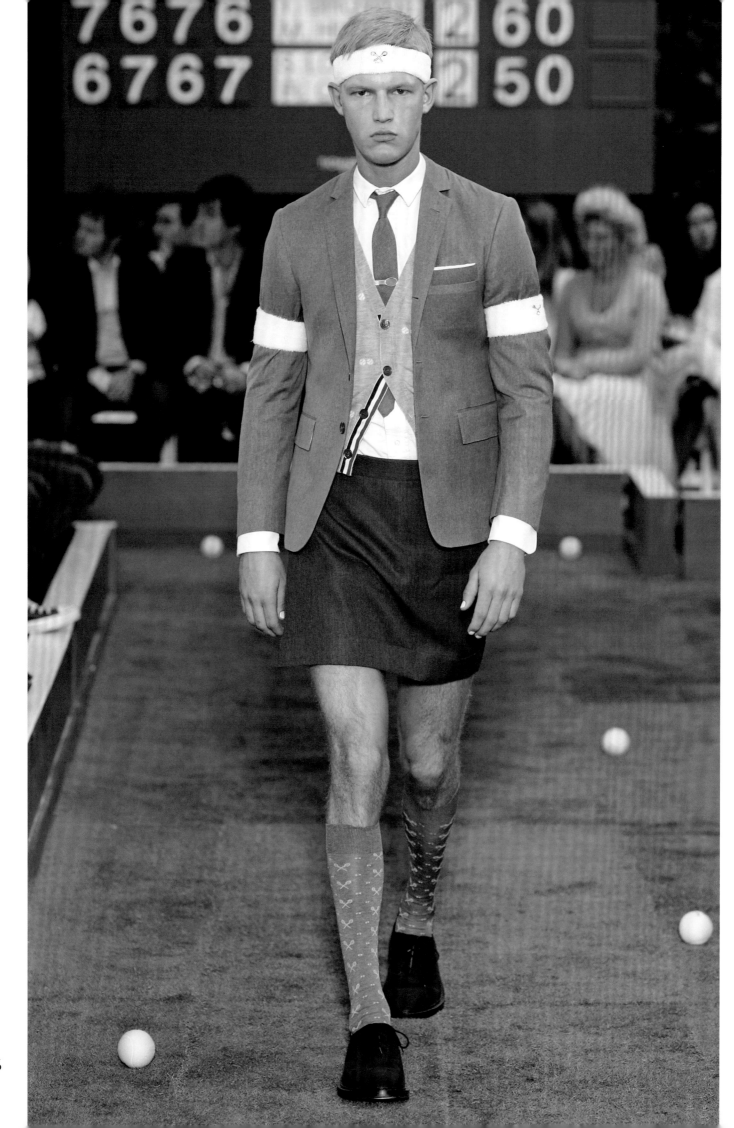

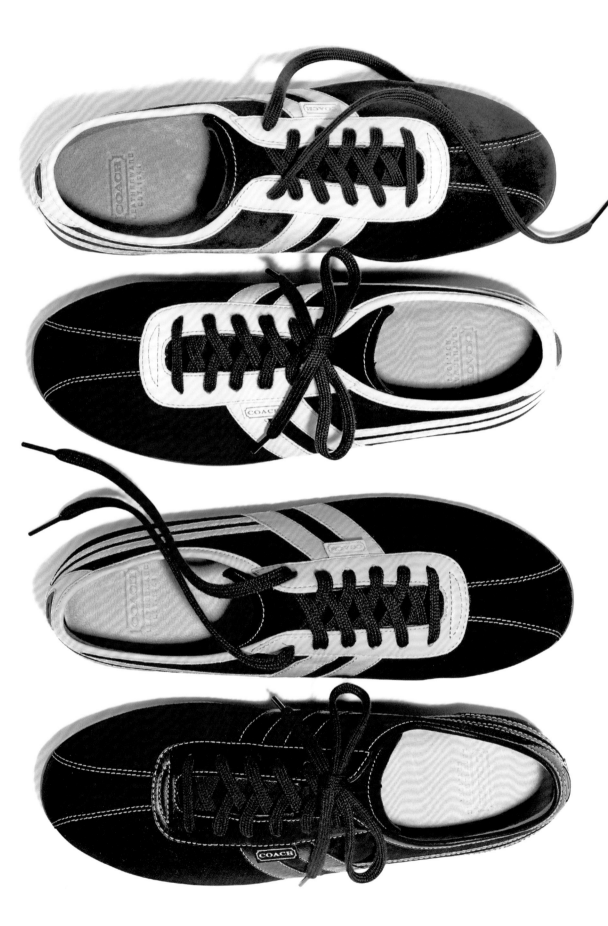

Reed Krakoff for Coach, 2004

Left In the 1940s, sneakers made the leap from active sports to casual sportswear. Here, an assortment of bowling shoe–influenced suede sneakers designed by Reed Krakoff for Coach.

Thom Browne, 2009

Opposite The provocative Thom Browne's take on tennis-inspired attire from his Spring 2009 collection: tennis-white nail polish and sweatbands optional.

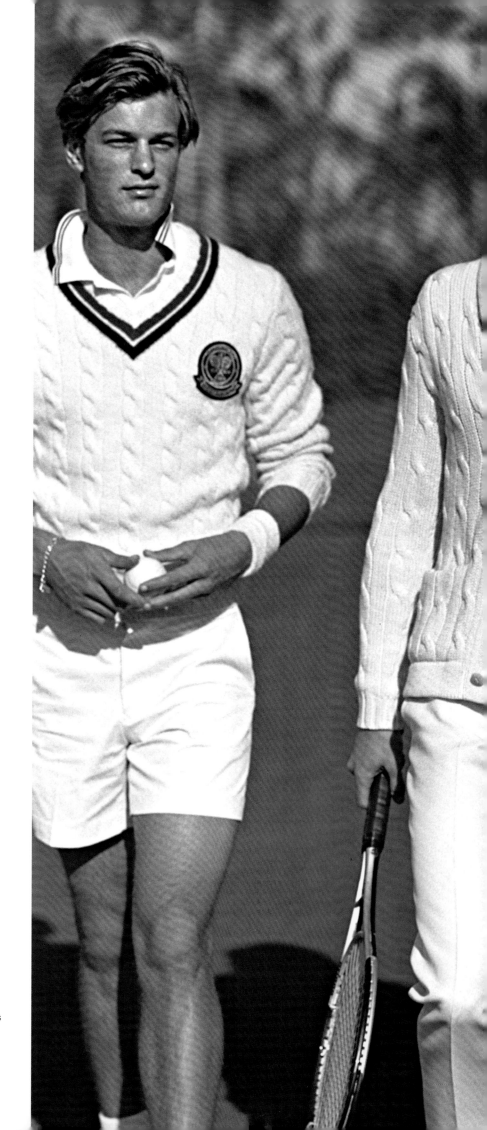

Ralph Lauren, 2006

Ever the classicist, Ralph Lauren designs signature tennis whites
reminiscent of those worn in the 1930s.

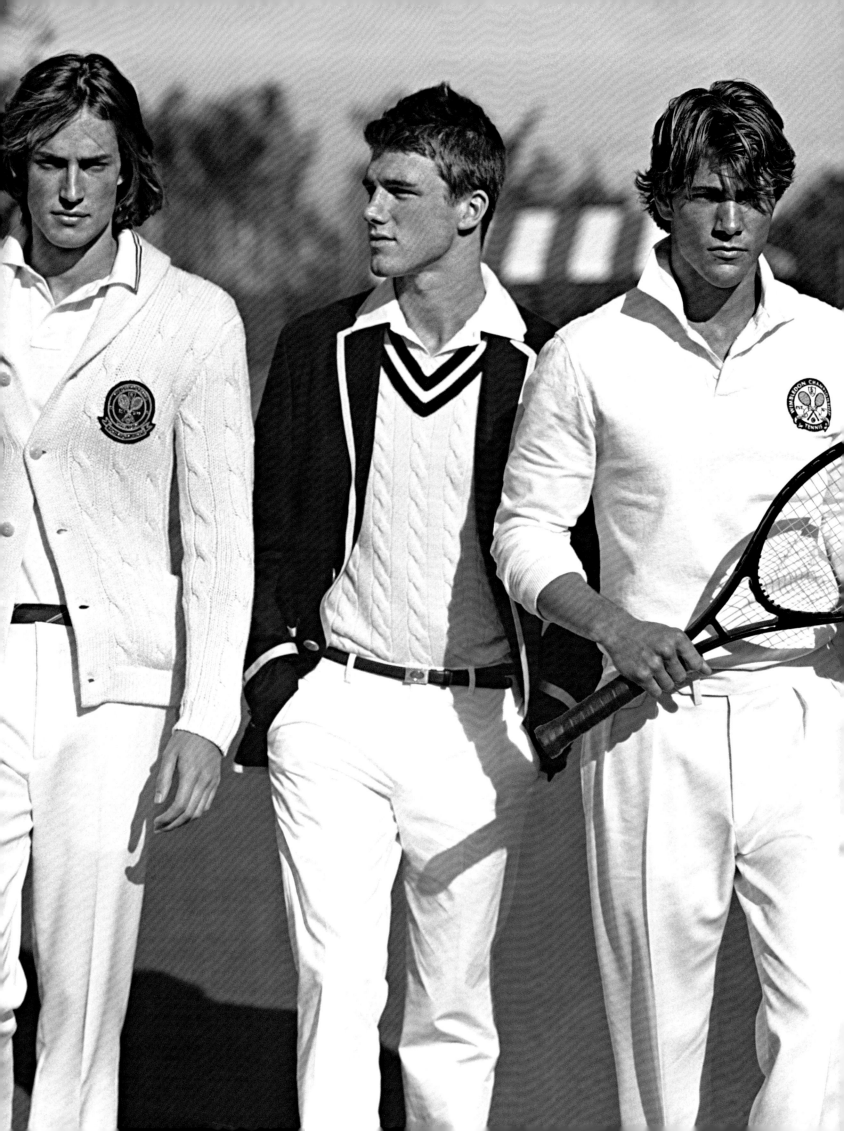

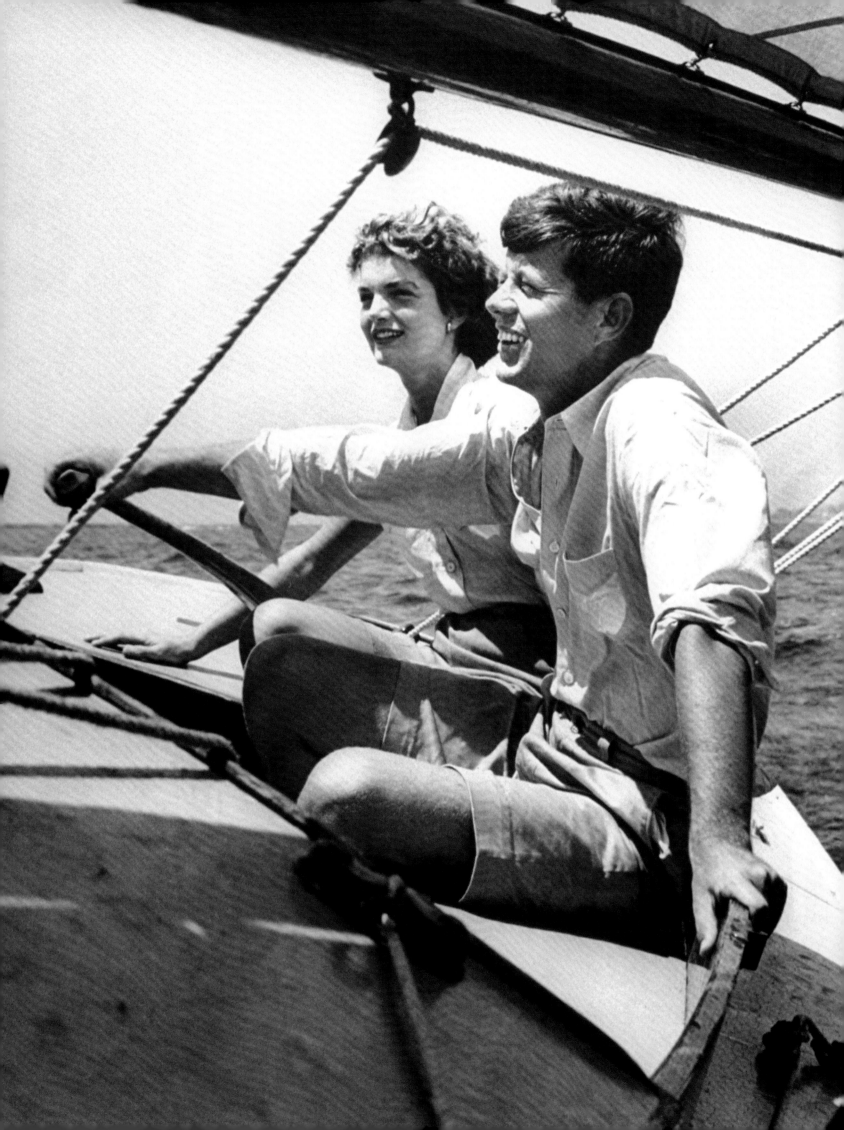

Sportswear

{ *America's free-spirited, casual lifestyle brought about a more democratic way of dressing.*

AMERICAN INFORMAL

"Cultivated leisure is the aim of man."

OSCAR WILDE

When anyone today thinks of American fashion, it is sportswear that invariably comes to mind. It's easy to see why: America has always enjoyed a more free-spirited, casual lifestyle than its European counterparts. In contrast, England, the ancestral home of menswear, was long bound by a rigid class structure and a pervasive sense of formality. In Italy, men would sooner slander their mothers than muss their cherished sartorial finery. So it was sports-minded American men who not only embraced the latest English fashions for polo, golf, and tennis but also freely adapted these styles into their daily dress. At first this evolution was fueled by wealthy Americans at exclusive resorts and colleges, but over the decades their sporty approach to dressing became increasingly democratic, gradually spreading into mainstream American society.

Brooks Brothers was pivotal in the development of classic American sportswear and the Ivy League look. It also served as a training ground for Ralph Lauren, preparing him for a revival of classicism in the 1970s. Then came the 1980s preppy revival, and once again Brooks Brothers was in its element. In the twenty-first century, the company embraced longtime admirer Thom Browne, whose Black Fleece line pays homage to the store's traditions in his own unique way.

But more than Brooks Brothers, it was sophisticated men-about-town who truly set styles during the groundbreaking 1920s and 1930s. Foremost among these fashion leaders was Edward, Prince of Wales, whose influence on American fashion was tremendous. An article in *Men's Wear* magazine in 1924 about this "captivating young heir to the British throne" maintained, "There is no other single individual in the entire universe whose clothes attract anything like as much consideration and admiration as his do."

Jhane Barnes, 1994 *Opposite* All-American sportswear: a tweed sport jacket, a polo, and a printed shirt by designer Jhane Barnes in a photograph in the Fall 1994 issue of *W* magazine's Men's Portfolio. **Jack and Jackie Kennedy, 1953** *Previous page* Jacqueline Lee Bouvier and her fiancé, Senator John F. Kennedy, illustrate their signature, understated New England style on a sailing outing two months before their marriage.

The prince's every innovation was photographed, written about, and emulated, even in this pre-paparazzi era. When he wore Fair Isle sweaters (single-handedly bringing prosperity to the depressed Scottish islands) and tweed plus fours on the golf course, boldly mixing patterns in the process, a new trend was born. A dandy and a modernist, Edward broke what he considered outdated rules, ever pushing toward more casual, comfortable clothes, and always with his own individual flair.

America also produced its own society figures and fashion plates, including members of the idle rich such as Anthony Drexel Biddle, Jr., who was photographed at resorts around the world like Newport, Nassau, the French Riviera, and Palm Beach. The Florida enclave was a "southern garden of fashion, a man-made paradise" in the words of a *Men's Wear* writer, and by 1928 it was considered as fashionable as any European resort. Each season, fashion reporters and retailers flocked to this playground of the rich to discover what styles would be moving from Palm Beach to Main Street. In 1935, this trendsetting link between wealth and fashion was acknowledged in *Esquire* with the headline "On the Beach with the Sons of Riches." The article went on to expound, "When the gilded playboys turn to bronze under the winter sun, that's when summer's beach fashions are born." Remarkably, this fashion merry-go-round remained unaffected by the Great Depression ravaging the rest of America.

In retrospect, it could be argued that these fashion plates at play were creating "street fashion" just as much as their counterparts later did in the 1960s. After all, though these innovative dressers walked the beaches rather than the streets, they weren't copying designers or runway shows but instead creating the newest styles themselves. In turn, their fashions were reported by *Men's Wear, Esquire*, and a host of newspaper society columns around the world and then copied by clothing manufacturers and consumers. Clearly the concept of "What They Are Wearing" photo spreads has a long and illustrious history that goes back even farther than Bill Cunningham and *The New York Times*.

Beyond these bon vivants were sports professionals, from the French tennis star Rene Lacoste to legendary golfer Bobby Jones, who were always breaking new fashion ground for amateur sportsmen and spectators to follow. In 1936, *Men's Wear* acknowledged what today would seem obvious: "Play has become a definite and essential part of daily life, and play demands its own special apparel." One of the most important aspects of this new clothing category was the sport shirt: not yet acceptable for street wear, but worn by fashionable men at resorts everywhere.

Following World War II, the California apparel market was well positioned to satisfy the sportswear needs of military men returning to a decidedly more casual civilian lifestyle, largely situated in the newly developing suburbs. Color and comfort were key, with bold sport shirts (especially Hawaiian prints), khakis carried over from military uniforms, and gabardine leisure jackets topping the fashion list.

By 1953, the Republican Dwight D. Eisenhower was in the White House, the demagogue Joseph McCarthy was hunting for communists everywhere, and the mood of the country had taken a more conservative turn. Suddenly everyone wanted to blend in, rather than stand out, and the Ivy League look, rooted in Anglo-American sportswear fashions developed before the war, was the perfect solution. Brooks Brothers, Chipp, J. Press, and other menswear retailers came to the fore, offering New England style for the entire country.

In the 1970s, Ralph Lauren spearheaded the updated traditional revival, and in no time there were plenty of other American designers ready to join the return to "good taste." Another notable designer at the time was Perry Ellis, who, beginning in 1980, offered a uniquely contemporary approach to traditional men's clothing that was both streamlined and clever. In some ways, he could be considered the father of modern American sportswear design, with his influence seen in post-millennium collections from Calvin Klein to Banana Republic.

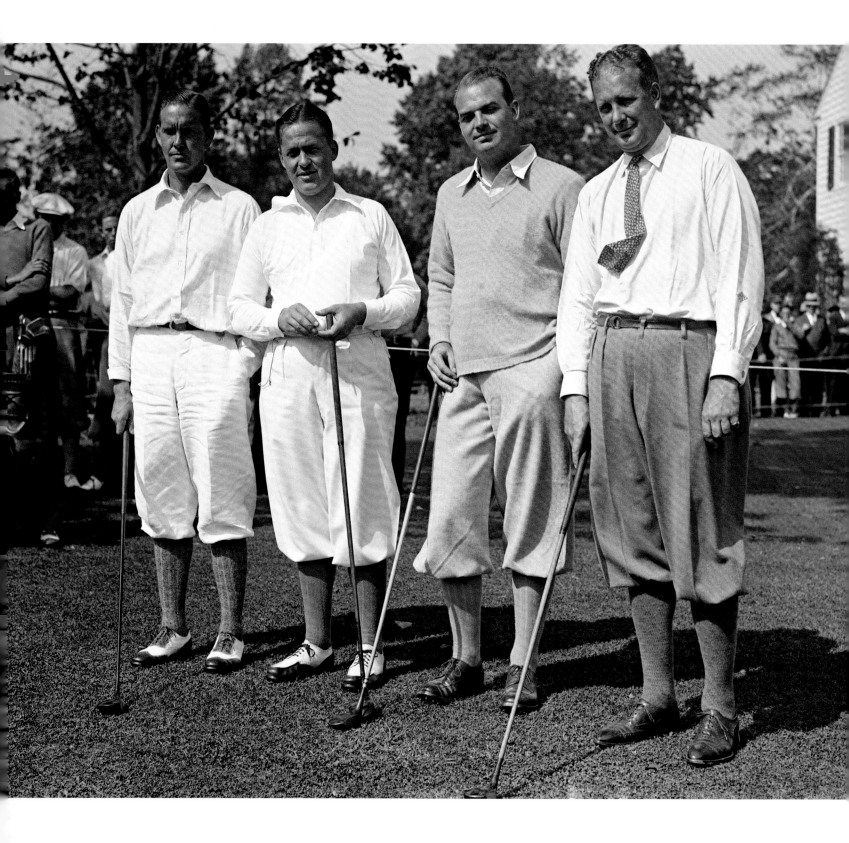

Harrison Johnston, Bobby Jones, Jess Sweetser, and Max Marston, 1930

Above Plus fours—knickers that extend four inches past the knee—were popularized in the United States in the 1920s by Prince Edward of Wales and became a favorite of golfers, including the legendary players in this photograph. (The extra fabric allowed for more movement than knickers did.) Plus fours enjoyed a fashionable revival in the 2008 collection of the performer-turned-designer André Benjamin.

Gap, 2009

Opposite A zip-front windbreaker worn with a jersey polo and chinos, designed by Patrick Robinson for Gap.

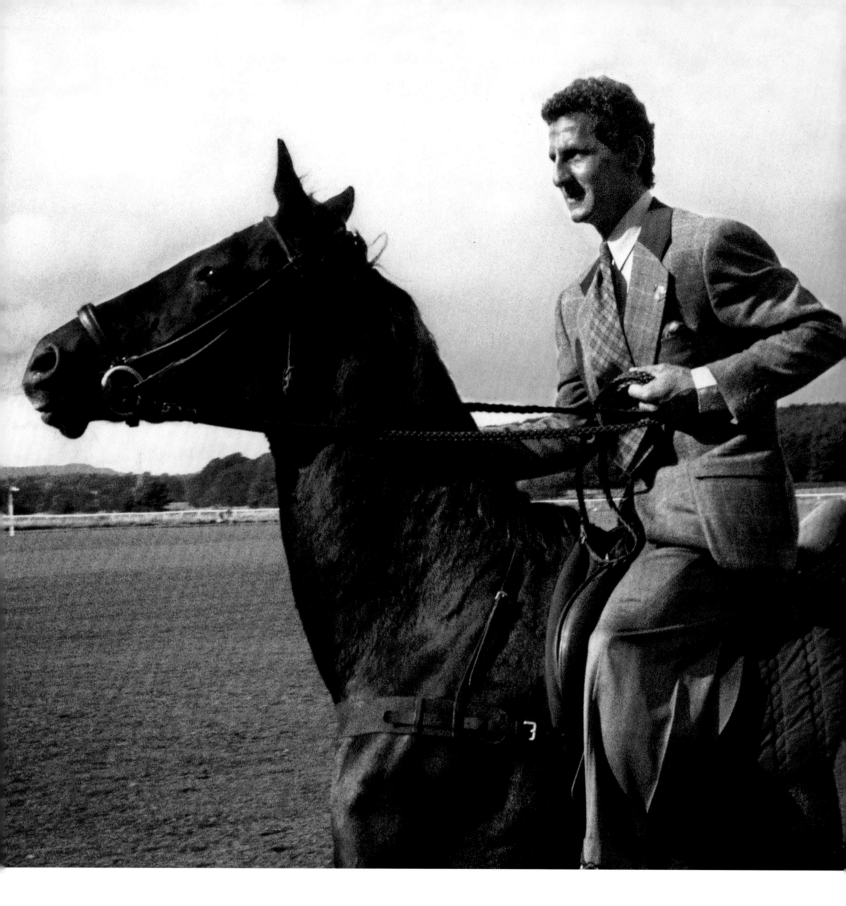

Joseph Abboud, 1994

Above Designer Joseph Abboud demonstrates perfect sartorial style, even on horseback.

Michael Kors, 2008

Opposite Kors, a longtime admirer of classic chic from Nantucket to Palm Beach, suggests what a man of leisure might wear on or off the courts.

The Punter, 1908

Following page, left Football, the central focus of college sports, is the subject of this oil painting by J. C. Leyendecker.

Cole Haan, 2007

Following page, right Actor Aaron Eckhart models Cole Haan's Motocross leather jacket, a style always admired for its masculine flavor and body-conscious fit.

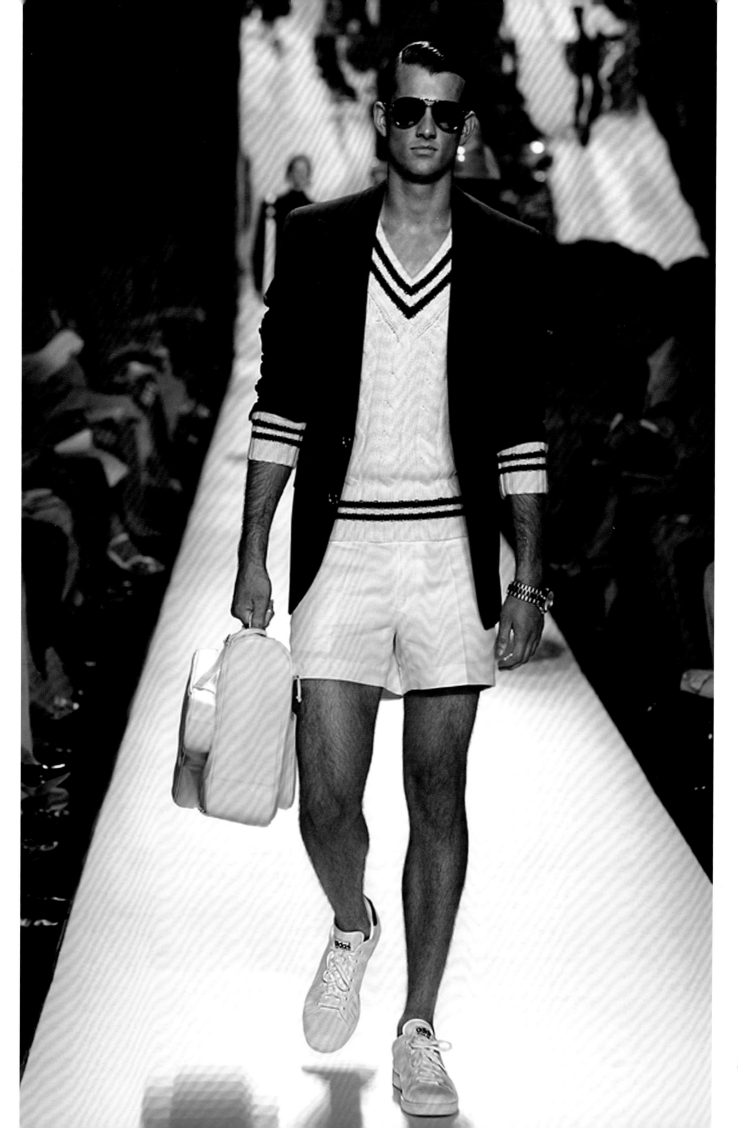

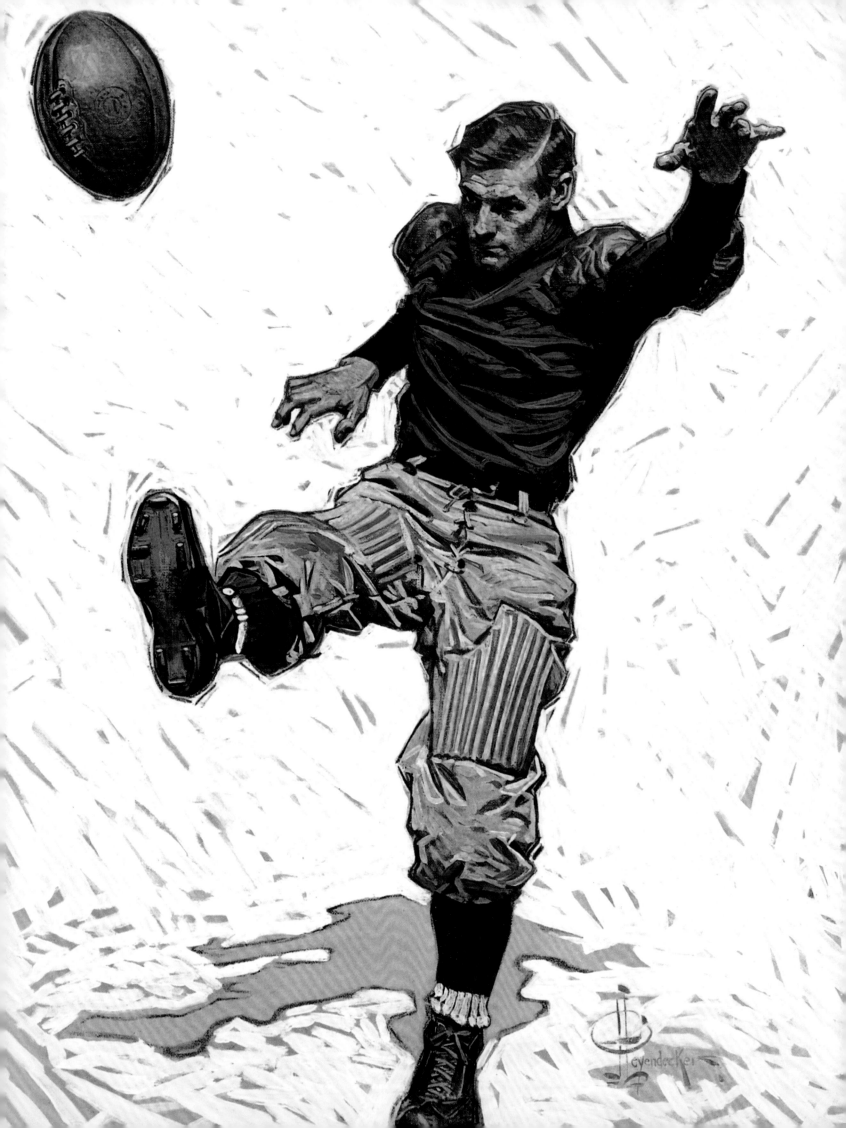

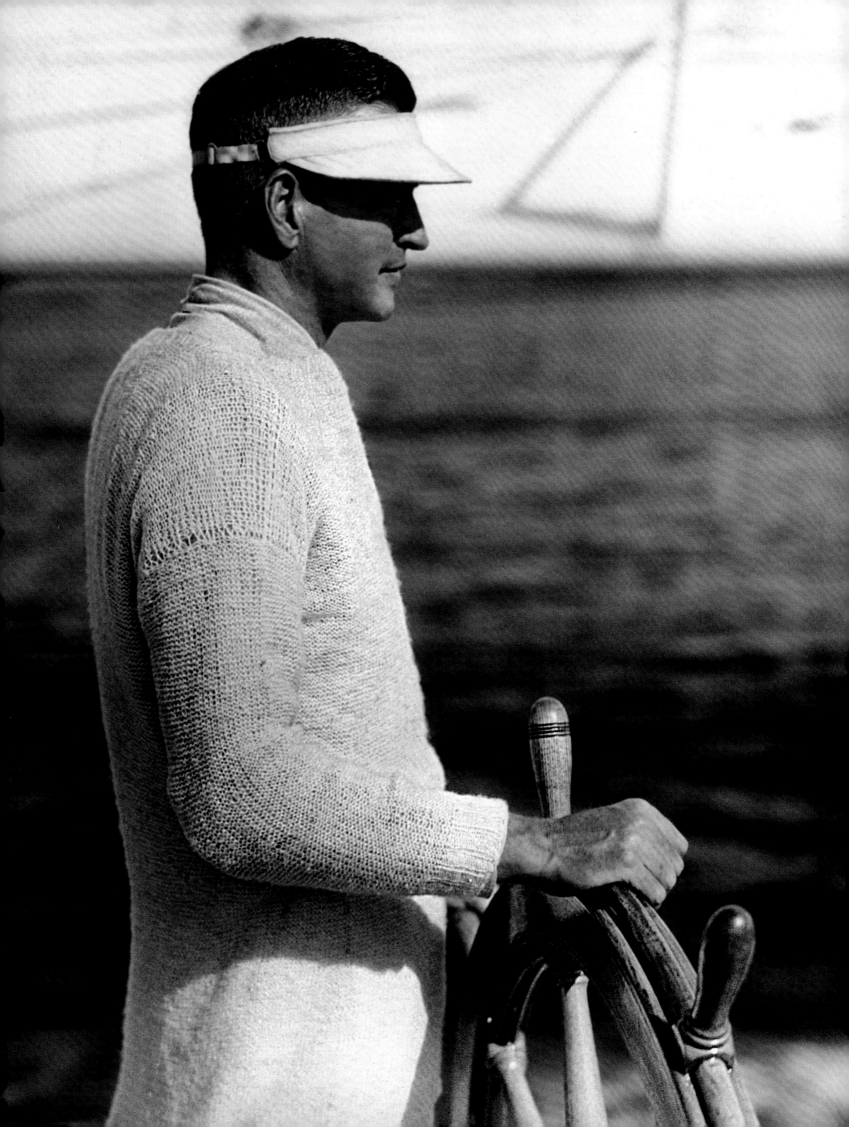

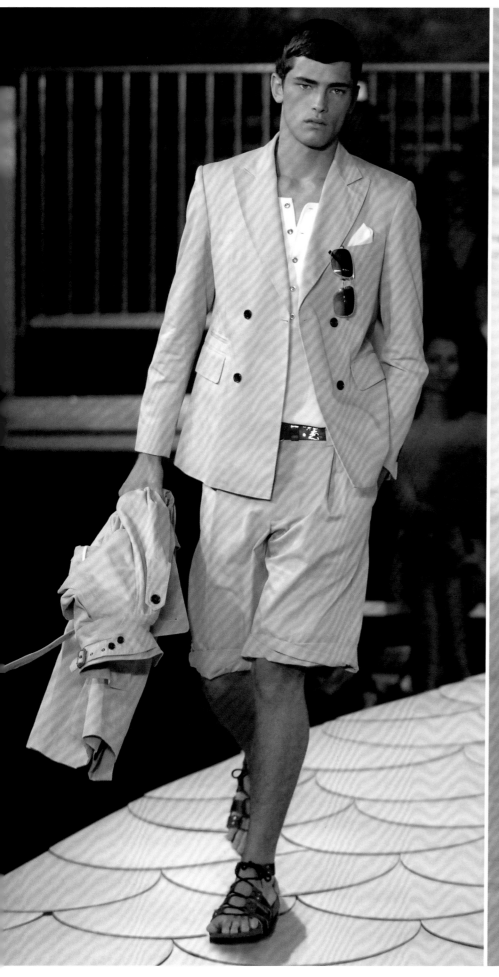
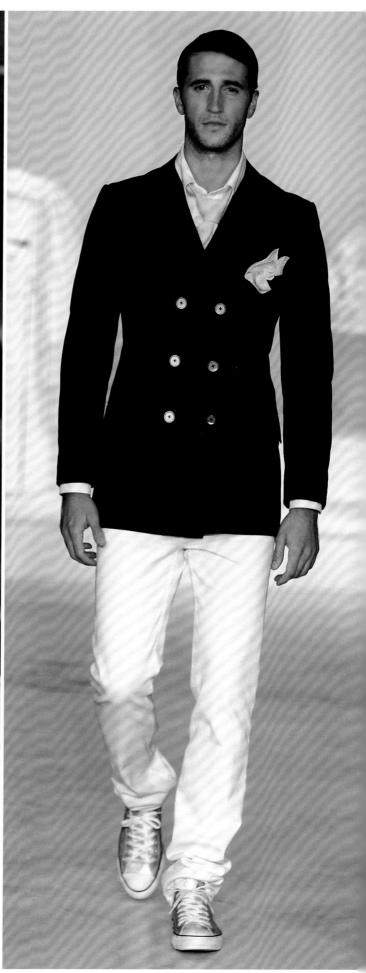

93

Harold Stirling Vanderbilt, ca. 1925
Previous pages, far left The American financier and three-time America's Cup winner Harold Stirling Vanderbilt, simply attired in a long white sweater and a functional sun visor, at the wheel of one of his many racing yachts.

3.1 phillip lim, 2008
Previous pages, center right The shorts suit, first tried out by adults on Ivy League campuses in the 1950s, reappeared on Phillip Lim's Spring-Summer 2008 runway.

Charles Nolan, 2009
Previous pages, far right The classic double-breasted men's blazer dates back to the 19th century. Its timeless cut never goes out of style.

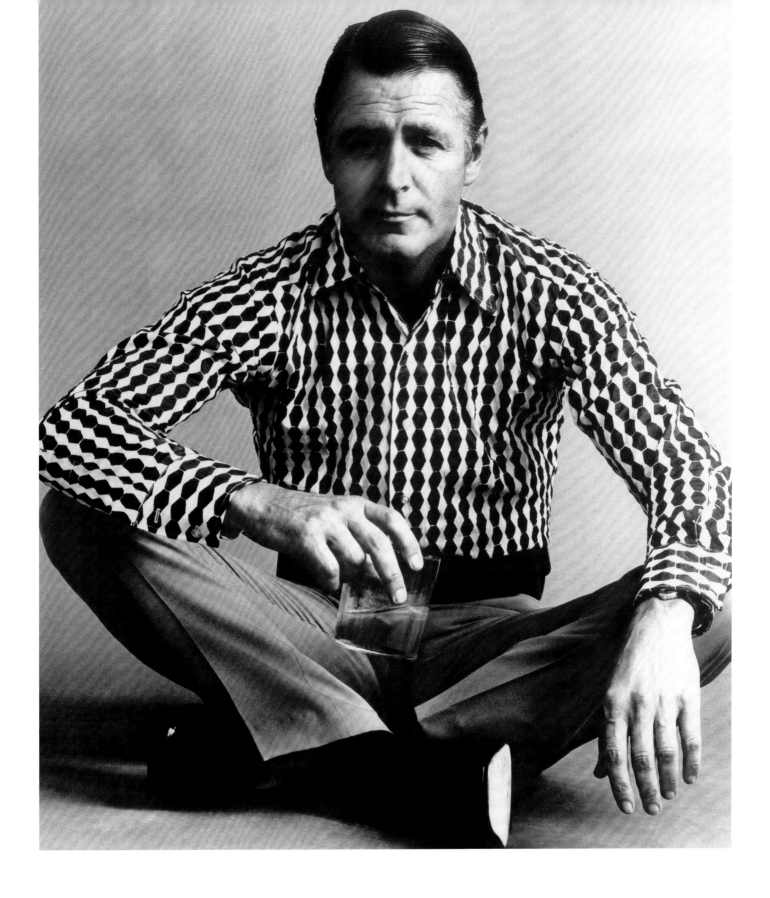

Bill Blass, 1970

Above Designer Bill Blass updated the gentleman's sport shirt with an optical pattern
in a subtle nod to Britain's "Peacock Revolution" of the 1960s.

Bright sportswear, 1968

Opposite Brightly colored sportswear, as seen in this illustration by Ken Dallison
from the April 1968 issue of *Esquire* magazine, has always been a tradition in country-
club settings.

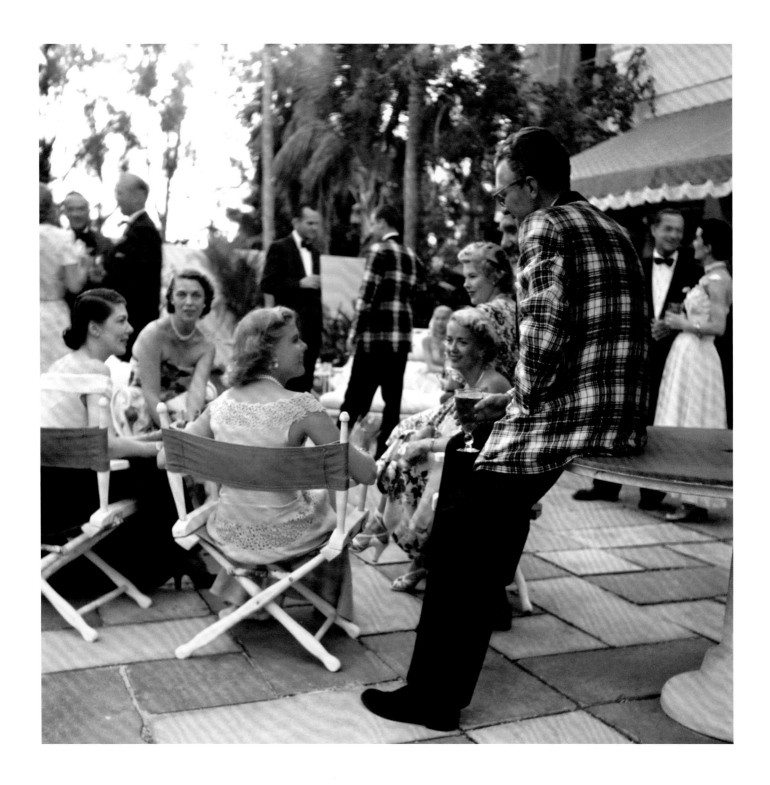

Suburban casual wear, 1950

Above The Ivy League influence eventually moved from students to their tartan-wearing parents, as seen at this poolside cocktail party from a 1950 issue of *Life* magazine.

Michael Kors, 2009

Opposite Michael Kors mixed patterns with preppy flair for his Spring 2009 collection. Here, a madras plaid jacket is paired with sixties-inspired floral-print shorts.

Jeffrey Banks, 1984

Following pages, left The look of a true country gentleman, featuring a balmacaan overcoat, a Donegal tweed sport jacket, and a plaid flannel shirt.

Sal Cesarani, 1997

Following pages, right Starting in the 1970s, designers like Sal Cesarani revived traditional sportswear styles with 1930s flair. For example, a plaid sport coat was paired with a cream-colored vest and accessorized with a vintage camera.

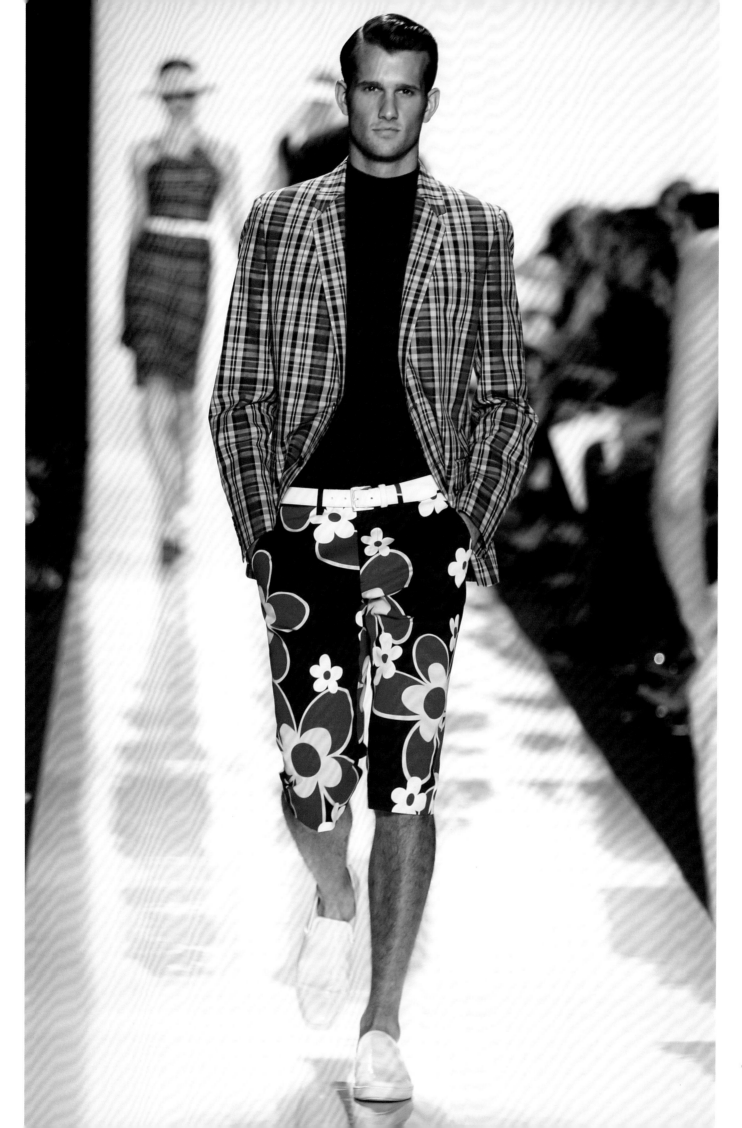

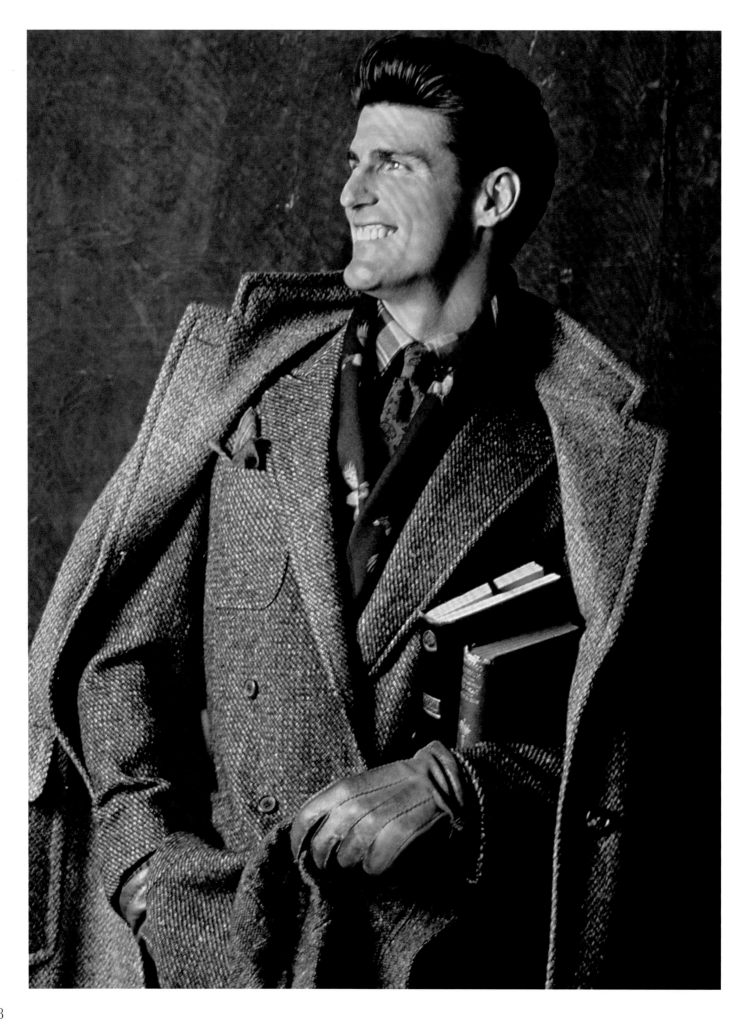

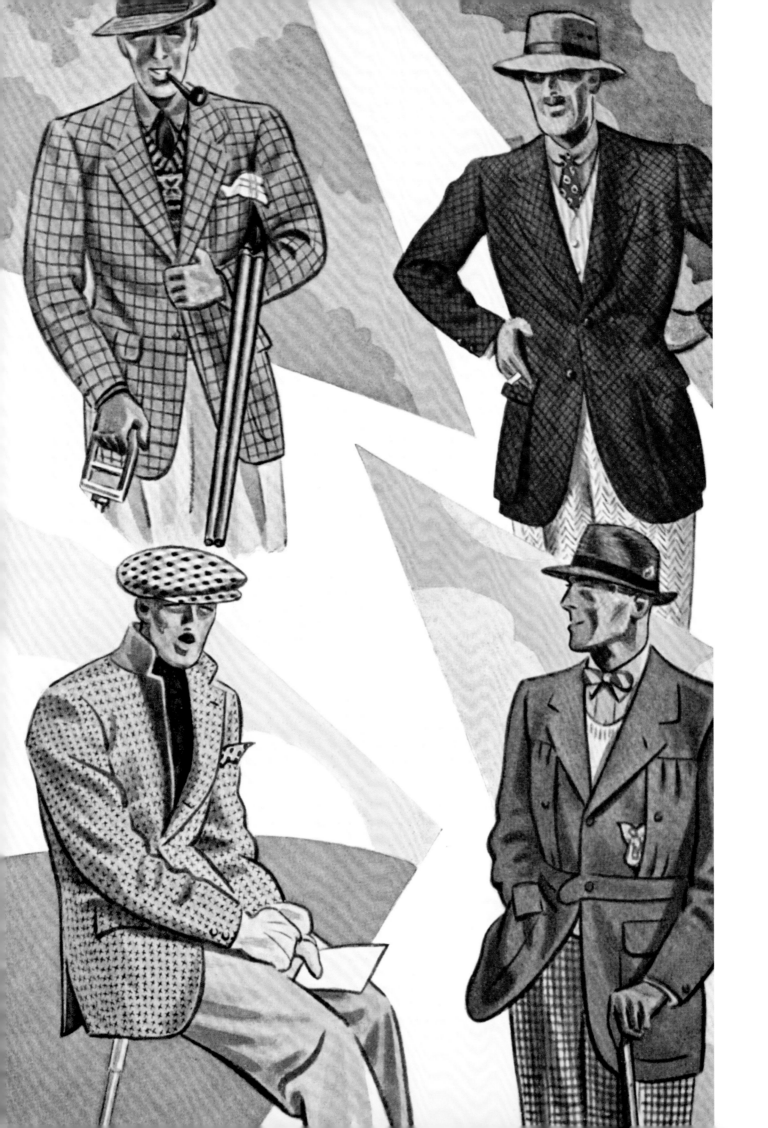

Italo Zucchelli for Calvin Klein Collection, 2008

Right The name Calvin Klein has always been synonymous with modern, minimalist design, as demonstrated by this streamlined wool turtleneck.

Perry Ellis, ca. 1980s

Opposite Designer Perry Ellis had a truly modern vision that foreshadowed the future of men's fashion.

Sporty tweeds, 1934

Previous pages, left A celebration of country-flavored tweed sport jackets, beautifully illustrated for the September 1934 issue of *Esquire*.

Alexander Julian, 1981

Previous pages, right Alexander Julian became a major name in men's fashion in the 1980s, innovating with his use of color and more casual styles, such as this tweed sport jacket worn over a classic argyle sweater.

Kenneth Cole, 2009

Above Kenneth Cole's substantial shoes have a strong utilitarian flavor that works equally well in the country or the city.

Billy Reid, 2008

Opposite A turtleneck sweater can function as a casual and stylish substitute for the more traditional shirt and tie.

Elie Tahari, 2008

Following pages Elie Tahari expanded his successful fashion empire to include menswear in 2006, specializing in urban sportswear, like this sleek leather motorcycle jacket.

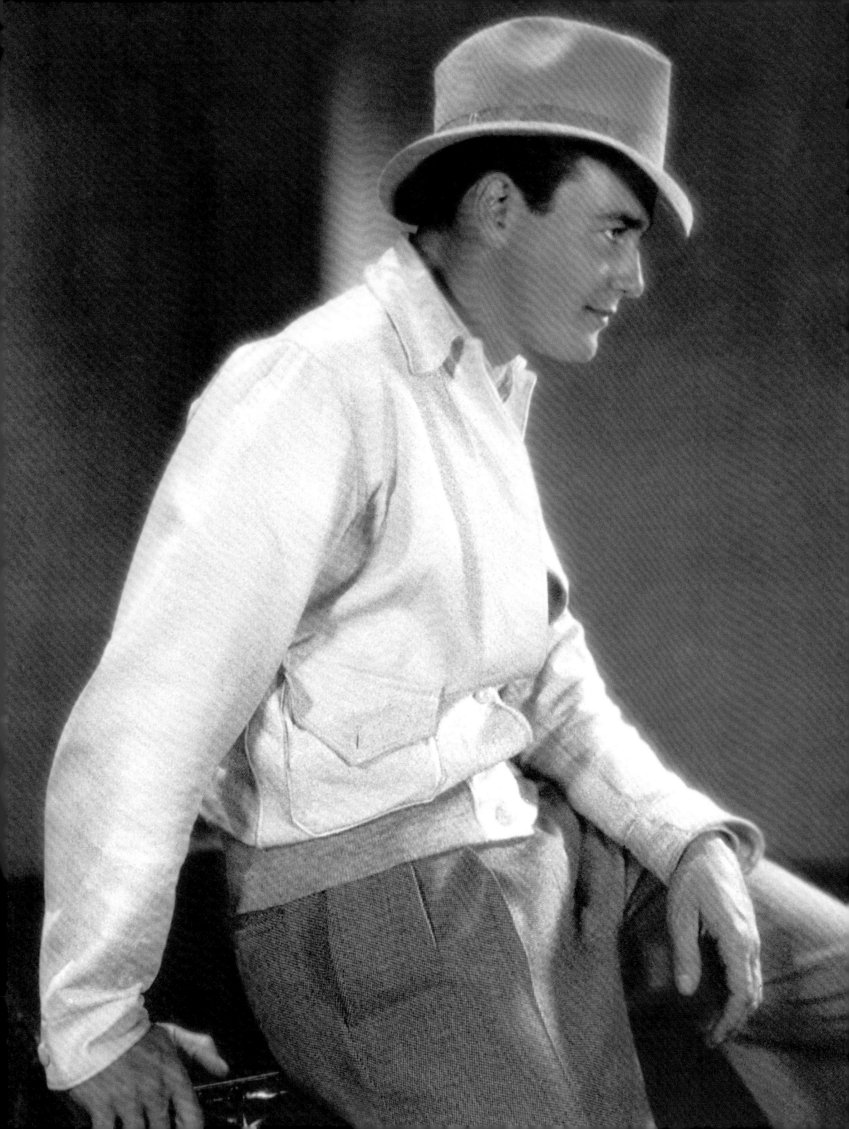

Trina Turk, 2005

Above Los Angeles–based designer Trina Turk's laid-back 1970s styles, such as the abstract-print party pants and breezy, open-collared sport shirt pictured here, have become the uniform for many Hollywood stars and aspirants alike.

Lew Ayres, 1930

Opposite In the golden age of Hollywood, stars received the glamour treatment, as in this Ray Jones photograph of actor Lew Ayres wearing a classic leather windbreaker, pleated trousers, and a rakish felt fedora.

Richard Chai, 2009

Following pages The designer Richard Chai (left of center, arms folded) surrounded by models wearing an assortment of his downtown-chic sportswear.

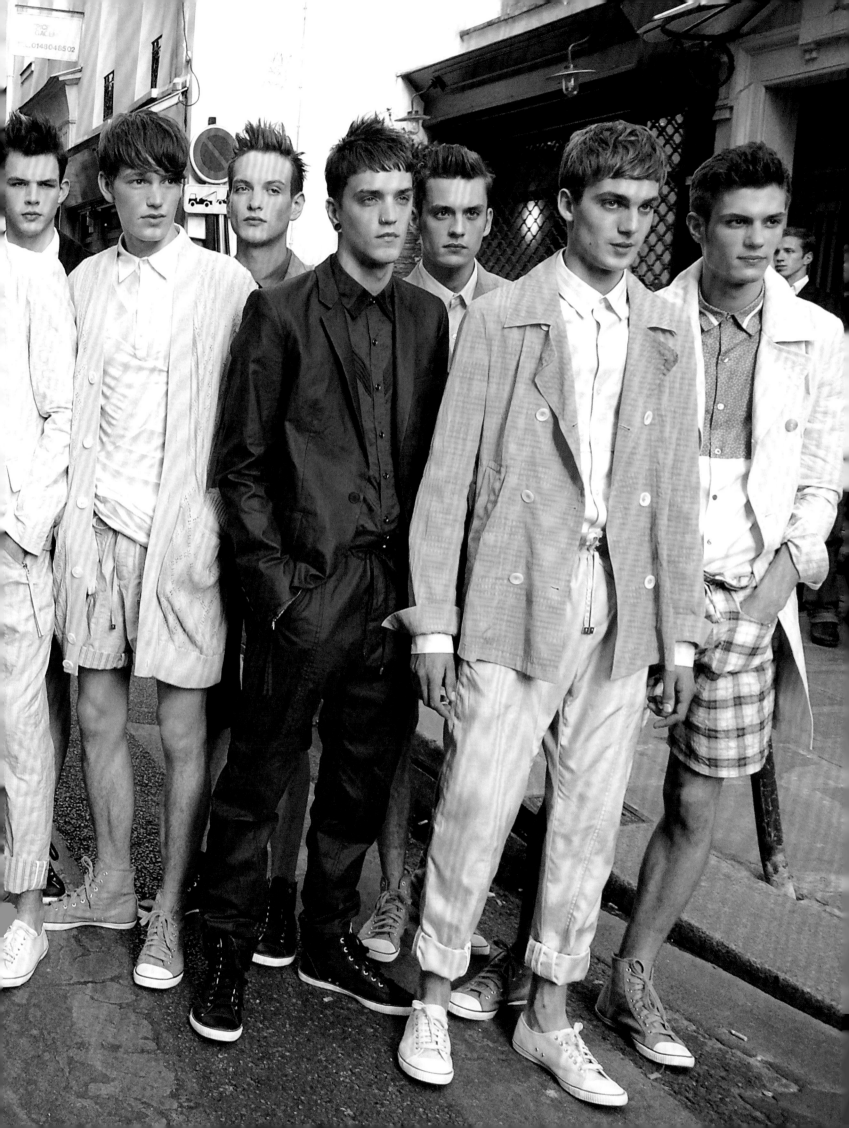

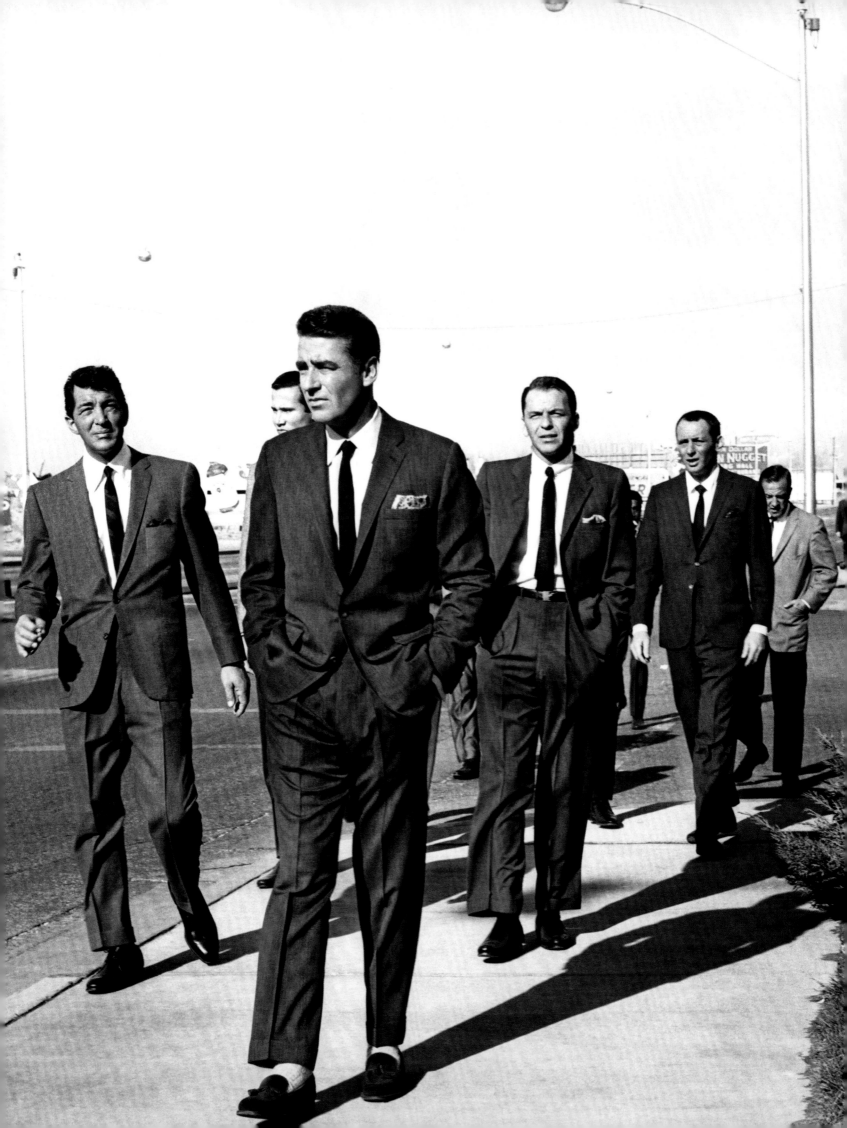

The American Suit

{ *Much more than a workplace uniform, the American suit is a form of self-expression.* }

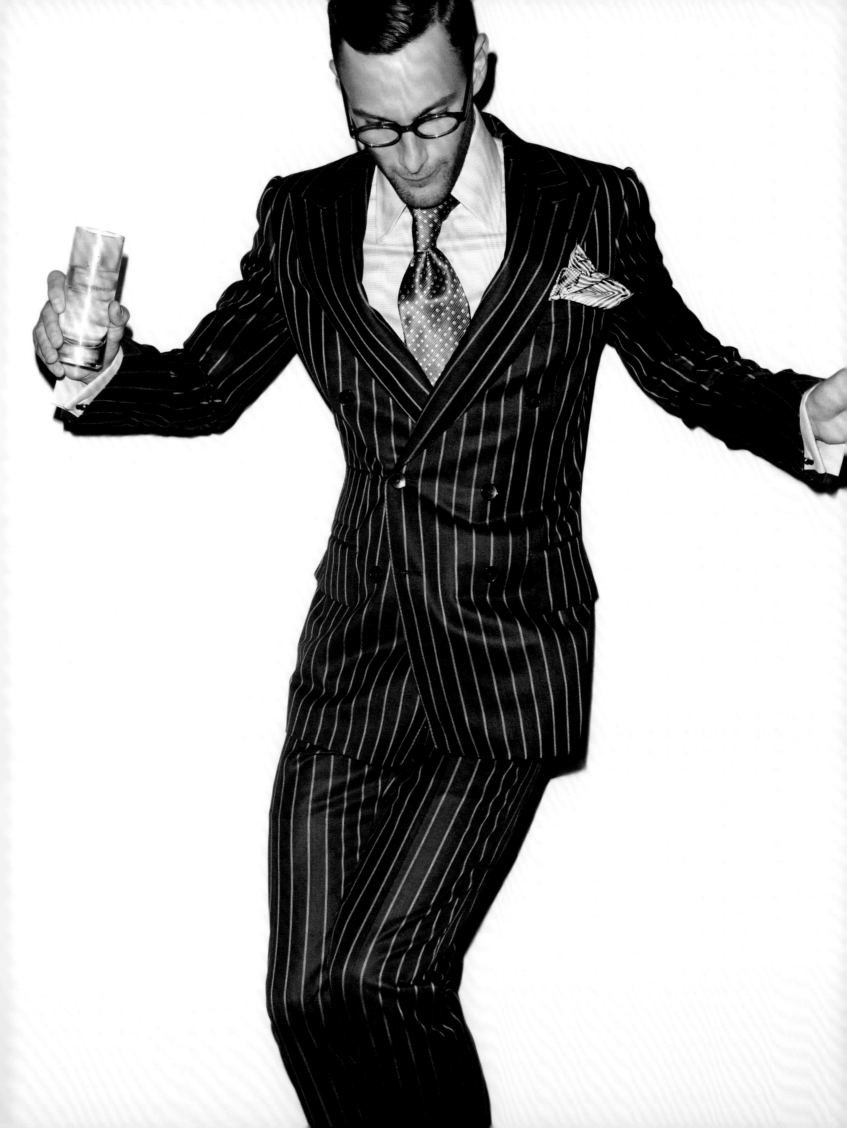

DRESSED FOR SUCCESS

"The chief business of the American people is business."

CALVIN COOLIDGE

At the dawn of the twentieth century, the American businessman was positioned to dominate the world of commerce and industry. To fulfill these lofty goals, it was essential that he not only act but also dress the part. For the old-guard elite, dressing for success usually entailed a morning suit, comprising an unmatched tailcoat and vest worn with striped trousers. Younger men preferred a simpler, less formal working uniform consisting of a matching cropped jacket, trousers, and a waistcoat, first called a lounge suit. Being properly attired in this new-age business suit was a means to gaining respect and showing it in kind to work and personal associates.

While the business suit is no longer commonplace, it may be held in higher regard today than ever before. After all, with the demise of the tailcoat and even the tuxedo (except on Hollywood's red carpet—thank you, George Clooney), the suit has become the default formalwear of our time for weddings, funerals, and any other occasion on which men strive to look their best. What's more, changing attitudes now mean that wearing a suit no longer brands an individual as a drab and dreary gray-flannel conformist. Rather, contemporary suits can make radical fashion statements; witness the examples of dapper dressers in the media, entertainers (especially musicians), and cosmopolitan men of finance.

A hundred years ago, the situation could not have been more different. Men wore suits not to stand out from but to fit into society, and on all occasions, with the exception of formal events and sports. Since sport coats didn't take hold until the 1920s, men wore suit jackets informally with unmatched trousers—a mix-and-match concept that saw a major revival in our own century as hipsters substituted jeans for trousers with their pinstriped jackets. Fathers schooled sons in these and other aspects of dressing like a gentleman, all the while striving to emulate the era's uniquely

Dean Martin, Peter Lawford, and Frank Sinatra, 1960 *Previous page* The infamous "Rat Pack" sauntering down the strip during the making of the original *Ocean's Eleven*. Martin, Lawford, and Sinatra are in front in eternal hipster chic: slim black suits, white shirts, and skinny ties. Decades later, a 2001 remake starring George Clooney and Brad Pitt would garner some glamour by association for a new generation of leading men. **Tom Ford, 2008** *Opposite* Back from his European triumphs, Tom Ford now has a complete line under his own name, designed to be the ultimate in luxurious, sophisticated menswear. This dapper double-breasted suit from his Spring 2008 collection exemplifies Ford's impeccable tailoring and attention to every debonair detail.

American sartorial ideals of manhood: the robust Kuppenheimer Suit Man and the clean-cut Arrow Collar Man, both created by the noted illustrator J. C. Leyendecker. Though well-to-do gentlemen had personal tailors, most men bought ready-to-wear suits from mail-order catalogs like Sears, Roebuck and Co., or, for slightly higher prices, at growing department-store chains, such as Macy's and the May Company. At the same time, the legendary New York retailer Brooks Brothers was developing its own identity with the popular sack suit, characterized by a natural shoulder and a straight-cut, undarted jacket that, with some updating, continues to sell at Brooks and other traditional men's stores today.

This relatively slow evolution in tailoring quickly turned into a revolution by the end of World War I and the start of the modern era, the first period dominated by the tastes of young people. During the Roaring Twenties, a free-spirited generation dubbed "Flaming Youth" burst onto the scene with the motto "Out with the old, and in with the new," which they applied to everything from morals to fashions. Changes to the traditional suit came fast and furious. First was the radical Jazz suit: extremely fitted, with a very high jacket waist, a dramatically flared skirt, a deep center vent, and matching skinny high-water pants. This was perhaps the first instance of what's known today as street style; that is, fashion that wasn't inherited from the upper crust but emerged independently from the lower rungs of the social ladder. As is often the case with more extreme fashions (like the band-collar Nehru suit almost fifty years later), the most daring dressers—especially the entertainment crowd—flaunted it before it quickly disappeared into legend. It is interesting to note, however, that this very shapely jacket anticipated not only the retro-dandy street style of 1950s English Teddy Boys but also the trendy, shaped, "European"-cut jackets of the 1970s.

While fathers in the mid-1920s looked to Savile Row for direction, their college-age sons were more likely inspired by what their peers at Oxford were wearing—namely very short, fitted, natural-shoulder jackets (not too different from what came down runways in 2008), worn with elephantine Oxford bag trousers available in bottom widths to twenty-six inches. Many of these formerly extreme fashions are vividly recalled in the illustrations of John Held, Jr., whose witty caricatures of the fashion fads and foibles of this truly revolutionary generation are just as entertaining today.

With the onset of the Great Depression, in 1929, such frivolous young fashions were no longer tolerated, and adults once again took full charge of the way men dressed. Savile Row continued to shape the look of men's suits, but it was Edward, Prince of Wales (later the Duke of Windsor) who truly gave a face to English style, inspiring such notable American fashion icons of the Depression

era as Fred Astaire, Gary Cooper, and Cary Grant. Toward the end of 1933, Hearst Publishing introduced *Esquire* magazine, which promoted the ultimate in sophisticated menswear with illustrations by the artist L. Fellows that fully embraced Edward's innovative style. As for Savile Row, first and foremost was the English drape-cut lounge suit, which was introduced on this side of the Atlantic in 1932 and gradually replaced the slimmer, more fitted suits of the twenties. Its broader shoulders and full, creased chest would, in one form or another, dominate American tailoring until the mid-1950s. *Esquire* promptly recommended the new cut to its readers, but with the caveat to wear the suit only "if you are so sure of yourself under the New Deal that you are unafraid of offering a striking similarity to a Socialist cartoon's conception of a Capitalist. Since a good appearance is about all that's left to the Capitalist, now, anyway, why not go ahead and enjoy it?"

The advent of American engagement in World War II, in 1941, and the creation of the War Production Board, brought fabric restrictions to the hypermasculine, broad-shouldered suits of the era: no vests, cuffs, or pleated pants, and for the truly patriotic, no lapels, resulting in the first tailored cardigan jackets. Thus the stage was set for one of the most dramatic fashion statements of all time, the zoot suit. African Americans and Latinos had prided themselves on their sharp style since at least the twenties, epitomized by the impeccable presentation of entertainers like Duke Ellington, Xavier Cugat, and Cab Calloway. But the zoot suit was different. Born as true street fashion, without the blessings of the elite, it wildly exaggerated every contemporary trend to comic-book proportions: extra-wide padded shoulders, jackets cut to the knee, and superbaggy trousers rising to the chest, thus making a complete mockery of wartime restrictions. For blacks and Latinos, wearing the zoot was a statement of racial pride and an opportunity to thumb their noses at the establishment for a lifetime of oppression. But in June 1943, servicemen stationed in Los Angeles saw wearing the zoot suit rather as an act of treason, attacking anyone they saw sporting this admittedly outrageous costume. The result was a full-scale race riot named for the zoot, ending with hundreds of men (predominantly Mexican American) hurt and jailed. It's safe to say that no suit before or since has achieved such notoriety.

The placid postwar years witnessed the move to suburbia, increased leisure time, and the rise of casual sportswear, with free-spirited California leading the way. But if suits were losing their total menswear monopoly, at least they were still considered proper business attire. By the end of the 1950s, bulky double-breasted suits had been replaced by the slim, three-button, Ivy League style, most often worn with white shirts and skinny ties. (For a near-perfect recreation of the look, see

television's *Mad Men,* which chronicles the ups and downs of a midcentury advertising agency.) And while the dashing Senator John F. Kennedy had suits custom-made by the Roman tailor Angelo Litrico (reflecting America's first interest in Italian tailoring), he wisely switched to a youthful two-button model by the homegrown retailer Brooks Brothers during his presidency. Everything seemed tranquil on the surface, but there were already signs of trouble. Nonconformists, disillusioned with the American dream, had come to see suits as the monotonous cookie-cutter uniform of the establishment, rather than as a proud sign of achievement in the business world.

The 1960s began and ended in two different worlds, going from *Leave It to Beaver* family values to Woodstock-flavored revolution in society and fashion. In the wake of this veritable "youthquake," street style ruled, as the young rejected everything about the establishment, including its suits. The clothing industry tried to adapt to changing times by offering trendy Edwardian, Nehru, and safari suits, often teamed with turtlenecks and pendants for enhanced hipster credibility. But this was not enough to shake the suit's old-fogey image. In the midst of this fashion insurrection, John Weitz and later Bill Blass became the first American "designer names" in menswear.

Suitmakers next tried new fabric technologies, producing polyester double knits in geometric patterns and a variety of polyester "leisure suits," that propelled America's taste level to an all-time low. In fashion, as in physics, every action brings an equal and opposite reaction. Many designers, appalled by the state of seventies fashion, turned their sights back to the classic period between the wars. Foremost among them was a young neckwear designer named Ralph Lauren. In 1968, he produced a complete clothing line inspired by aristocratic American styles of the 1930s. But good taste alone could not satisfy all segments of society, and the prevailing seventies disco culture soon gave birth to the white polyester disco suit famously worn by John Travolta in 1977's *Saturday Night Fever.*

Ronald Reagan, Wall Street, and yuppies joined forces to put both the economy and the suit back in business during the ultimate "Me decade," the 1980s. Broad-shouldered, double-breasted "power suits" inspired by the Italian designer Giorgio Armani and the styles of the 1940s were the new uniform. Once again, the idea of the American dandy was back; boldly patterned ties, colorful suspenders, and flashy cuff links were the requisite finishing touches for this late-capitalist power broker. At the same time, other young men, taking a cue from Don Johnson on NBC's *Miami Vice,* transformed their pastel suits into hip leisurewear, trading ties for T-shirts, a look that has a following to this date. Moving forward, former women's wear designers such as Calvin Klein and Donna Karan turned their talents to soft, drapey suits, but even these relaxed styles weren't sufficient

to satisfy the nineties desire for still more casual, comfortable business clothes. Consequently, computer companies and even some Wall Street firms adopted casual Fridays, an invention of the late fifties, which sometimes—especially in dot-com start-ups—stretched out to the entire workweek. As the decade came to a close, a few companies reinstated certain dress restrictions for their sportswear-bewildered employees, but one thing was certain: The authority the business suit had long enjoyed was finished. Heading into the new millennium, the average man had forgotten how to wear a suit, much less how it should fit—and that is often still the case. On a more positive note, there has been a resurgence in custom tailoring among affluent businessmen looking for the kind of perfection their great-grandfathers enjoyed at the turn of the last century.

Though suit sales continue to fall, more men today—from serious stockbrokers to flamboyant dandies to trendsetting musicians—are wearing suits not because they have to, but because they want to look their best. The designer Thom Browne gets much of the credit for redefining and reinvigorating the suit with his dramatically new (and controversial) "shrunken" proportions. Browne maintains that "what I am doing has become the anti-establishment, because the jeans and T-shirt look has become so acceptable and part of the establishment." Indeed, now that suits are no longer so closely tied to the mainstream, cutting-edge performers in pop, R & B, and especially rap have wholeheartedly taken to tailoring. Some, such as Justin Timberlake and Brandon Flowers, usually mix it up with jeans, while others wear it head-to-toe; see R & B performer Ne-Yo, dapper in a chalk-striped suit and a fedora on his 2008 album *Year of the Gentleman*. Moving into the future, the suit will perform a more specialized role, becoming the province of those who realize just how great a suit can make them look and feel—not just for work, but whenever and wherever they choose.

Thom Browne, 2008 Since the premiere of his first suit collection in 2001, designer Thom Browne has changed the shape of menswear, notably by shrinking its proportions to appeal to a younger customer, as seen in this photo from the February 2008 issue of *id* magazine. *The New York Times* has called his work "hilarious" and, in a more serious assessment, "light and good-natured, not dogmatic and snobby."

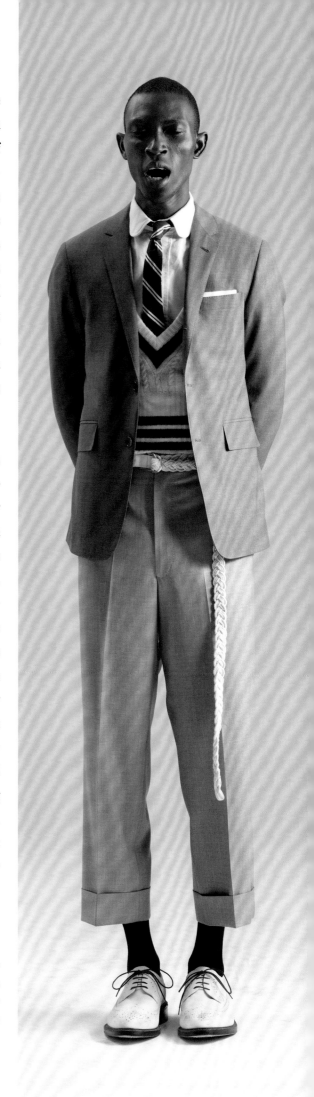

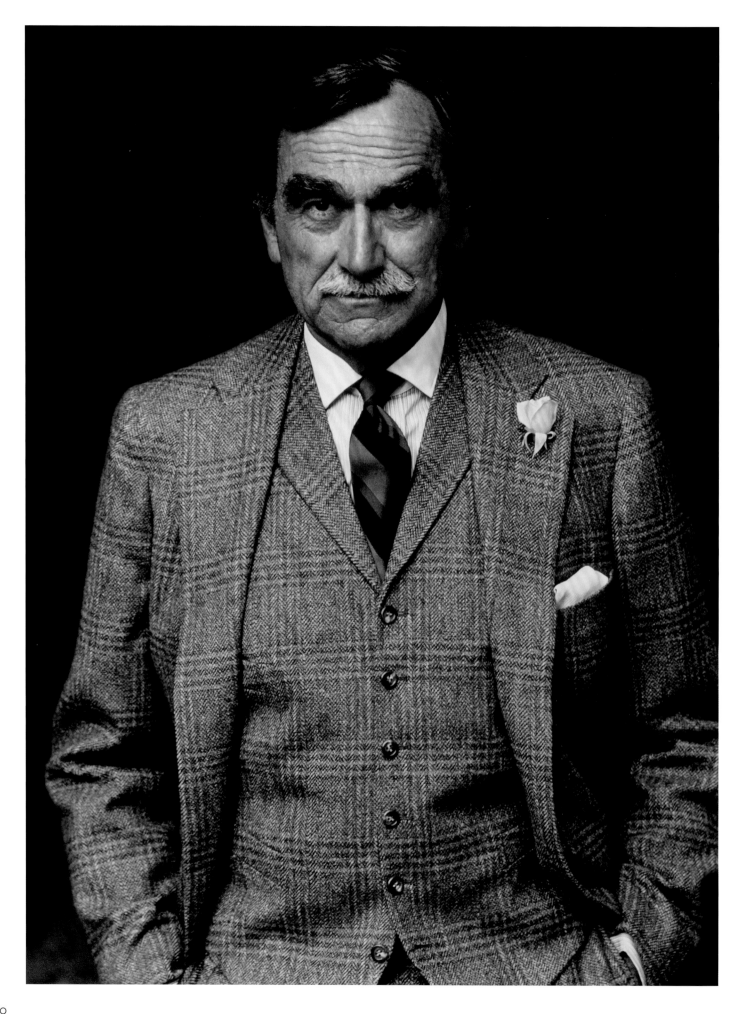

SEPTEMBER 1999

The **Shuttle Sheet**

FOR ~~READE~~RS OF THE DELTA SHUTTLE

We've Got Male

Clothing completely scoped out. So slip this story on for size, guys. *page 11*

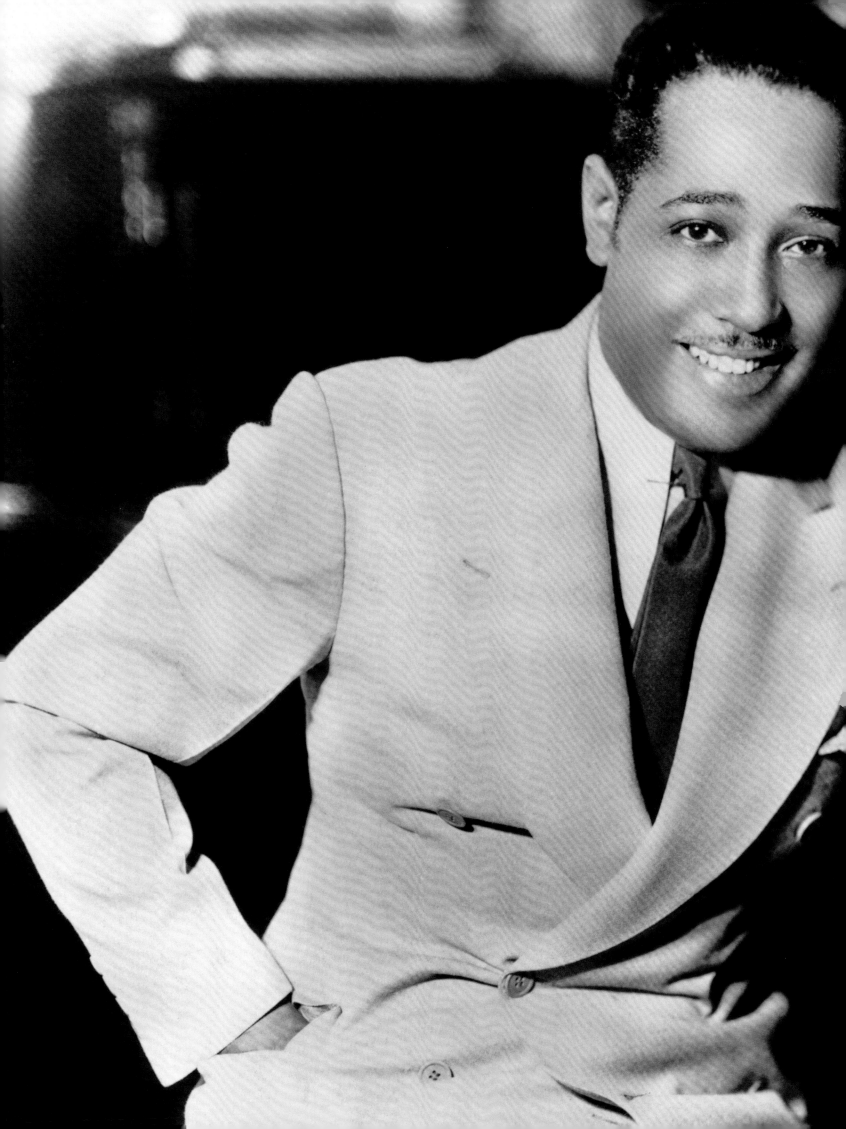

Duke Ellington, 1933

Opposite The elegant Ellington—pianist, composer, arranger, and bandleader—in the impeccable double-breasted suit he wore for his 1933 London appearances.

Ralph Lauren, 1980

Previous pages, left A classic plaid wool three-piece suit from Polo Ralph Lauren's Fall 1980 collection, as worn by architect Tom Moore.

Cover of *The Shuttle Sheet*, 1999

Previous pages, right Alan Flusser, tailor to Wall Street's best-dressed businessmen, is known for his love of classic 1930s style, particularly the easy elegance of the drape-cut suit. This Michael Witte illustration captures the jaunty, wry self-presentation that makes the designer one of his own best models.

Bill Blass, 1973

Right The debonair Bill Blass poses in a windowpane-check suit, given some heft by the era's fashionably wide tie, and some flair by kiltie loafers.

Thom Browne, 2007

Opposite Thom Browne's take on the three-piece suit, as worn by soccer player Hidetoshi Nakata in the July 2007 issue of *GQ*.

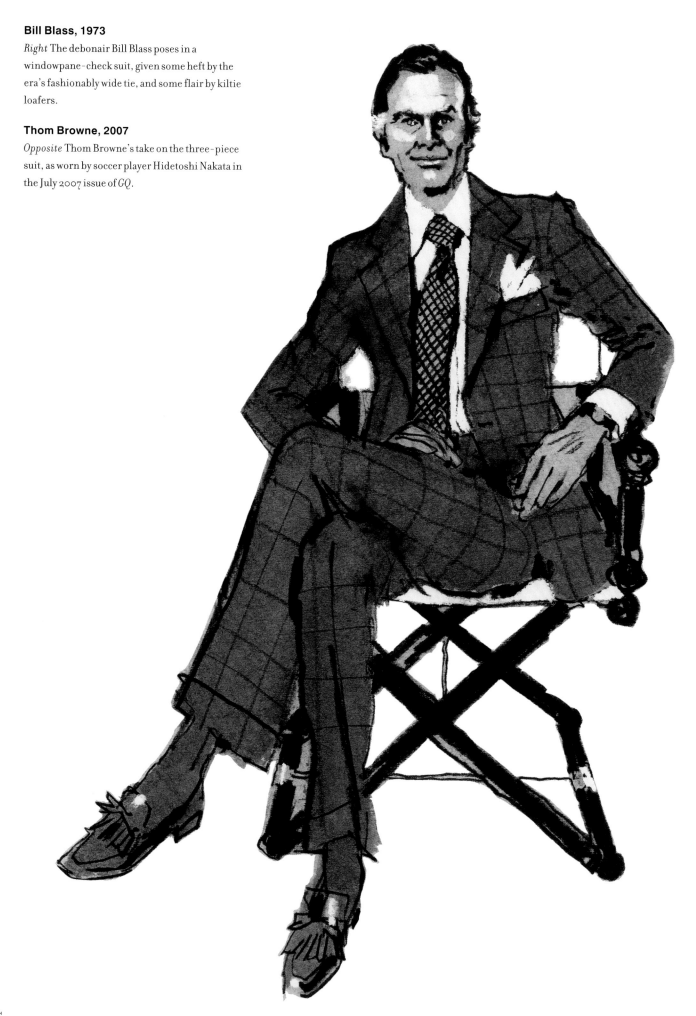

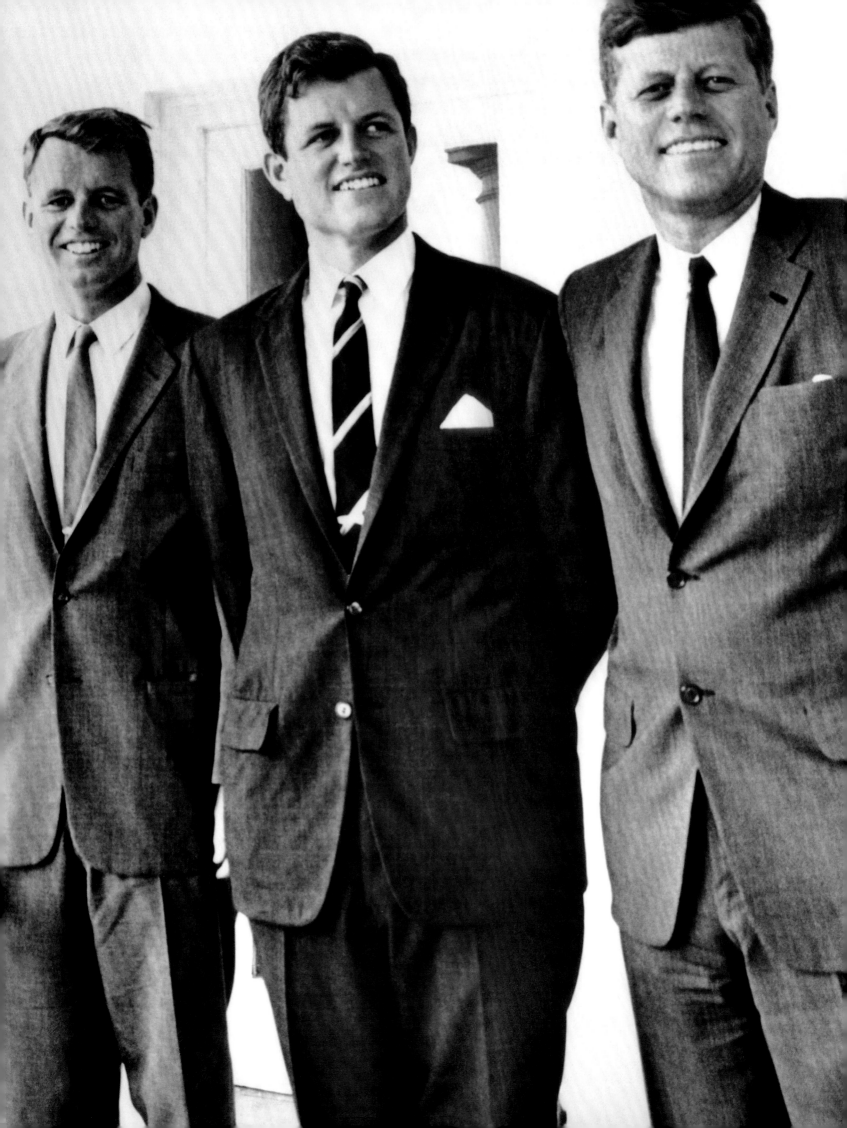

Brooks Brothers, 2008

Above Henry Sands Brooks's classic clothier has been the go-to for Ivy League basics since the early 1800s. Here, a classic three-button suit is brightened with a signature rep tie.

Robert, Edward, and John Kennedy, 1960

Opposite With the ascendancy of the Kennedy brothers, Ivy League suit style took on a new, national level of influence.

Well suited, 1934

Following pages, left Fashion artist par excellence L. Fellows shows off both his sense of style and an impeccable range of suits for both town and country. This grouping appeared in the September 1934 issue of *Esquire*.

Billy Reid, 2008

Following pages, right Although it could have stepped out of the 1930s selection on the facing page, this handsome tweed country suit, worn with a plaid shirt and a jaunty bow tie, is from the designer Billy Reid's Fall 2008 collection.

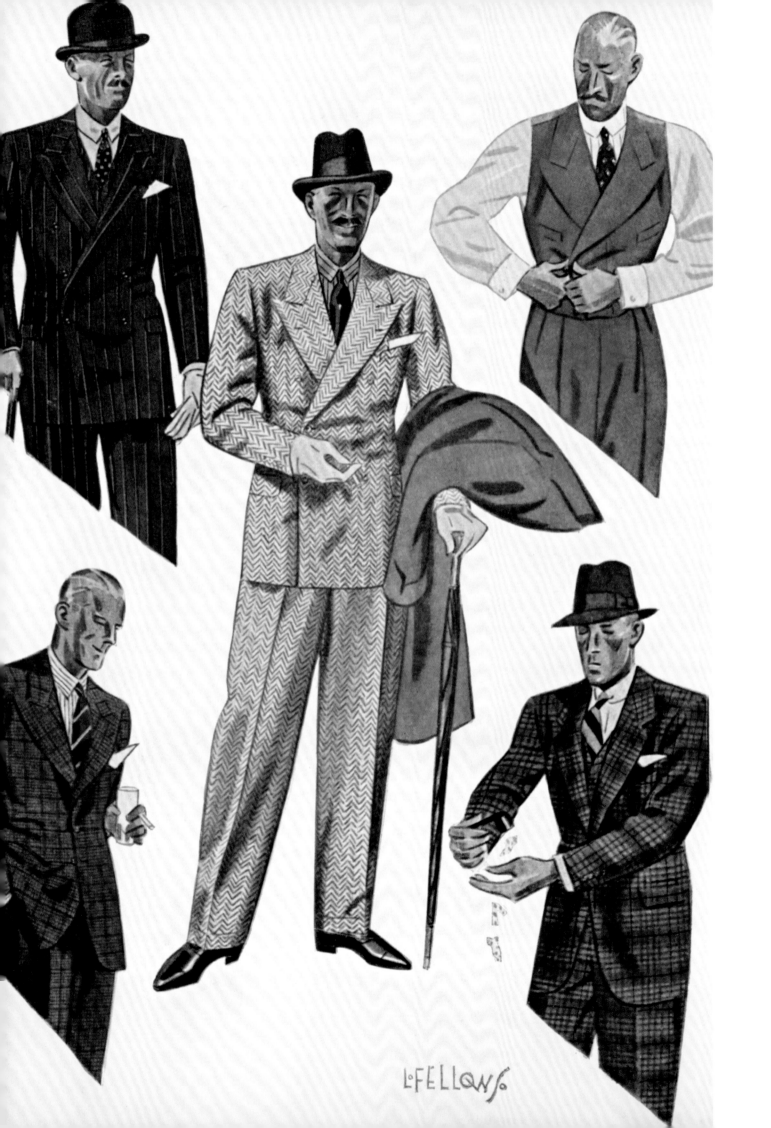

L·FELLOWS

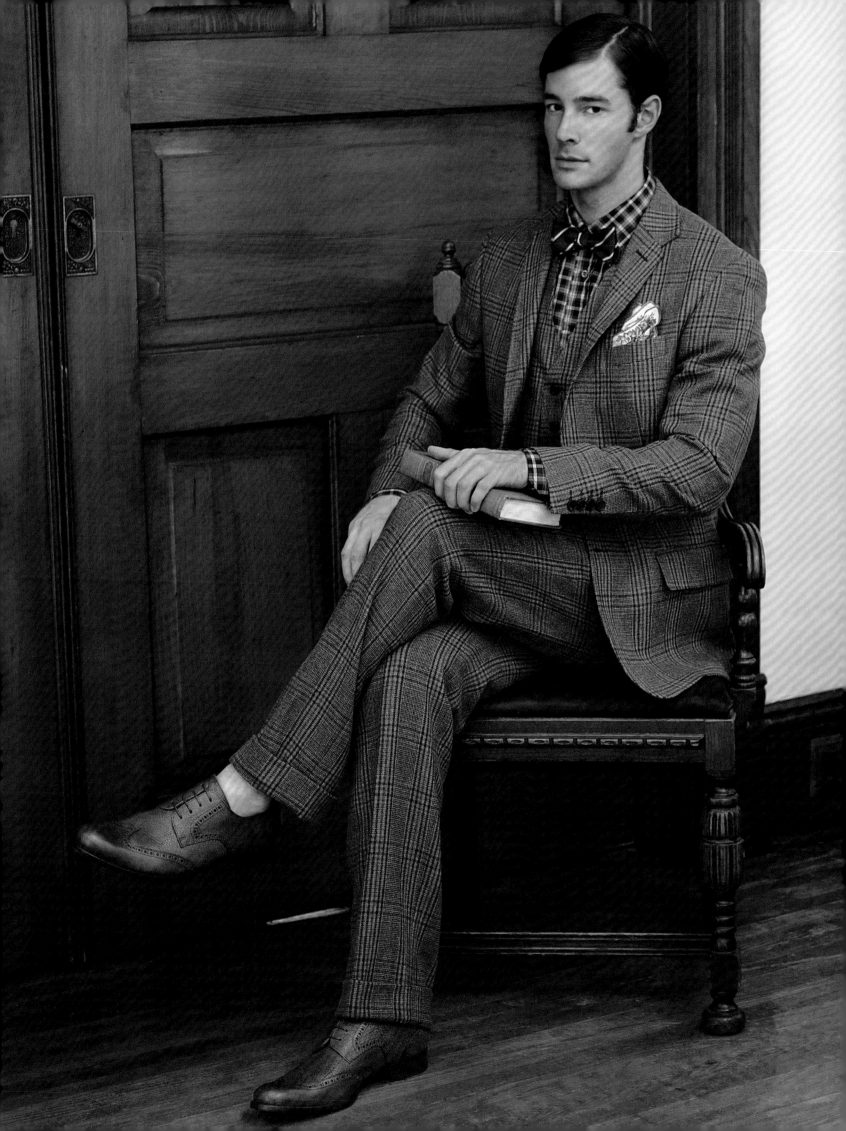

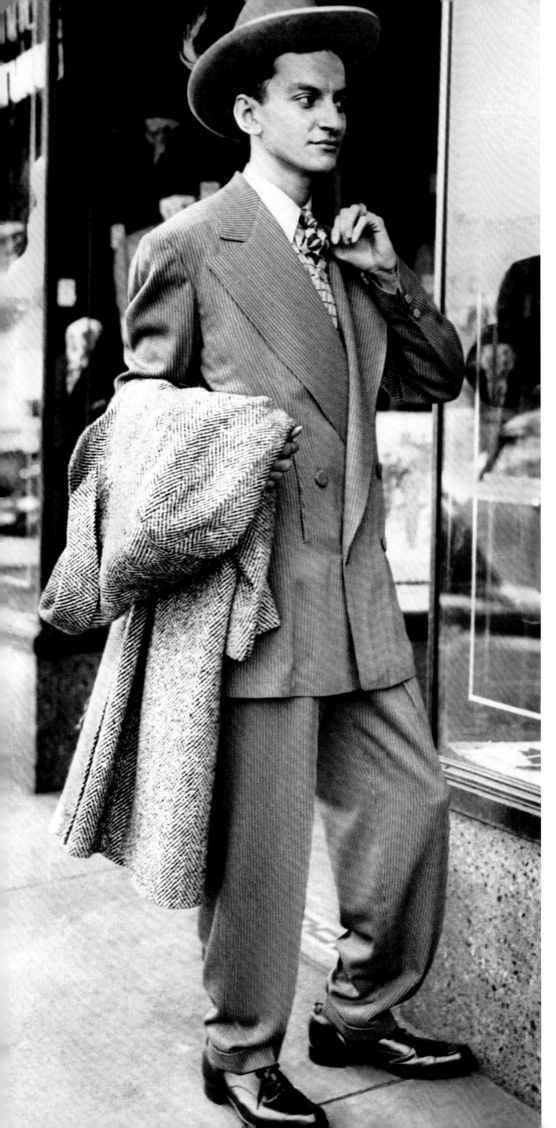

The zoot suit, ca. 1940s

Left The "zoot" may be the most notorious suit on record. Its exaggerated proportions—especially in the face of World War II fabric restrictions—led to controversy and ultimately to violence.

Donna Karan, 1995

Opposite In a photograph by Herb Ritts, the actor Fred Ward wears a soft, drapey suit, a signature of Donna Karan's designs for men.

Corduroy, Claiborne, H & M, Target, and Express Design Studio, 2006

Following pages The October 2006 issue of *GQ* featured an enticing choice of business suits that wouldn't cut into a gent's paycheck.

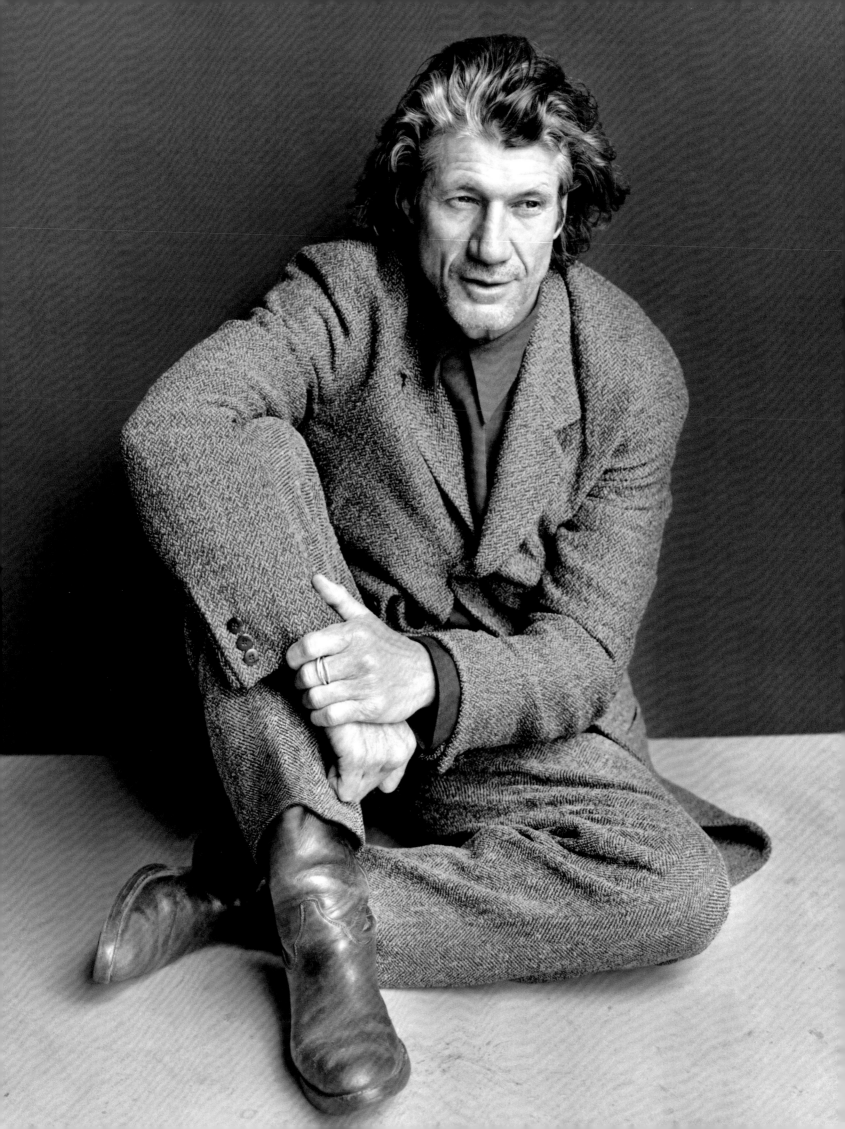

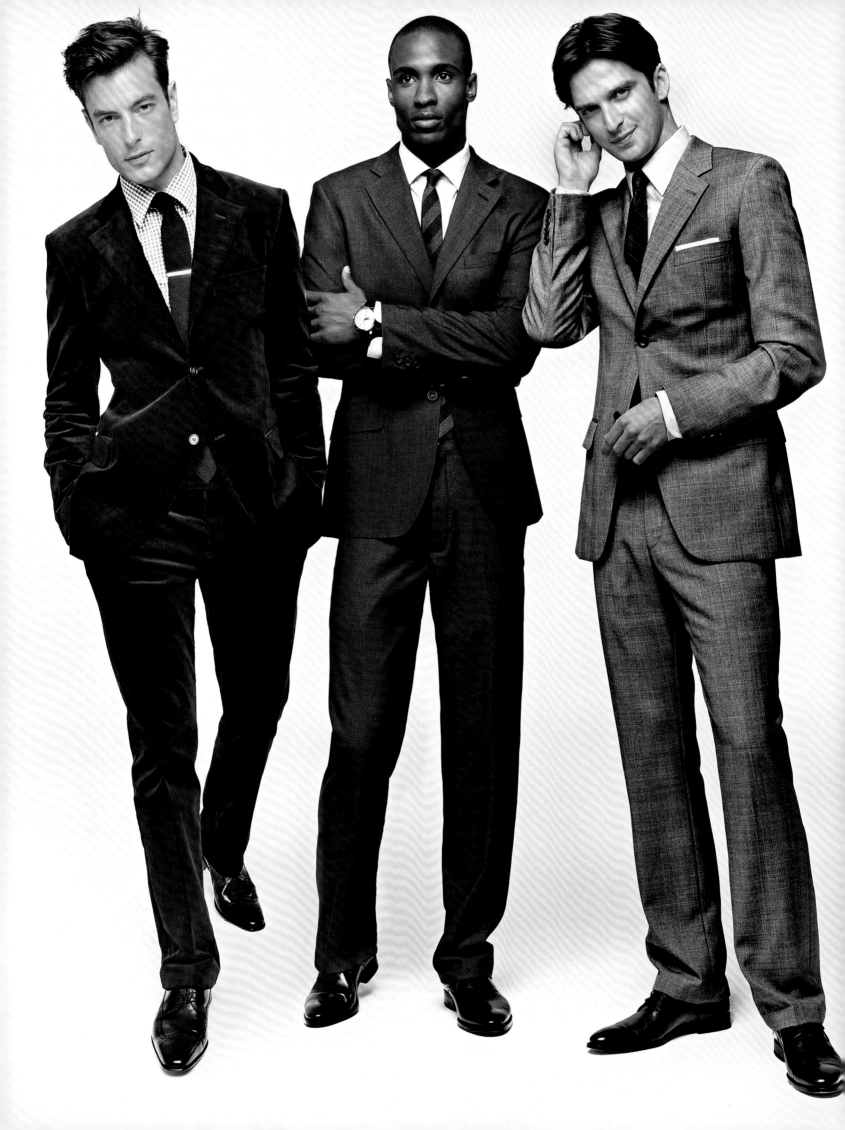

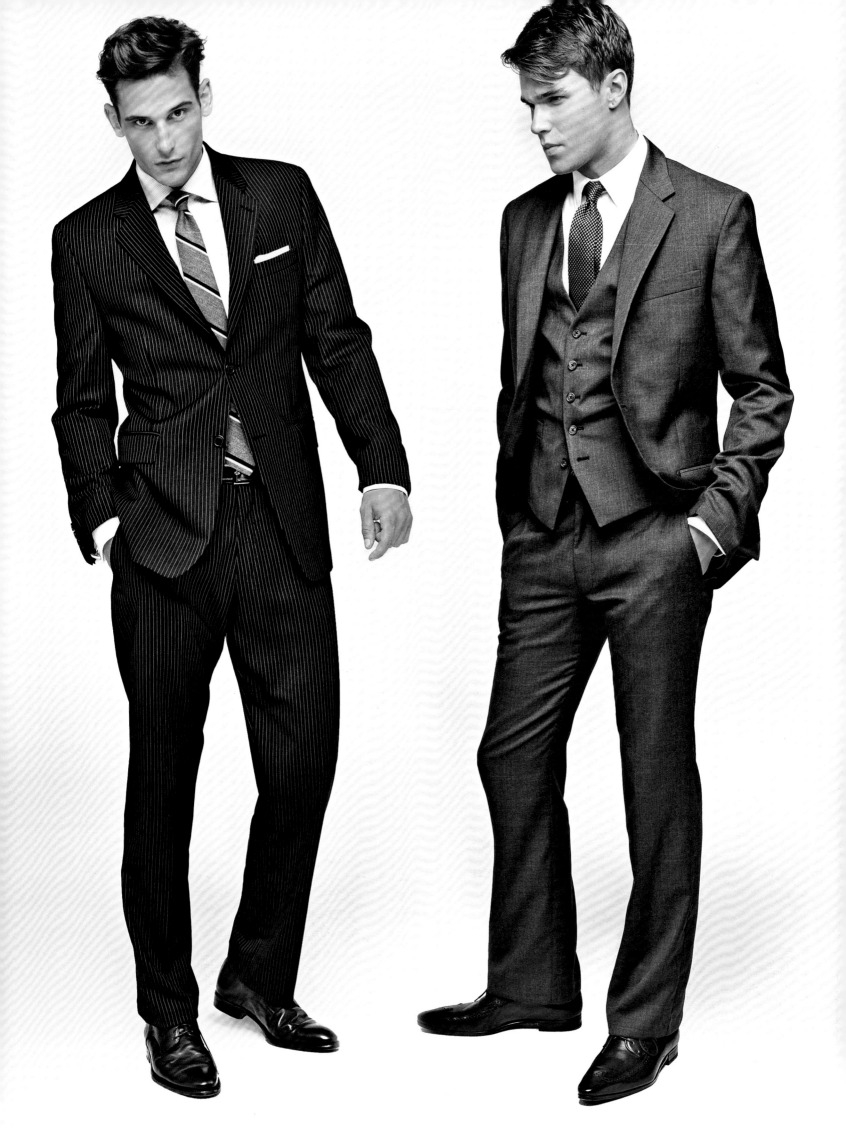

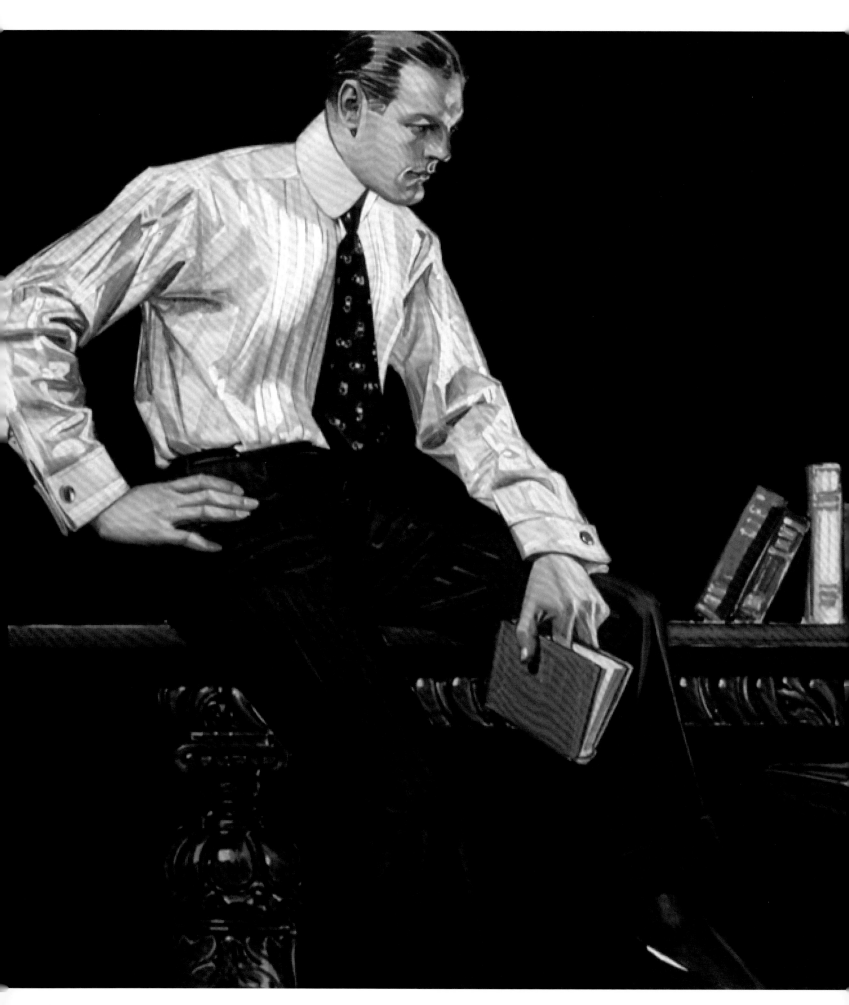

Brooks Brothers, 1970

Following pages, left Seersucker suits were introduced by Brooks Brothers in the 1920s, and they've been a symbol of summer ever since. This advertisement shows the colors available for Spring-Summer 1970.

Alexandre Plokhov, 2006

Above This modern tuxedo appeared in Alexandre Plokhov's Spring 2006 collection.

Italo Zucchelli for Calvin Klein Collection, 2009

Following pages, center Calvin Klein has always been known for neutrals, but CK menswear czar Italo Zucchelli is no shrinking violet. His Spring 2009 runway show included this atypical bright red suit.

Men Reading (detail), 1914

Opposite This Arrow Collar advertisement by J. C. Leyendecker promoted prewar men's dress shirts with detachable, high, stiff collars. After World War I, returning troops demanded the attached, soft collars they had grown accustomed to in the army.

Gene Meyer, 2001

Following pages, right Meyer rose to fame in the 1990s with the quirky, colorful take on menswear manifest in this turquoise suit and conversational tie from his Spring 2001 collection.

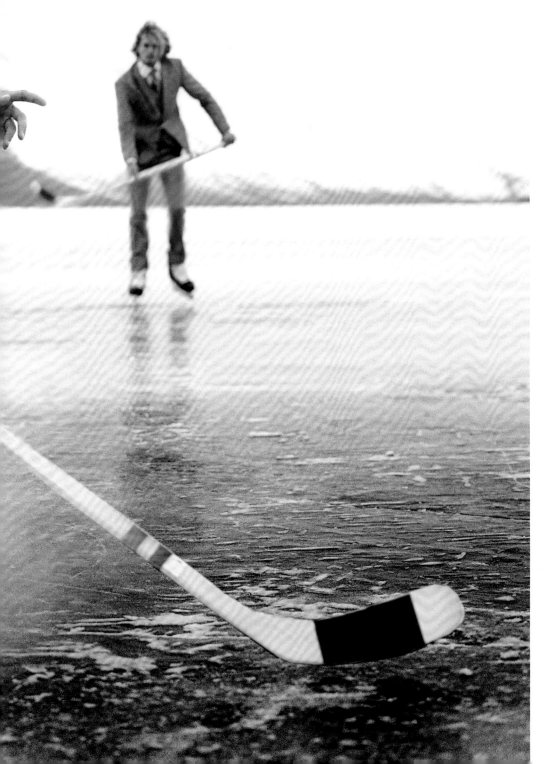

Tommy Hilfiger, 2008
Left Hilfiger, whose work has always shown a sporting influence, makes the point that suits look just as good on the ice as in the office.

The suburbs, ca. 1960
Previous pages, left The phrase "the man in the gray flannel suit" became the title of a 1955 novel (by Sloan Wilson) and a 1956 film (starring Gregory Peck). It described a broad category—the organization man, the office worker—but was also a literal description of a daily uniform. Here, a man in a gray flannel suit leaves his suburban home for work in the big city.

DKNY, ca. 1994
Previous pages, right A contemporary businessman (in the person of the legendary model Mark Vanderloo) rollerblades to work in a DKNY NYC advertising campaign.

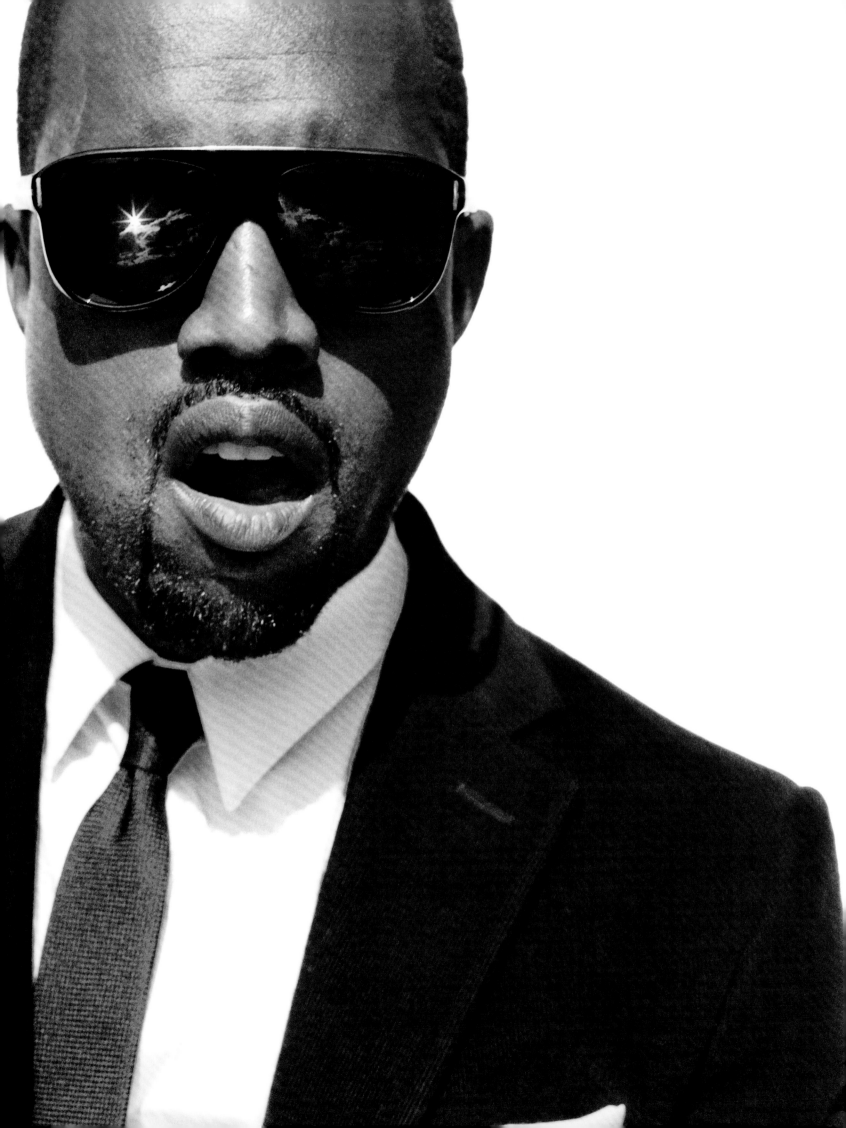

Kenneth Cole, 2008

Right The executive's classic three-piece suit turns hip in this interpretation by Kenneth Cole.

Calvin Klein, 2007

Opposite Rapper Kanye West looks the part of the urban hipster in dark sunglasses, a black Calvin Klein suit, a white shirt, and a skinny black tie in this portrait for the January 2007 issue of *GQ*.

The Dandy

{ *Individualistic, dapper, or outrageous, the American dandy is in a league of his own.*

AMERICAN IDOLS

"One should either be a work of art, or wear a work of art."

OSCAR WILDE

Considering the outrageous connotations the word "dandy" has accrued during the past two centuries, it is indeed ironic that George "Beau" Brummell, the most celebrated of all dandies, actually simplified the way Regency Englishmen dressed. Replacing powdered wigs, colorful brocades, and lacy ruffles with naturally groomed hair, spare but impeccably tailored jackets, and starched white linen shirts, Brummell has rightfully earned the title "father of modern costume."

As the Romantic poet Lord Byron once said, there was nothing remarkable about Brummell's appearance except "a certain exquisite propriety." Hardly the description of a fop! Brummell himself lived by a maxim of moderation: "If John Bull [the English John Doe] turns round to look after you, you are not well dressed; but either too stiff, too tight, or too fashionable."

Though Brummell was not ostentatious, there is no denying that this Regency rake did devote an inordinate amount of time to his meticulous appearance, taking as long as five hours to dress, as he facetiously maintained. Brummell at least deserves credit for encouraging men to brush their teeth and bathe daily—a revolutionary act at the time. This sense of male vanity, this assiduous attention to cleanliness and personal appearance, is one aspect of Brummell's regimen that continues to apply to American dandies in the twenty-first century.

The nineteenth-century French writer and noted dandy Charles Baudelaire described the situation best, believing that true dandies had "no profession other than elegance . . . no other status, but that of cultivating the idea of beauty in their own persons. . . . The dandy must aspire to be sublime without interruption; he must live and sleep before a mirror."
Enter the metrosexual and the flurry of products, services, and publications targeted at this

Prince, 2005 *Previous page* Prince, caught primping before the camera at the 2005 Academy Awards, wears a razor-thin mustache, a starched wing collar, a puffed pocket hankie, and glittering jewels. Maintaining both mystery and tradition, he defines the 21st-century dandy. **Billy Reid, 2008** *Opposite* This young gentleman's aesthetic attitude and flowing tresses transform Billy Reid's Fall 2008 three-piece suit into true dandy material.

burgeoning demographic, and it is obvious that the narcissism of the dandy has continued to influence masculine society at large. Today it is not uncommon for a heterosexual male to visit a day spa for a facial and a pedicure, peruse a men's fashion magazine laden with olfactory-stimulating cologne ads, and browse a selection of cosmetics and treatment creams while awaiting pampering fit for a king.

For most men, dressing remains an insignificant part of their day, as they simply try to blend in with the rest of humanity in a way that will not draw attention, either good or bad. The sartorial peacocks, on the other hand, display a sensibility that has more in common with how women have always dressed. While these fastidious gents may vary in their desire to be recognized, all use style for self-expression as well as for flaunting status within a particular culture, be it banking, literature, media, theater, sports, fashion—or even organized crime.

In a world where the cult of celebrity has reached a new high and the competition for the spotlight is more intense than ever, how men dress can be the difference between success and failure. This notion has been particularly borne out during the past century by several minority groups, including gays, African Americans, and Latinos, who have used bold fashions to create an identity, attract attention, and, in some cases, to gain the kind of power and influence that might otherwise have been denied them. There are also those who, like Brummell and the exquisite Comte d'Orsay, assume an aristocratic style as a means of rising above a mundane middle-class background. Finally, there are a glittering few following in the footsteps of Baudelaire, for whom dressing up is a magnificent end in itself. Simply put, their motto is "I dress, therefore I am—and the rest of the world had best take note."

The American concept of a dandy invariably includes some form of tailored clothing, as wearing a suit is the simplest way for a man to dress up. Consequently, most dandies have a certain retro flavor—witness Oscar Wilde's notorious aesthetic garb, including knee breeches and stockings. Joked the witty epigrammatist about his effect on Americans after an 1882 tour in the United States, "Strange that a pair of silk stockings should so upset a nation."

Of course, suits alone are usually not enough to make the necessary impact, hence the need for attention-grabbing accessories. In the mid-nineteenth century, Comte Robert de Montesquieu led the way to a more flamboyant type of dandyism by wearing a white suit with a bouquet of violets at the throat. Less inspired but nonetheless eye-catching options

Venice, 1923 *Previous pages* Dandy, dilettante, artist, and host to the elite at his Villa America in Cap d'Antibes, Gerald Murphy (far left) on the town in Venice with his wife, Sara (far right); Ginny Carpenter; and Cole Porter.

today include pocket handkerchiefs, dress jewelry, conspicuous watches, tailored hats, flashy suspenders, natty waistcoats, boutonnieres, bow ties, and two-tone spectator shoes. Extremists may go still further, experimenting with boldly clashing patterns, vivid colors, wildly exaggerated silhouettes, radical hairstyles, and even makeup, as does the fashion columnist Patrick McDonald.

Generally speaking, these contemporary swells can be categorized into two principal groups. The first is made up of serious types, who are greater in number but inversely noticeable. It consists primarily of successful businessmen, stockbrokers, politicians, and even the occasional gangster. These gentlemen favor expensive bespoke suits accessorized to a T. The second group, and by far the more colorful, is made up of creatives, which consists of artists, entertainment personalities, figures from the world of fashion, and rock stars. They are the progressives, the ones who are likely to favor an adventurous mix of jeans, unique sportswear items, and extreme tailoring—from Jimi Hendrix in the 1960s to Brandon Flowers of the Killers today.

Lastly, there are the fashion victims, those less ingenious but equally showy fellows who slavishly parrot whatever creation comes down the runway, whether it suits them or not. Wilde himself quipped that "fashion is a form of ugliness so intolerable we have to alter it every six months." And who would know better?

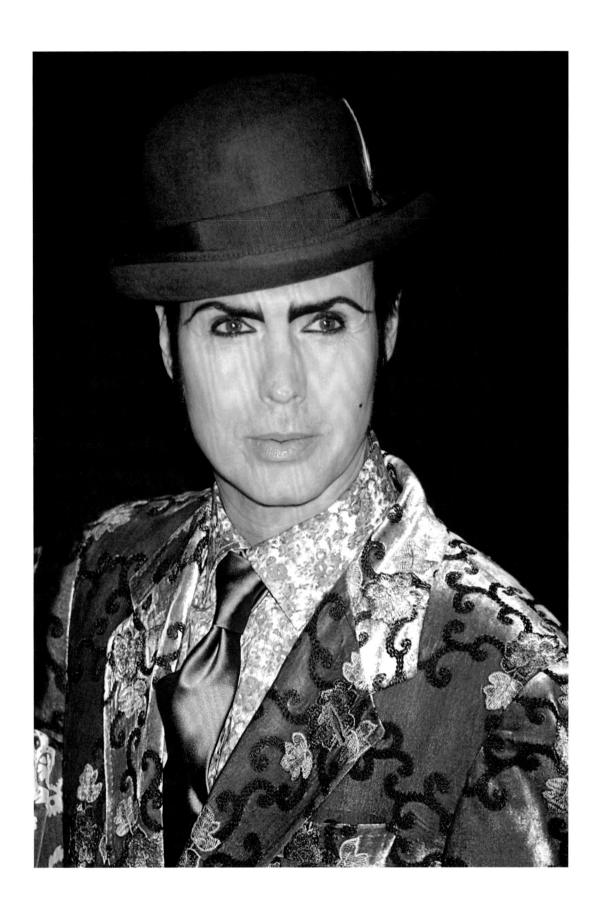

Patrick McDonald, 2009

Above Fashion columnist Patrick McDonald is not afraid of anything—neither a jaunty hat, nor an outrageous mix of patterns, nor even the most dramatic eyebrows in all New York.

Man Reading in Circle, 1916

Opposite J. C. Leyendecker created this Proust-reading dandy, smartly attired in a quilted satin brocade dressing gown, for a 1916 Arrow Collar advertisement.

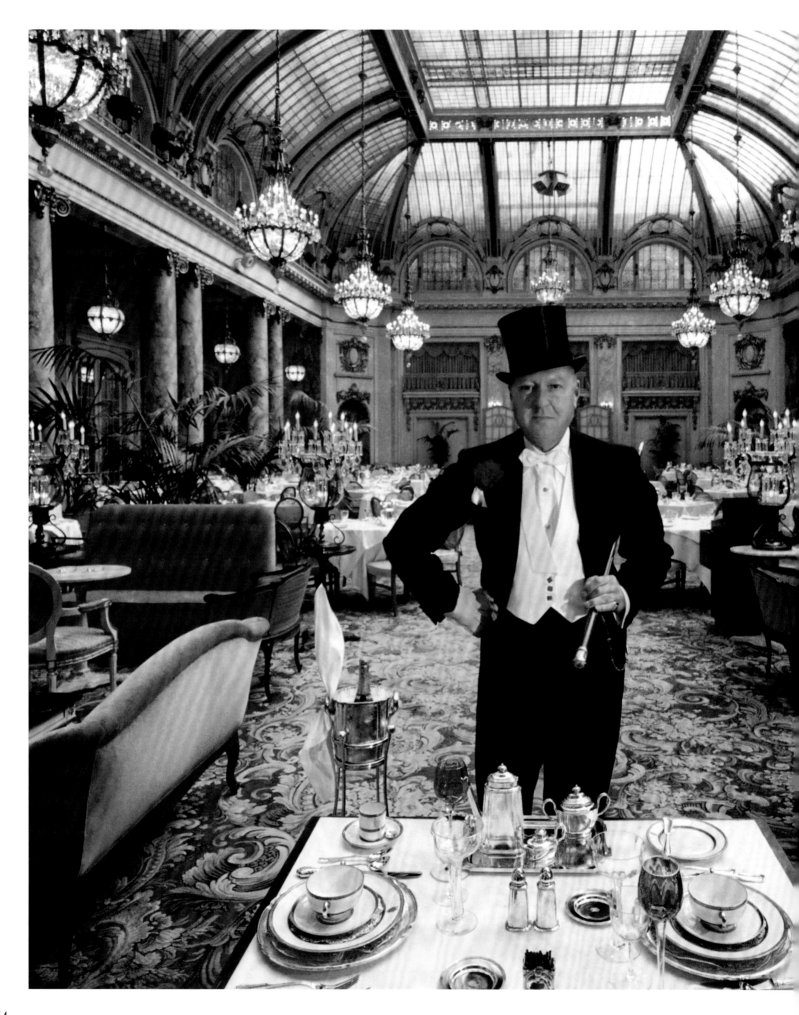

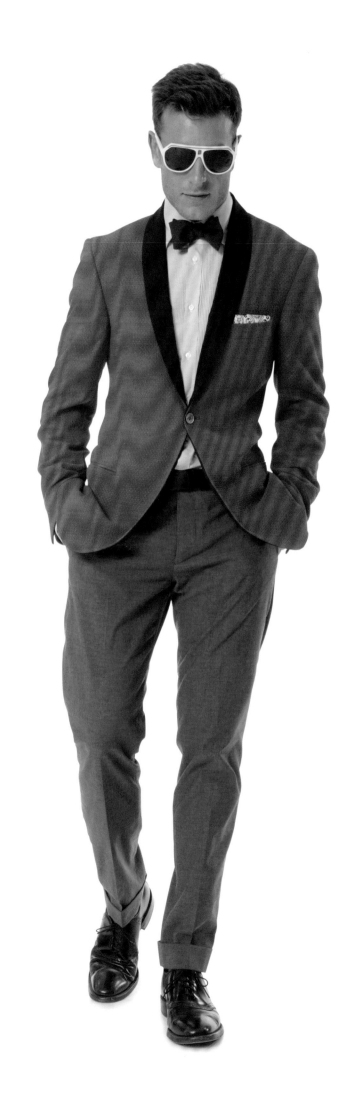

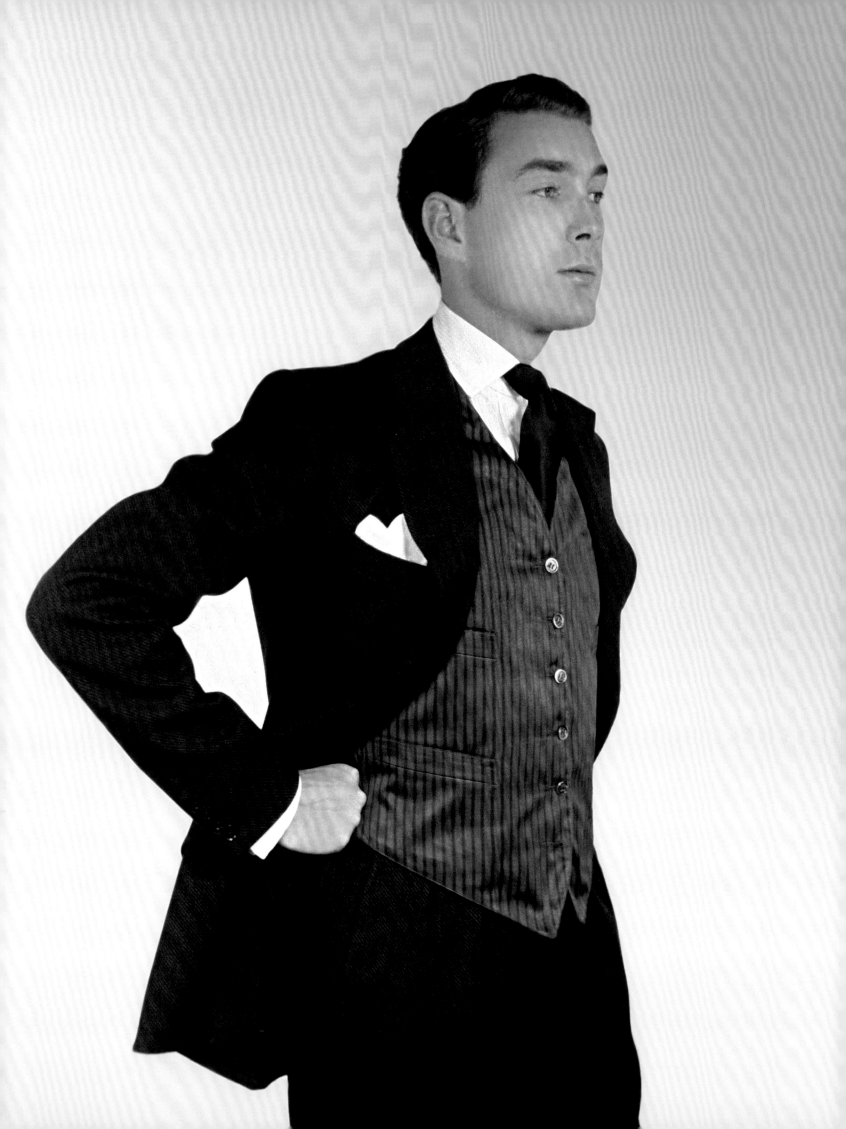

Mish, 2007

Above If one aspires to be a dandy in the classic sense, cuff links are de rigeur—preferably an important pair, like this coral and yellow gold set from Mish.

Brooks Brothers, 1952

Opposite The vest (or waistcoat in British English) can transform any man into a dandy, especially once he puts his hands on his hips. This imported silk example with pearl buttons is worn under a regal Brooks suit.

Lucius Beebe, 1960

Previous pages, left Historian, gourmand, boulevardier, and originator of the term "café society" Lucius Beebe was photographed in top hat, white tie, and tails in the Garden Court at San Francisco's Palace Hotel.

Michael Bastian, 2009

Previous pages, right This barn-red dinner jacket, worn with a spiffy bow tie and white-framed sunglasses, spells modern-day dandy.

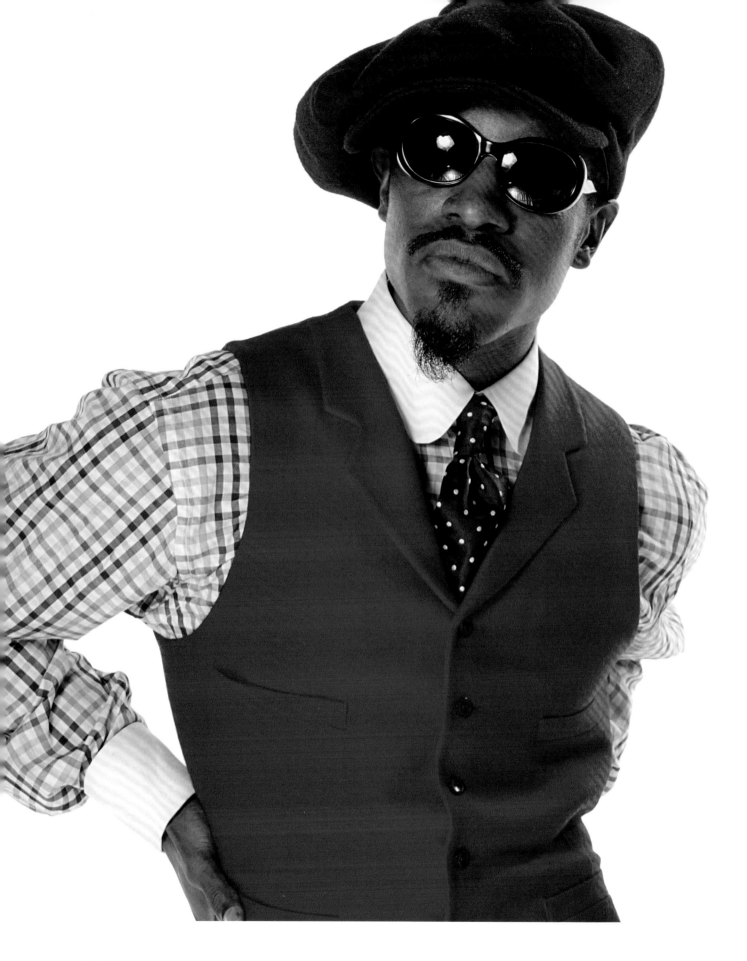

André Benjamin, 2004

Above The musician known as André 3000, front man for Outkast and designer of Benjamin Bixby menswear, is an old-school dandy with a modern twist. He is credited with reviving 1930s styles like plus-fours and club sweaters.

Alan Flusser, 1997

Opposite The dandy is the sole of expression, even (or especially) while relaxing at home: here, tweed slippers are paired with wool trousers printed with a jockey motif.

Dennis Rodman, 1997

Right Renegade dandy Dennis Rodman has added some spice to the game of basketball. Here he wears a Rod Keenan hat, a fur coat, earrings, and little else.

Simon Doonan, ca. 2001

Opposite The true English eccentric, proud Barney's window-dresser, prolific author, and all-around tastemaker Simon Doonan frames himself as an absolutely mad hatter.

André Leon Talley, 2009

Following pages, left As an editor-at-large for *Vogue*, the 6'8" Talley makes only major fashion statements, like this flowing black cape and dramatic red scarf, worn to the Fall 2009 Marc Jacobs show.

Cab Calloway in the film *Stormy Weather*, 1943

Following pages, right The "King of Hi-De-Ho," bandleader and singer Cab Calloway, was always a flashy dresser, but he outdid himself with this highly theatrical white zoot suit.

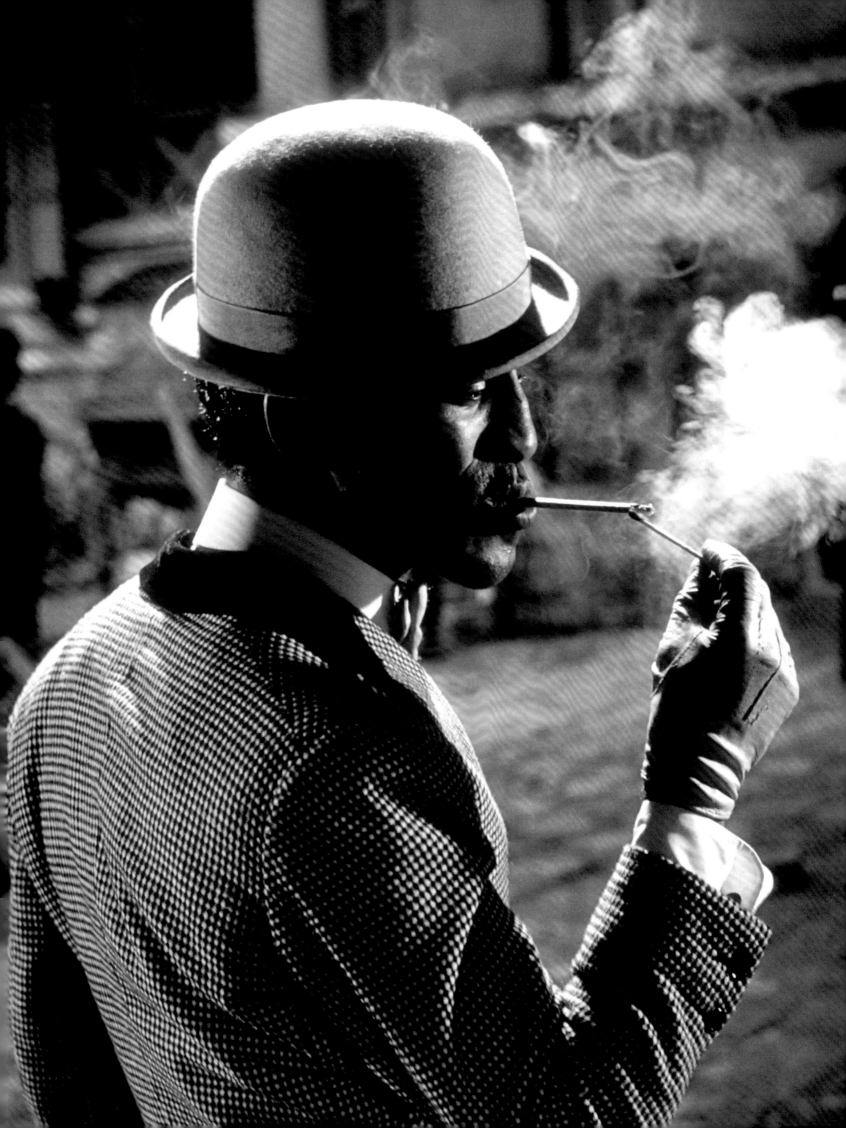

Zac Posen, 2002

Right Judging by the obvious pride he takes in his personal apparel, women's designer Zac Posen loves menswear almost as much as women's wear. Here he is dressed in a frock coat and—one sure sign of a dandy—swathed in fur.

Sammy Davis Jr. in the film *Porgy and Bess*, 1959

Opposite Davis, a jack of all theatrical trades, was a charter member of Frank Sinatra's Las Vegas-based Rat Pack. Consequently, he found himself typecast as the dapper character Sportin' Life in George Gershwin's folk opera.

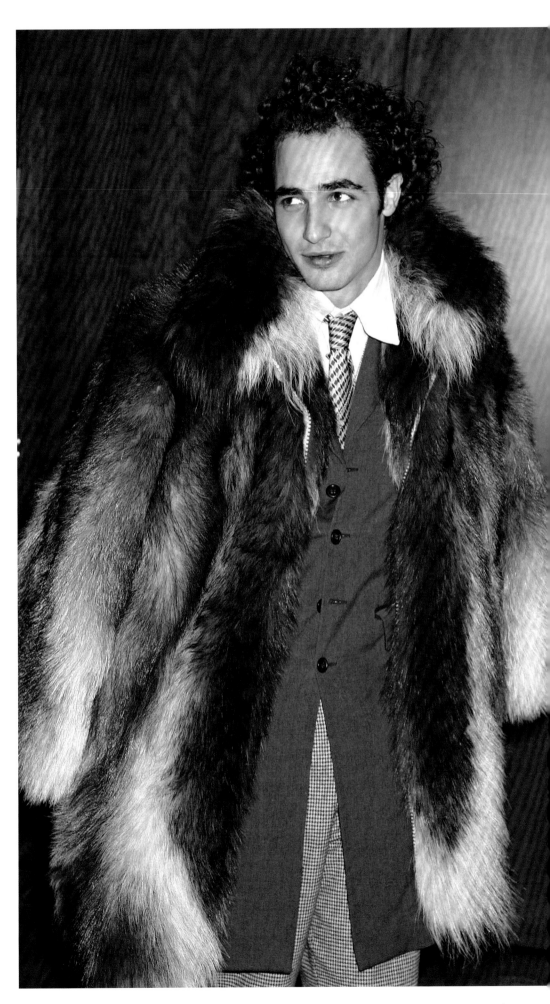

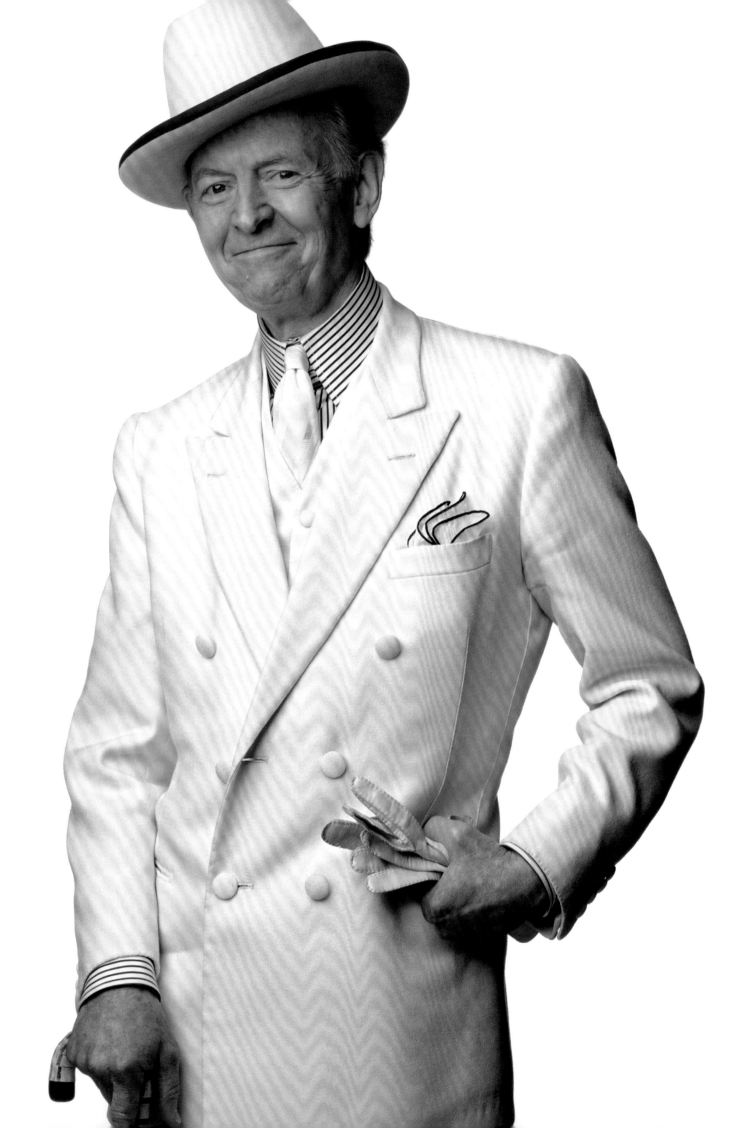

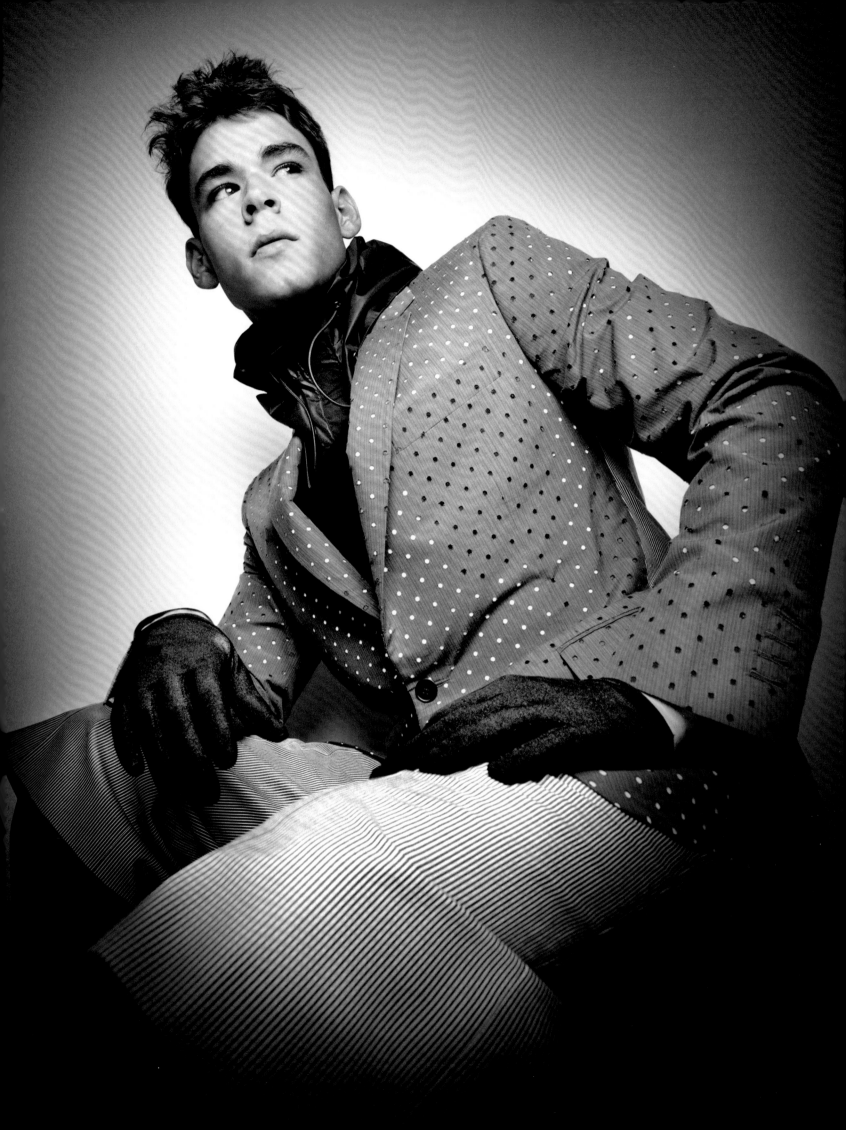

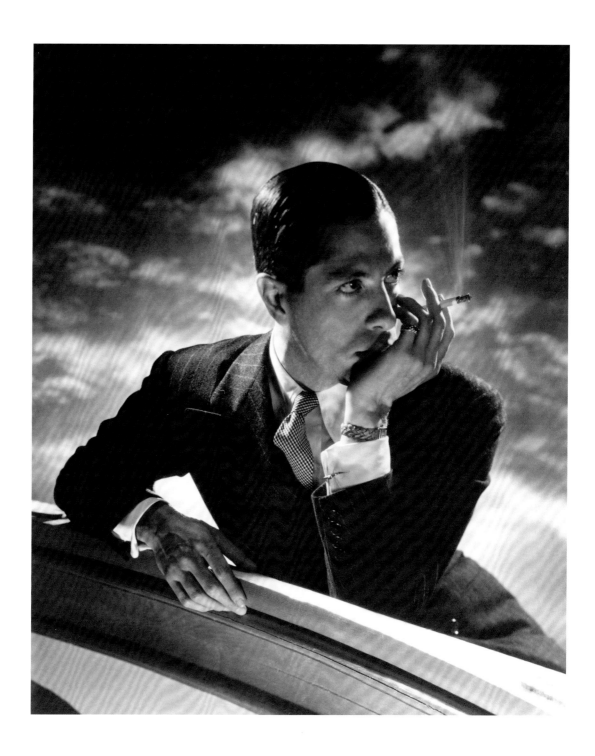

Baron Niki de Gunzburg, 1934

Above The impossibly elegant man-about-town Baron Niki de Gunzburg (here perfectly captured by glamour photographer Horst P. Horst) came to America from France in 1934 after starring in Carl Dreyer's classic 1932 film *Vampyr*. For the next 40 years he worked as an editor at *Town and Country*, *Vogue*, and *Harper's Bazaar*.

Duckie Brown, 2009

Opposite Luigi Tadini of *Paper* magazine called this line, designed by Steven Cox and Daniel Silver, a bit of Europe by way of Brooklyn: "Gstaad—that is if the ski lift had been transferred to Bedford Avenue." Here, a 21st-century dandy is dressed for spring's uncertain weather in high-gloss synthetics.

Tom Wolfe, 1998

Previous pages, left Tom Wolfe, author of *Bonfire of the Vanities* and a blatant dandy since the 1960s, wears his signature white suit on the cover of *Time*. (White homburg and kid gloves optional.)

Geoffrey Beene, 1990

Previous pages, right Innovative women's wear designer Geoffrey Beene played it safe when it came to menwear, as seen in this striped dress shirt with contrasting white collar and paisley tie.

Jeffrey Banks, 1984

Following pages This elegant (and elegantly photographed) tribute to summers of yore—and to classic literature—shows the importance of being earnest—Hemingway, that is.

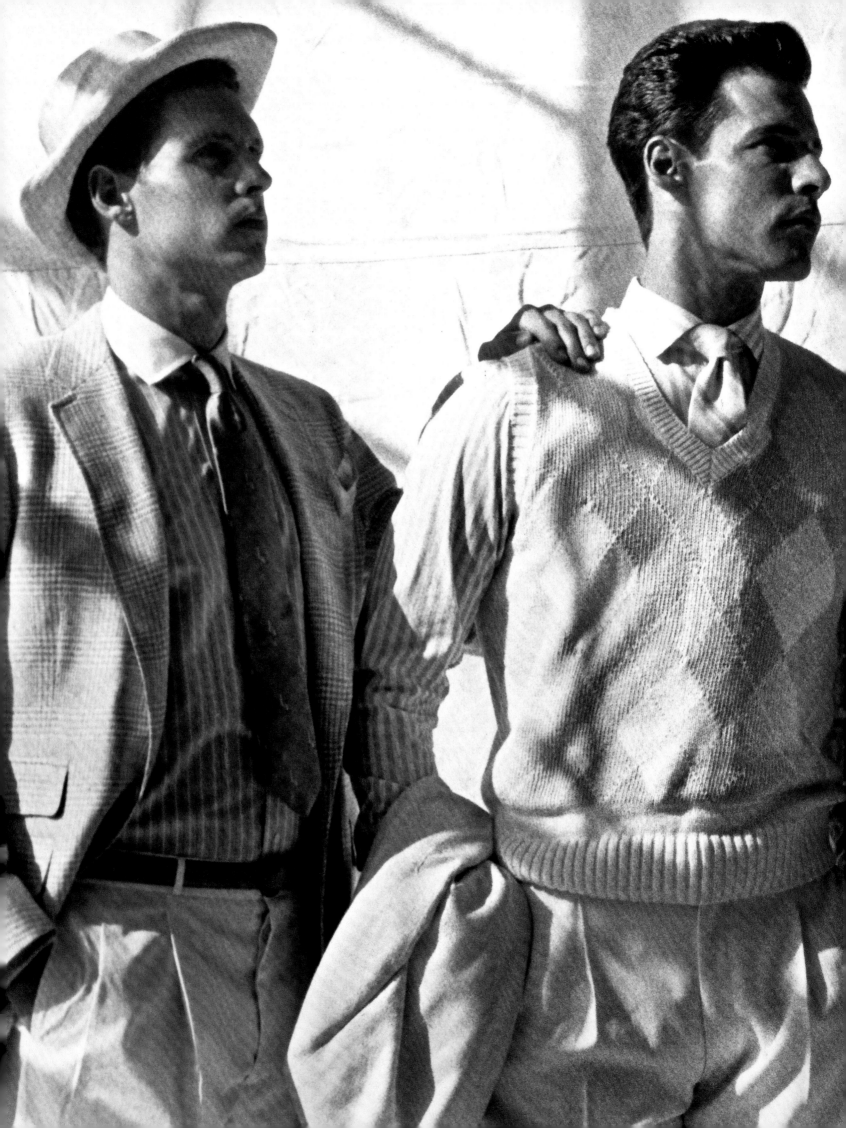

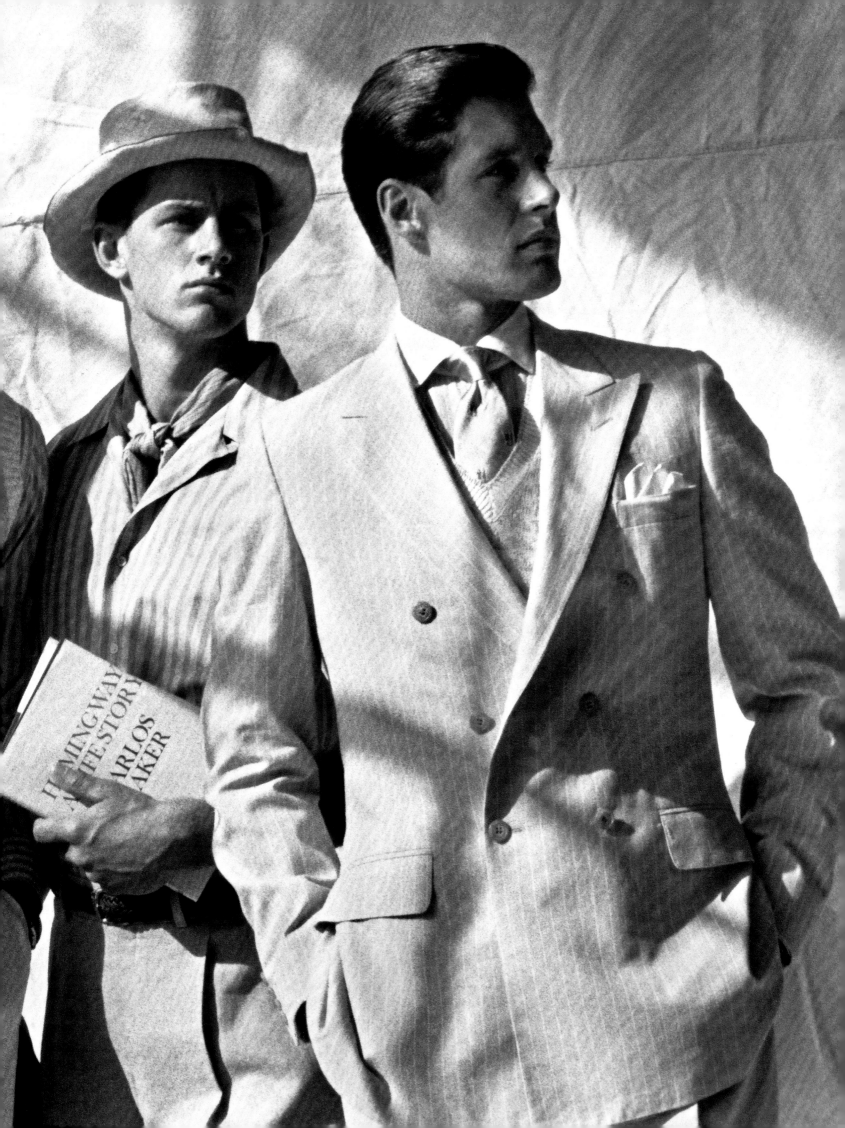

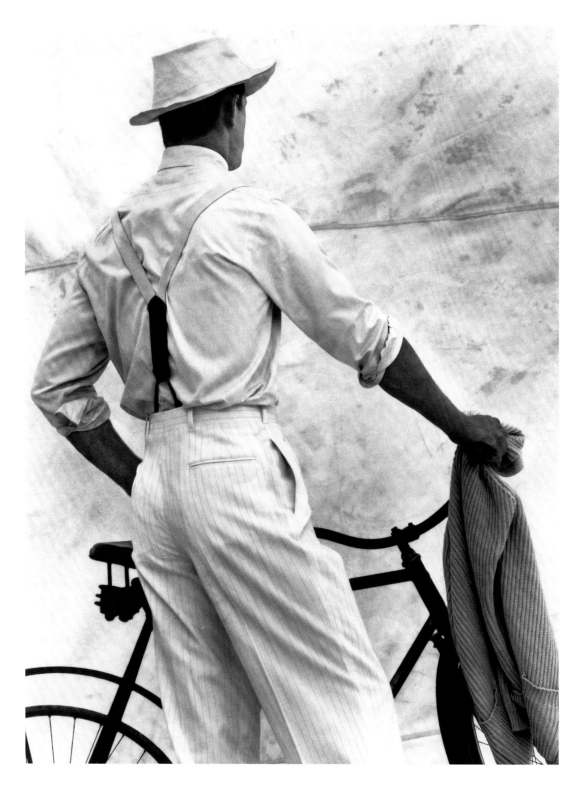

Jeffrey Banks, 1984

Above Cycling goes "old school" with striped flannel high-waisted trousers and braces.

Ralph Lauren, 1974

Opposite The Oscar-winning costumes for the 1974 film of F. Scott Fitzgerald's *Great Gatsby* included a full Ralph Lauren wardrobe for Robert Redford, thus exposing the up-and-coming designer to a wider audience. In this portrait, Redford is dressed for his title role as that great dandy of American literature, Jay Gatsby.

Thom Browne, 2008

Following pages, left What cutting-edge dandy wouldn't covet a Thom Browne tuxedo covered in linen rosettes?

Tim Hamilton, 2009

Following pages, center This modern bike messenger, a pastiche of past and present, zippered from top to toe, has a flair for the dramatic.

Robert Geller, 2009

Following pages, right A stark black ensemble with a white scarf and elbow-length leather gloves—one part Hells Angel, one part Lord Byron—unites history's iconic dandies with future generations.

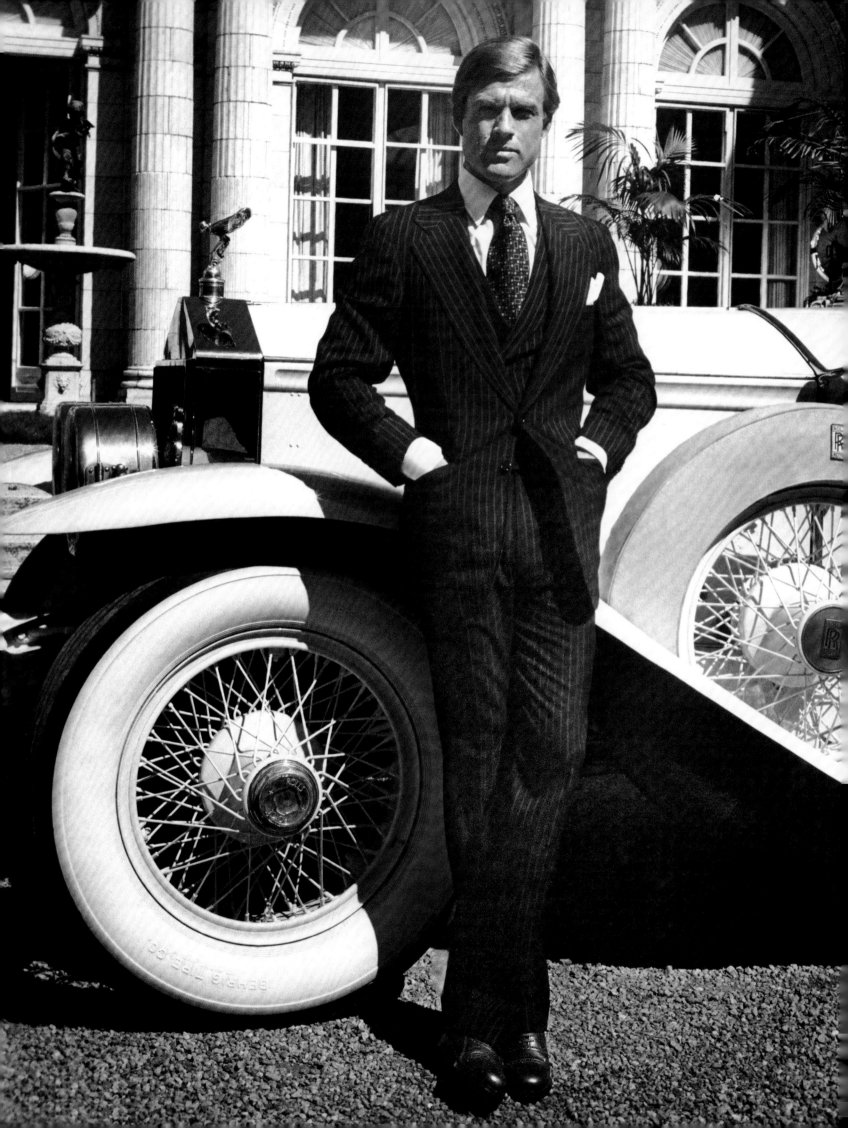

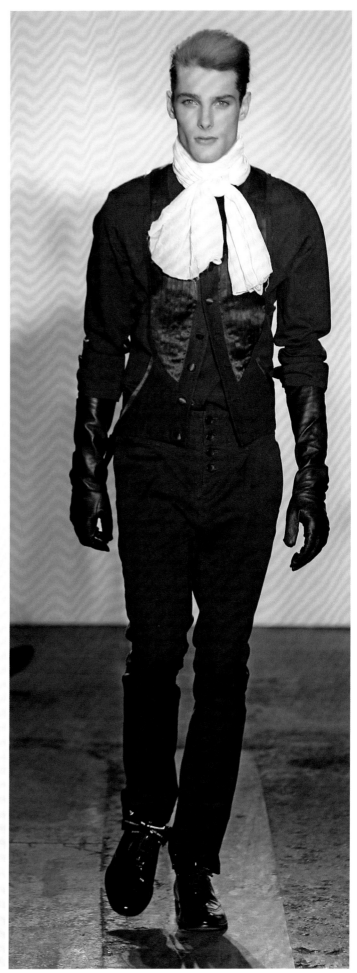

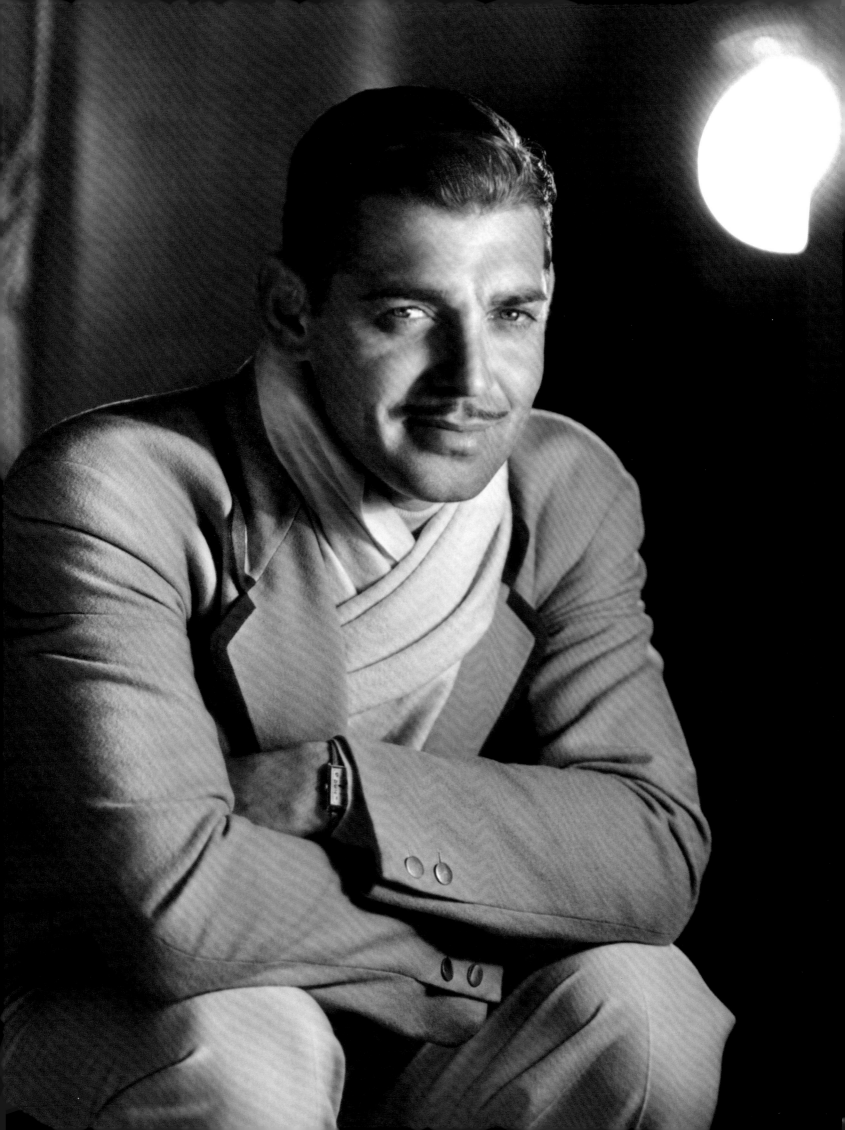

Hollywood

{ *America's greatest film stars brought glamour and panache to their roles on-and offscreen.*

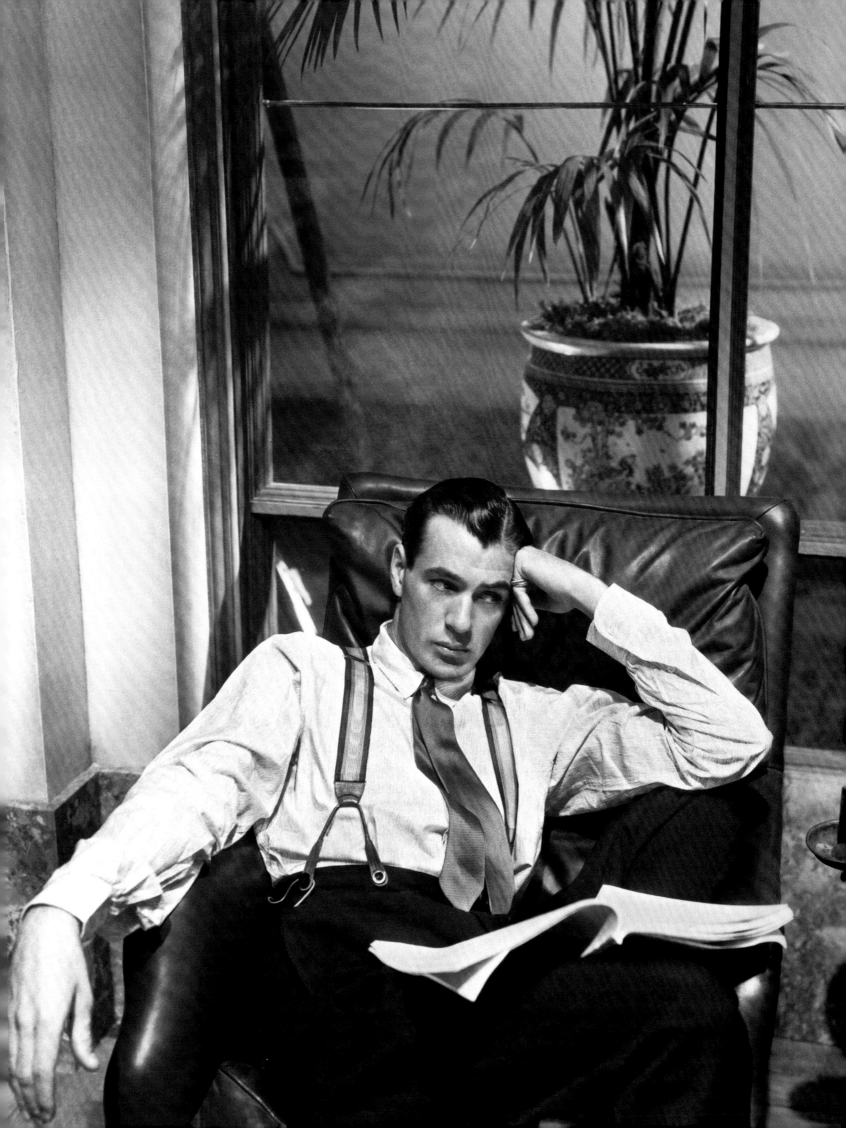

STAR POWER

Hollywood legend has it that when Clark Gable removed his shirt to expose a bare chest in the 1934 film *It Happened One Night*, undershirt sales fell precipitously and didn't recover for nearly two decades. But here's the rest of the story: roughly twenty years later, Marlon Brando boosted modern masculine attire by flaunting a simple T-shirt in *A Streetcar Named Desire* (1951). The movies giveth and the movies taketh away, at least where underwear makers are concerned. Of course, this process is rarely so clear-cut. Is it art imitating life, life imitating art, or a combination of the two? Perhaps men were already growing tired of undershirts, and Gable gave them permission not to wear them; perhaps the more casual postwar environment already permitted body-revealing T-shirts, and Brando merely became their icon.

As much as clothes can influence a film and its audience, it takes the charisma of the star wearing them and the strength of the character he plays to seal the deal. When men rushed out to buy brown-felt fedoras after seeing *Raiders of the Lost Ark* (1981), it wasn't because of the hat itself— it's a bit generic—but because they wanted to be Harrison Ford's adventurer, Indiana Jones. As appealing as Tom Ford's clothes are in the 2008 James Bond film *Quantum of Solace*, it is the debonair Daniel Craig who powers their high-voltage appeal.

These magnetic characters, the stars who play them, and the clothes they wear can be divided into roughly two types, the fashion plate and the fashion rebel. Fashion plates have upheld, through the years, society's standards of how a well-dressed man should look. From Cary Grant and Gene Kelly to Steve McQueen, right on up to George Clooney, and yes, Daniel Craig, they look great both on- and offscreen. The more provocative personalities are the fashion rebels who defy accepted dress codes, break new ground, and create excitement in the process.

Theirs are the fashion statements that still resonate, just as the subversive paintings of Jackson Pollock and Willem de Kooning resonate more than those of their realist contemporaries—

Gary Cooper, 1930s *Opposite* Gary Cooper was a true fashion plate and one of the leading trendsetters of early Hollywood. Here, he smolders in a relaxed—but perfectly posed—portrait, typical of the era. **Clark Gable, ca. 1930s** *Previous page* When both he and Hollywood were young, Clark Gable was known simply as The King. He brings a strong, masculine attitude to this classic Hollywood glamour portrait.

George Chakiris in the film *West Side Story*, 1961
Juvenile delinquency was a major concern in the 1950s, and *West Side Story*, a take on
Romeo and Juliet by directors Jerome Robbins and Frank Wise, revolves around
warring New York City gangs. George Chakiris (center) and his buddies demonstrate
Hollywood's fanciful version of street-gang style.

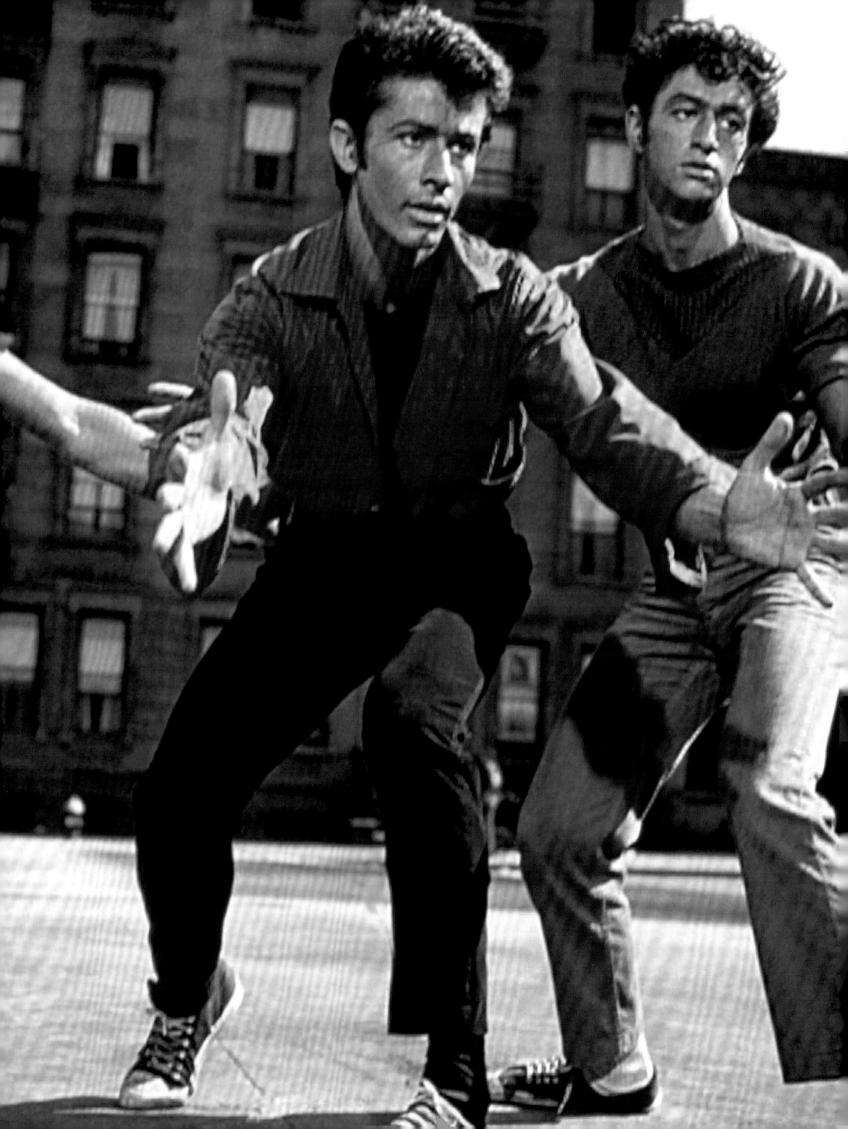

and just as radical designs resonate through the years (by Andrew Fezza and Perry Ellis in the eighties, John Bartlett and Gene Meyer in the nineties, and Duckie Brown and Thom Browne today), attracting attention by engendering controversy, making for shows everyone is anxious to see.

REBELS

The working-class rebels, including Sal Mineo in *Dino* (1957), James Dean in *Rebel Without a Cause* (1955), and especially Marlon Brando in *The Wild One* (1953)—which was so intense it was banned in Britain until 1968—disrupted the mannered, middle-class world of the 1950s while signaling the modern age of fashion. Brando, playing a Hells Angel, expressed their attitude by responding to the question "What are you rebelling against?" with an impudent "Whaddya got?" His style was equally brazen—a black leather motorcycle jacket, boots, a cap, a white T-shirt, and jeans. He was a macho role model for the ages, dressed more for sex than success.

Proletarian antiheroes have continued to make fashion statements (many of which start with jeans) through the years, from Peter Fonda dressed in an American-flag-appliquéd leather jacket, a gauze shirt, jeans, and sandals for the definitive hippie road-trip film *Easy Rider* (1969) to the rugged, all-American plaids and parkas of the 1978 film *Deer Hunter* (which looks, in retrospect, like a preview of the Fall 2008 collections). Later, *The Outsiders* (1983) trotted out a remarkable cast of future stars, including Tom Cruise, Matt Dillon, and Rob Lowe, in classic rebel chic: leather jackets, jeans, and T-shirts.

The gangster, on the other hand, is a rebel with a cause: namely, looking suave while getting rich. Early on, his double-breasted suits had bolder stripes, broader shoulders, and more defined waists than other men's. He accessorized them with ungentlemanly black shirts and flashy ties, in a garish caricature of his lawful counterpart, the Wall Street banker. These brash racketeers burst on the scene (both in the movies and in reality) in the early 1930s, impersonated by the likes of Jimmy Cagney, Edward G. Robinson, and George Raft, the sharpest of all. From his first major role in Howard Hawks's *Scarface* (1932), Raft was the tough guy who dressed with a touch of class. He was not above wearing a diamond stickpin or a boutonniere in his peak lapel. The Chicago mob boss Al Capone was said to emulate his style, while Raft was rumored to have real-life friends in the underworld, including the Las Vegas pioneer Bugsy Siegel (himself later the subject of the fashionable 1991 film *Bugsy*, starring a natty Warren Beatty).

Through the years, criminal characters have continued to burn up the screen, creating trends along the way. Faye Dunaway and a younger Beatty, in *Bonnie and Clyde* (1968), sparked a major 1930s revival. Robert De Niro, Ray Liotta, and Joe Pesci wore shiny mohair suits and silver ties as midcentury sharpies in *Goodfellas* (1990). And in 1992, the cool urban crooks of *Reservoir Dogs* appeared in narrow-lapel black suits, white shirts, skinny black ties, and Ray-Ban Wayfarer sunglasses—essential attire for twenty-first-century hipsters everywhere.

When Mel Gibson starred in *Mad Max* (1979) as the first in a long line of futuristic rebels strutting their stuff in postapocalyptic danger zones, the world saw the influence of London's 1970s punk scene. Dressed to kill—literally—in head-to-toe reinforced black leather motorcycle gear (enough of it to make Brando's Wild One look like a sissy), Gibson battled a sinister punk tribe for gasoline in a barren wasteland of tomorrow. Black leather reappeared in the sci-fi thriller *The Matrix* (1999) in dramatic, full-length topcoats worn by the protagonists Laurence Fishburne and Keanu Reeves as they navigated a high-tech alternate world. In *I Am Legend* (2008), set in the near future of 2012, Will Smith dressed for war in a black and gray military-inspired outfit. He could as easily have walked the Fall 2009 runways. That's typical; most science fiction says more about contemporary style than any future form of dress.

The rarest and most extraordinary rebel may be the "dude," who flaunts the extreme fashions of his day to a conventionally attired world. The dude shone brightest in the blaxploitation films *Shaft* (1971) and *Superfly* (1972). As Shaft and Priest, respectively, Richard Roundtree and Ron O'Neal modeled a boldly theatrical look widely called pimp style. Like the adventurous souls who dressed in zoot suits in the early forties (Cab Calloway epitomized the look in the 1943 film *Stormy Weather*), they wore black pride on their backs for all the world to see. In Edwardian-style maxi coats with oversize collars, polyester bell bottoms, broad-brimmed fedoras, and platform shoes, and sporting silver-tipped canes, they were hard to ignore.

Warren Beatty's hairdresser character in *Shampoo* (1975), a dude among dudes, pretends to be gay and then makes love to every woman in sight. The film is set in 1968, but Beatty's bold fashion statements are pure seventies hippie-chic. Touring Beverly Hills on a Triumph motorcycle in jeans and a cropped leather jacket, with a bouffant hairdo, aviator sunglasses, a flowing scarf, and multiple rings and bracelets, he defined an era. John Travolta in *Saturday Night Fever* (1977) did the same for the East Coast's disco scene. As Tony Manero, he single-handedly created a vogue for white polyester suits with flamboyantly flared pants, accessorized by black shirts, gold chain

necklaces, and chest hair. While some may deride his Brooklyn-based style as "pimp lite," when Tony swaggers onto the dance floor of 2001 Odyssey to the beat of a Bee Gees song, illuminated by a glittering disco ball, you can forgive almost anything. (Note to disco fans: This is by no stretch of the imagination the way that the chic revelers at Studio 54 dressed.)

FASHION PLATES

As effective as the rebels' methods of shock and awe may be, there are other ways for a man to make a fashionable impression—chiefly, by being so well dressed that no one can help but notice. A fashion plate, always picture-perfect, can reenergize vintage styles in period movies, spur new trends by wearing the latest looks in contemporary films, or make his mark simply by walking the red carpet in drop-dead gorgeous designer clothes.

The golden age of the fashion plate's influence was the period between the two world wars, before television, before rock (and long before the Internet). In a sense, the impeccably attired fashion plates of that period were rebels, too, although, from our distant perspective, their debonair, democratic rebellion is not nearly so obvious as James Dean's. They crafted a truly original blend of Anglo and American styles, casually elegant and totally nonchalant, which continues to inspire designers today, from Sal Cesarani and Alan Flusser to Joseph Abboud and Ralph Lauren.

The influence of the cinema during the 1930s is not surprising when you consider that more than half of all Americans went to the movies every week, escaping from the Depression into a star-studded world of fashion and fantasy. Beyond the movies themselves, there were the studio publicity machines, distributing glamorous photographs of the stars by the leading Hollywood image-makers of the day, Edward Steichen, George Hurrell, and Horst P. Horst (whose career lasted long enough for him to shoot dramatic ads for Calvin Klein in the 1980s). They glorified their subjects' dapper style in everything from tennis whites to white tie and tails for publication in dozens of movie magazines, as well as more sophisticated titles like *Vanity Fair*. In a 1938 issue of *Apparel Arts* magazine, an article entitled "The Hollywood Halo" describes "the Pied Pipers of Hollywood"—Clark Gable, Gary Cooper, Cary Grant, and Robert Taylor—as the stars who led men across the country into new fashions, boosting retail business everywhere.

As beautifully bedecked as those matinee idols were, today Fred Astaire is most often cited as the best-dressed man of the era—a fellow whose screen test was curtly summarized, "Can't act. Slightly bald. Also dances." The reviewer failed to notice the style, grace, and charm that would

Paul Newman in the film *Pocket Money*, 1972 *Opposite* By the 1970s, Hollywood glamour was out and a more gritty sensibility was in, as this manly shot of Paul Newman shows.

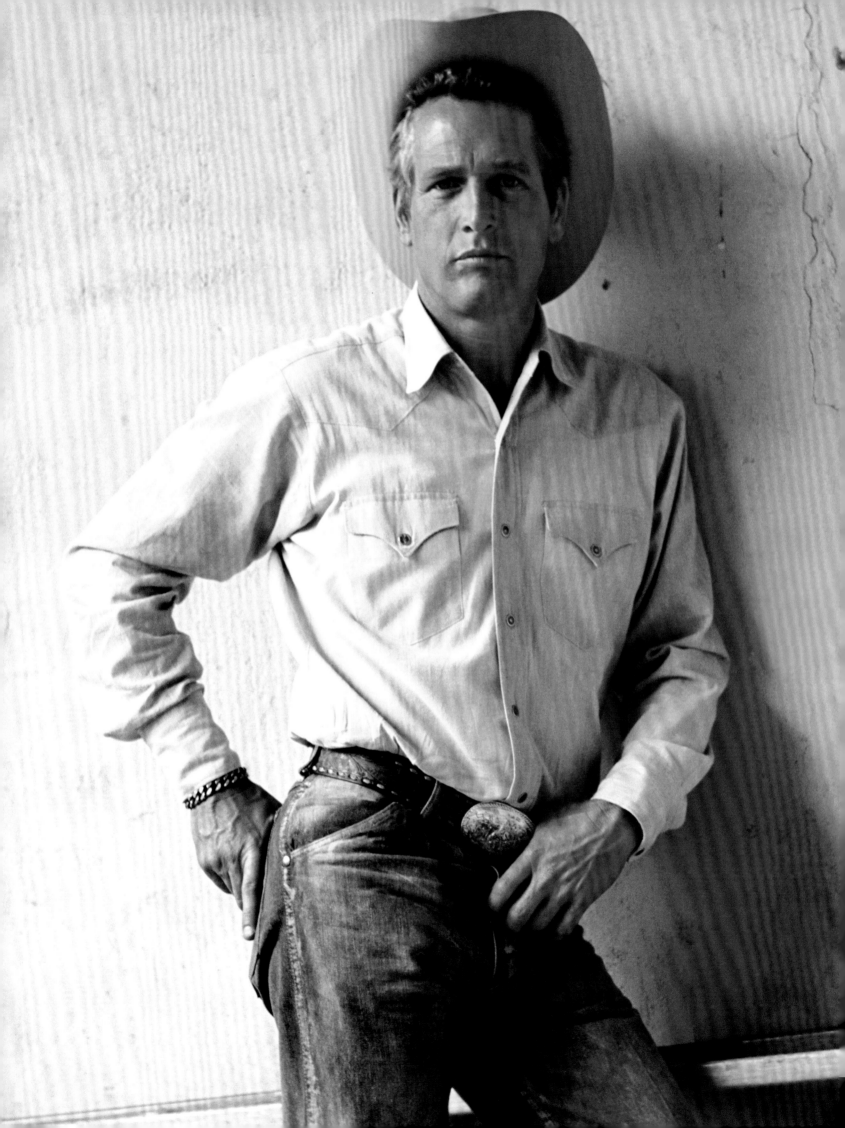

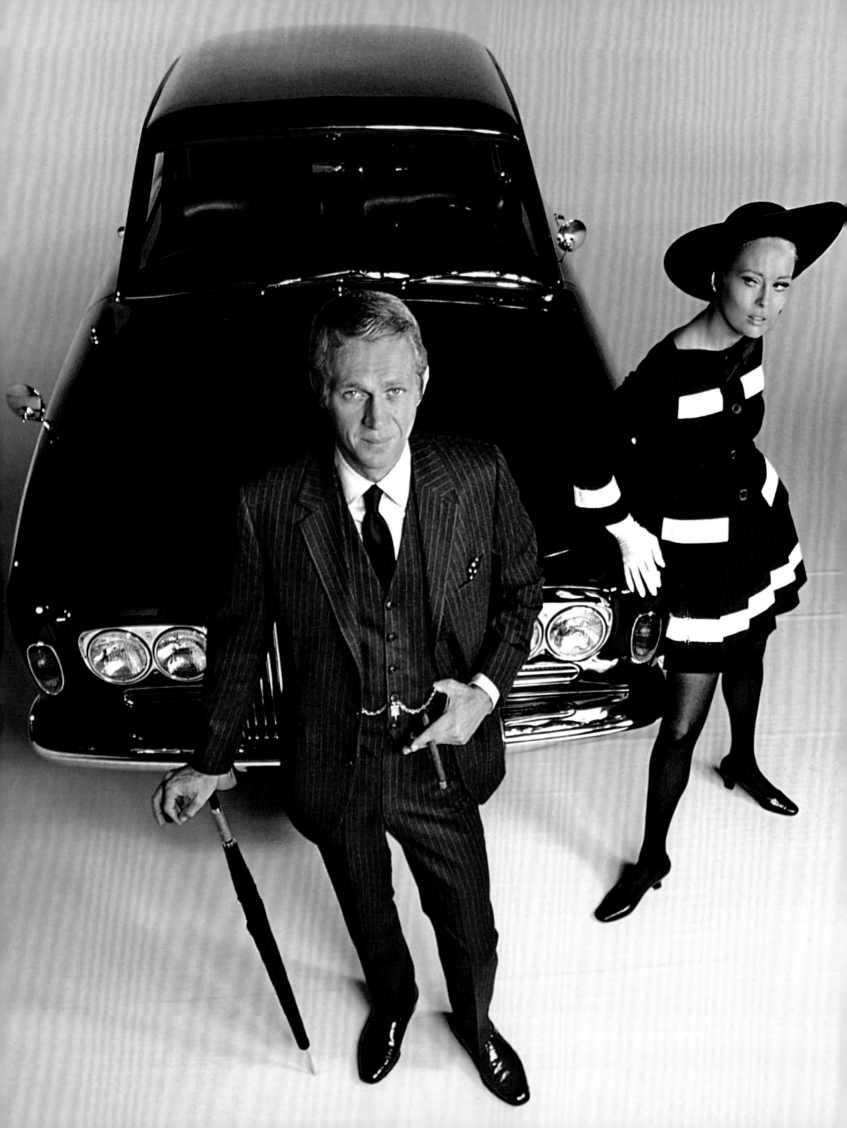

shine through in all of Astaire's movies, whether he was playing a dancer in 1935's *Top Hat* (the source of his signature song, and frequent attire, "Top Hat, White Tie and Tails") or simply a gob on shore leave in *Follow The Fleet* (1936).

Like other male stars of the era, Astaire sometimes wore his own clothes on-screen. An admirer of Edward, Prince of Wales, he had his suits custom-made in London, often by Edward's favorite tailors, Anderson & Sheppard. He was also a regular customer at Brooks Brothers, especially for their rep-stripe ties, which he nonchalantly tied around his waist. Comfort and maximal ease of movement were essential in his clothing, which is why (it's rumored) he softened his jackets by repeatedly throwing them against the wall—certainly more invigorating than the old method of having your valet break them in first. But whether in shirtsleeves or his ubiquitous tails, he moved with such facility that, like his fellow dancer Gene Kelly, he may well have been clothed in nothing more than a polo shirt and chinos.

Kelly, more than any actor of the postwar era, defined America's new casual and carefree style. He famously remarked—sounding just like a smoldering rebel—that "I didn't want to move or act like a rich man. I wanted to dance in a pair of jeans." The jaunty sports clothes and cocked baseball cap he wore as a painter in *An American in Paris* (1951) could as readily appear on any street today. Whether he was lounging on a piano in an open sport shirt, a white tank top, and rolled-up, ankle-length chinos; romancing Leslie Caron beside the Seine in a teal V-necked sweater and a crisp white shirt (sleeves stylishly pushed up); or dancing an elaborately staged production number in only a black polo, cropped black pants (the better to see his white socks), and penny loafers, his look was spotlessly informal and perfectly unpretentious.

Cary Grant, another star who often wore his own clothes on-screen, set high sartorial standards in *The Philadelphia Story* (1940) and then very nearly topped them all in Hitchcock's *To Catch a Thief* (1955). Surely no cat burglar before or since has shown such continental flair, not even on the French Riviera. Throughout, Grant was equally immaculate in a midnight blue, shawl-collared tuxedo and in a casual, pearl gray sport coat and white shirt, with the ascot that defined his character's style. George Clooney, the only comparable figure today, wore something very like that last ensemble in *Ocean's Eleven* (2001), although, alas, without the ascot.

Ten years after Grant's Riviera exploits, at the height of the hippie revolution, Steve McQueen showed that men could still dress like sophisticated adults—it made him an inspiration to

Steve McQueen, 1965 *Opposite* Whether he was racing his motorcycle in a leather jacket and jeans or posed with a Rolls-Royce in a well-tailored suit and tie, Steve McQueen was the epitome of supercool masculine chic.

grown-ups everywhere, then and now. The point is perhaps best demonstrated in 1968's *The Thomas Crown Affair* (1968), about a crooked millionaire playboy, virtually an American Bond. Along with a steady stream of action, it provides an endless array of great men's styles, from a black turtleneck and wheat-colored jeans to a dapper three-piece suit with a gold watch chain, and the requisite tuxedo. Really, it offers a complete runway collection, but its biggest accomplishment is still McQueen's, putting a totally modern spin on the best of old-style Hollywood.

As leading men's costumes and personal wardrobes have diverged, some films have made fashion statements more important than their stars. And some stars have made turns on the red carpet more influential than their films. *Wall Street* (1987) gave the homegrown designer Alan Flusser a chance to show just how great a ruthless, cigar-smoking capitalist could look in a splendid drape-cut, double-breasted suit. Unfortunately, the recession that began that year made it difficult for real Wall Street traders to equal Michael Douglas's extravagant style (let alone his character Gordon Gekko's "greed is good" philosophy), at least until the 1990s. *American Psycho* (1999) can be seen as an addendum to *Wall Street*; set in the late eighties, it takes an even darker, though no less stylish, view of the stock-trading world. Christian Bale, as the flawlessly dressed and groomed banker Patrick Bateman, demonstrates that a man can be a psychotic serial killer by night and the ultimate metrosexual by day. Some may ask which is more terrifying.

If *American Psycho*, made in the late nineties about the previous decade, is in some ways a period movie, it's in good company. Historical film settings had meant little to fashion until the 1950s—after all, there wasn't much chance of reviving Roman armor or Louis XV brocades—but when the history in question became more recent and more approachable, like the elegant 1920s world of *The Great Gatsby* (1974), designers such as Ralph Lauren could make quite an impression. Theoni V. Aldredge may have received the Academy Award for costume design, but Lauren's contribution to the film's sartorial dream went a long way toward establishing him as the world-class designer he is today.

The 1950s have their share of film tributes, too, even beyond teenage rock-and-roll movies such as *American Graffiti* (1973) and *Grease* (1978). The era's more sophisticated side has been beautifully realized in films such as *Purple Noon* (1960), starring Alain Delon, and in its American period remake, *The Talented Mr. Ripley* (1999). Watching Jude Law lounging on the Italian Riviera in elegant fifties resortwear, it's easy to see why the film won an Oscar for costume design. We've also seen seventies and eighties fashions revived in films such as *Boogie Nights* (1997), but they

are more often played for laughs than inspiration. Case in point: when porn star Dirk Diggler (Mark Wahlberg) is complimented on his groovy shirt, he proudly replies, "Yeah, well, this is imported Italian nylon."

In what can seem like a revival of the Depression-era movie-magazine craze, today there is ever more written and broadcast about whose clothes stars are wearing, both on and off the red carpet. While actresses in extravagant gowns frequently steal the spotlight, the actors also know they're being watched. So, too, do designers like Tom Ford, John Varvatos, and Giorgio Armani, who compete each season for the right to dress both presenters and prospective winners at awards shows. And so do stylists, who, for good or ill, work with more and more actors.

Two stars who clearly dress themselves—and who stand out from the crowd—bring the enduring archetypes of the fashion plate and the rebel up to the minute. Without a doubt, George Clooney is the fashion plate who does everything just right. In spite of his surprisingly spartan belief that "it is unmanly and unsexy if you always worry" too much about your looks, he's often described as having old Hollywood glamour and is regularly compared with golden-age stars like Gable and Grant. If he has a flaw, it's that his relentless perfection can get a bit monotonous.

Taking chances eventually lands most people in trouble (think Mickey Rourke), but for a rebel with real style, such as Johnny Depp, it can work. Depp can pull off almost any (but not quite every) look he creates, whether he's dressed like a 1940s gangster in a double-breasted pinstriped suit, a playboy in a perfect white dinner jacket, or a grungy homeboy in a knit cap and an oversize plaid flannel shirt. Whether an ensemble succeeds or fails, he keeps the public guessing about which devil-may-care attitude he'll next exploit to entertain his fans and, perhaps more important, himself.

Hollywood may not wield the iron-fisted influence it once did, but its reach is ever broader and more global. And as long as there are fashion plates and rebels to watch, audiences all over the world will watch both the picture and the credits, just to see who's wearing what.

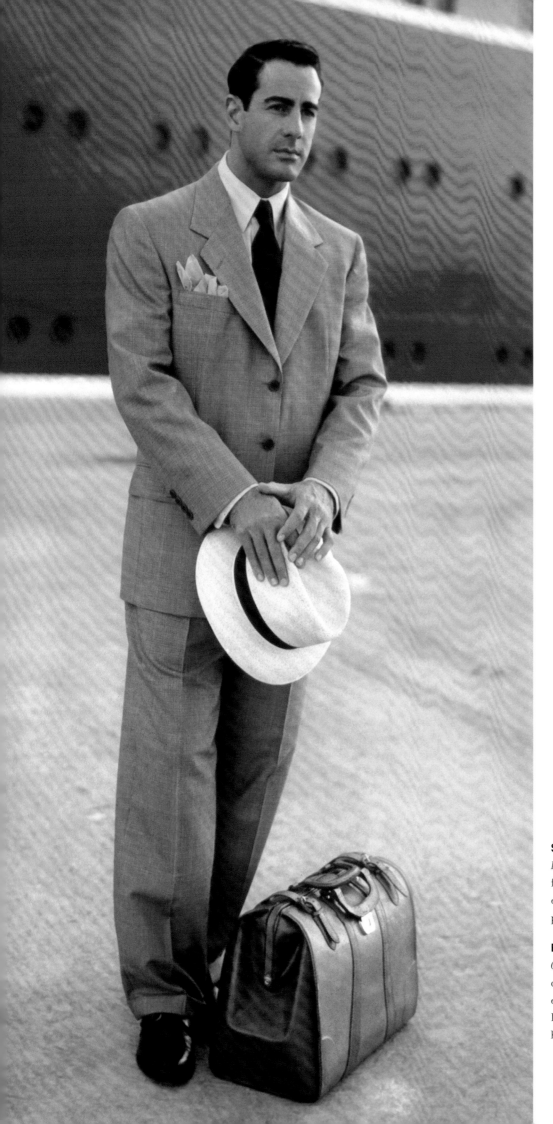

Sal Cesarani, 1997

Left Now boarding for classic lines with vintage flair: Sal Cesarani's midcentury movie look exudes both European elegance and American panache.

Rudolph Valentino, ca. 1920s

Opposite The great lover in such silent-era classics as *The Sheik* (1921), Rudolph Valentino exemplified the highly polished style of Hollywood in the 1920s, from his brilliantined hair to his peak-lapel suits.

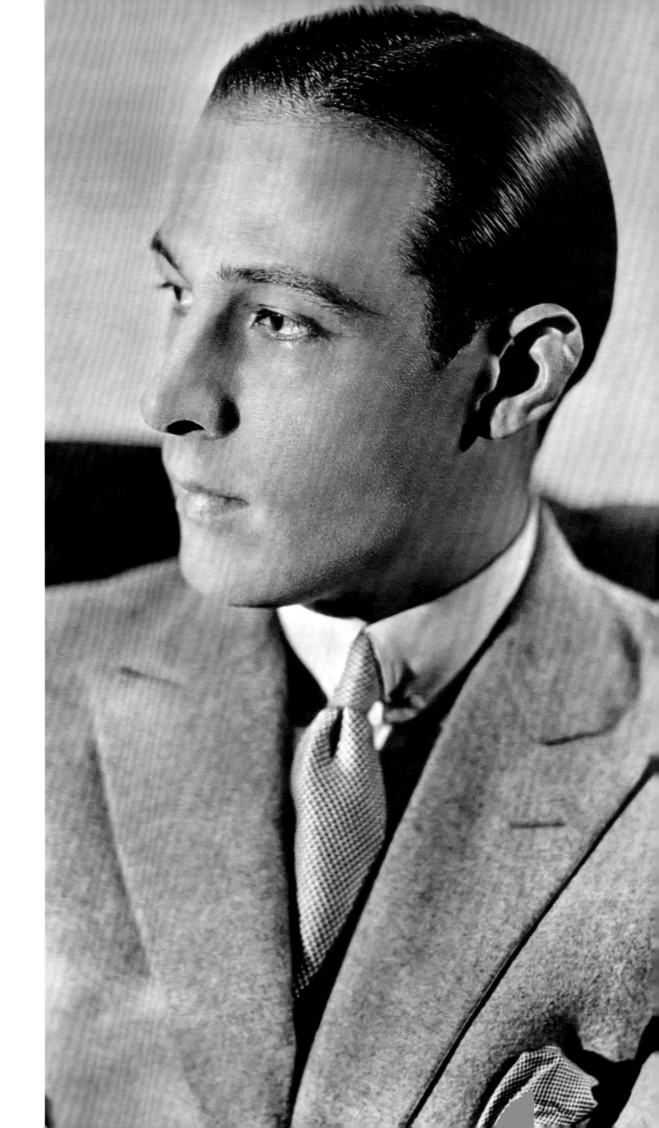

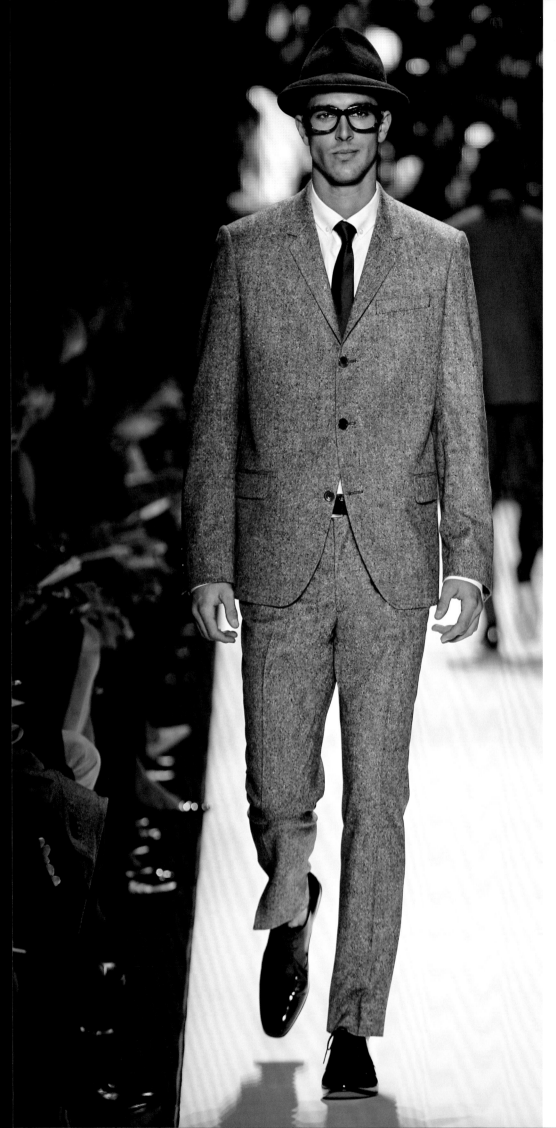

Michael Kors, 2008

Left The three-button suits, slim ties, felt fedoras, and Clark Kent eyewear in Michael Kors's Fall 2008 collection evoke both *The Man in the Gray Flannel Suit* (1956) and the very contemporary television series *Mad Men.*

George Raft, 1939

Opposite Film star George Raft in a jaunty pose on board the French luxury liner *Normandie.* Raft epitomized gangster style both on and off the screen with his well-tailored, peaked-lapel, striped suits, always perfectly accessorized.

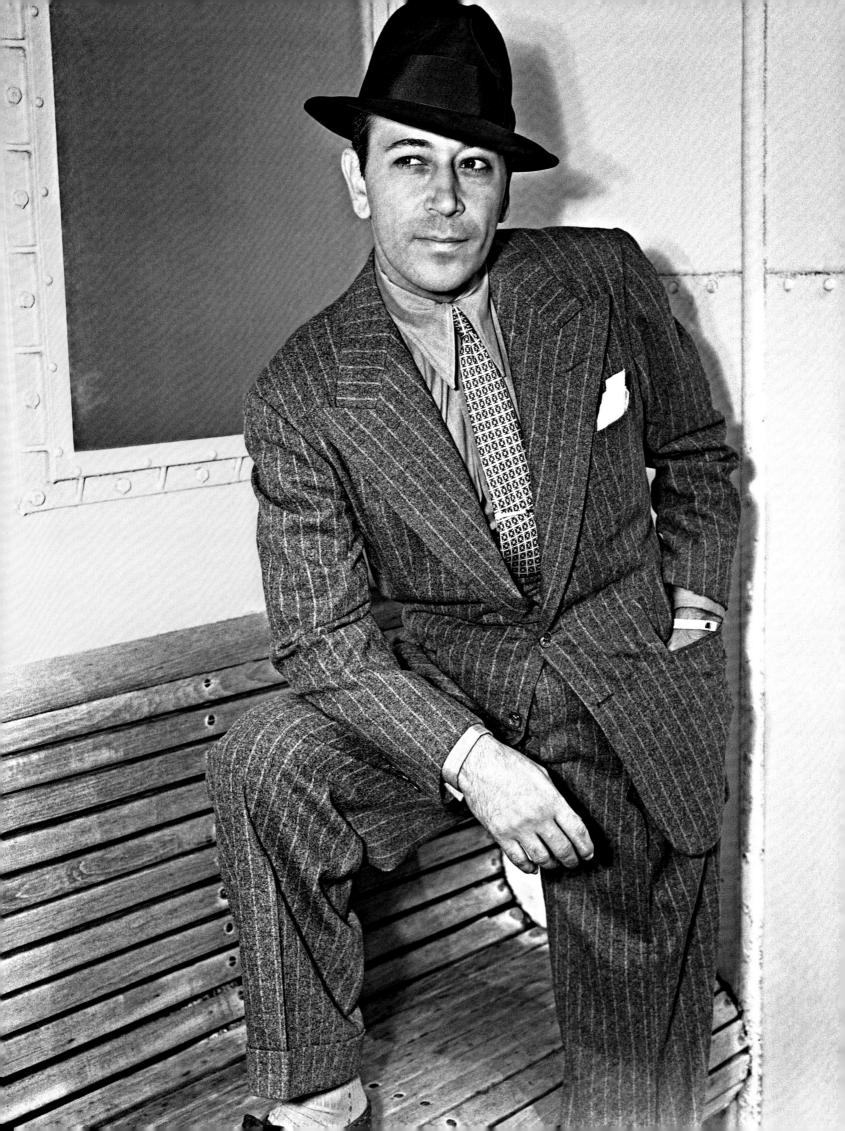

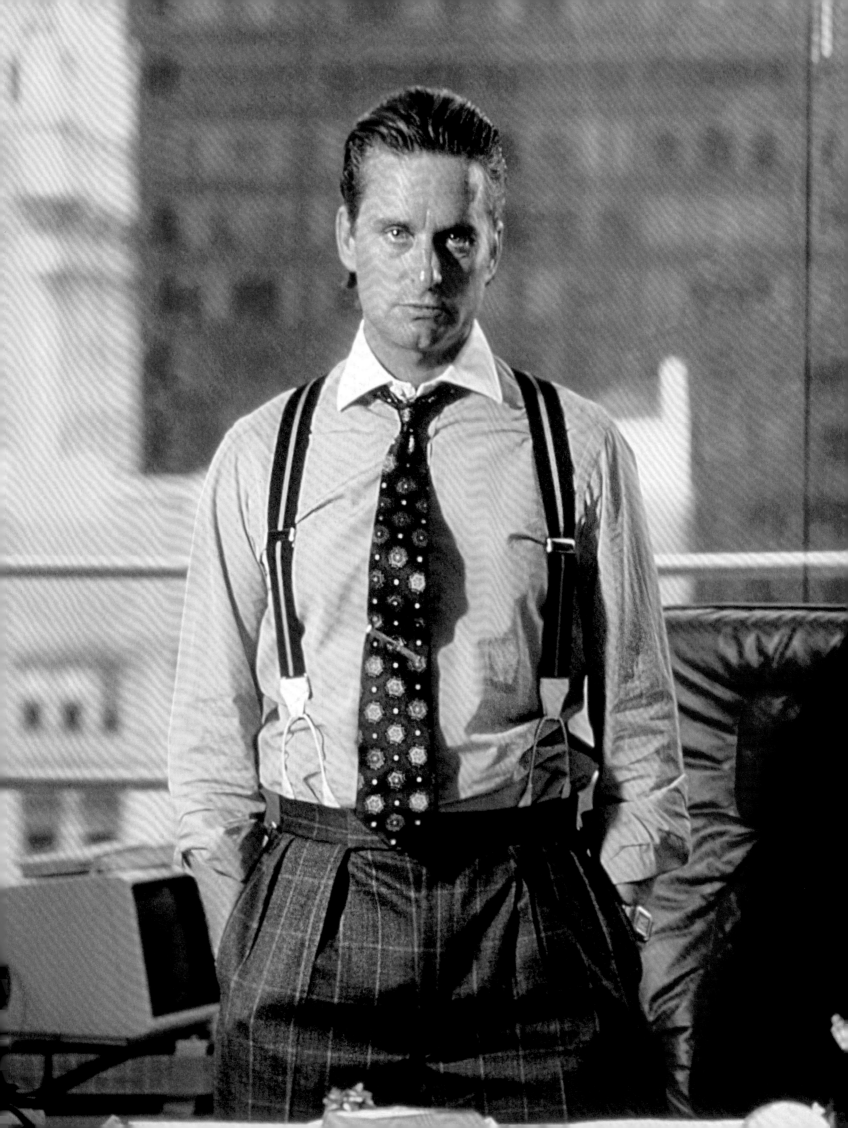

Band of Outsiders, 2008

Above Scott Sternberg is based in Los Angeles, in part because his first career was as a Hollywood agent. He used the straight-shooting actor John Dewis to bring a theatrical flair to this ensemble.

Alan Flusser, 1987

Opposite Michael Douglas's character in *Wall Street*, Gordon Gekko, was famous for two things: his "greed is good" philosophy and his dapper Alan Flusser power suits, worn with braces and white contrast-collar dress shirts.

Buckler for Andrew Buckler, 2008

Right For his Spring 2008 ad campaign, the cult designer Andrew Buckler created fog-shrouded spy-movie stills. His streamlined trench coat brings the scenario into the 21st century.

Cary Grant, 1943

Opposite One of Hollywood's greatest fashion icons wears an elegant glen plaid double-breasted suit, French cuffs, a collar bar, and a boutonniere with characteristic nonchalance.

Fred Astaire in the film *Silk Stockings*, 1957

Following pages, left These full, drape-cut, cuffed gray flannel trousers and brown suede shoes combined with that debonair pose suggest a man of great style and grace. And indeed it is Fred Astaire.

Gene Kelly, ca. 1945

Following pages, right Kelly, who was Astaire's opposite in many ways, danced his way through the 1940s and '50s in casually rolled sleeves and trousers. His unstudied, relaxed style made him a leader in America's shift toward more informal fashions.

Cynthia Rowley, 2000

Page 200 The dancer Mikhail Baryshnikov exudes style and sex appeal on- and offstage. He's seen here wearing a Cynthia Rowley sport shirt.

Tom Cruise in the film *Risky Business*, 1983

Page 201 Here, Cruise masters the casual crewneck sweater and tweed jacket and the Ray-Ban Wayfarer sunglasses that almost upstaged him in the movie.

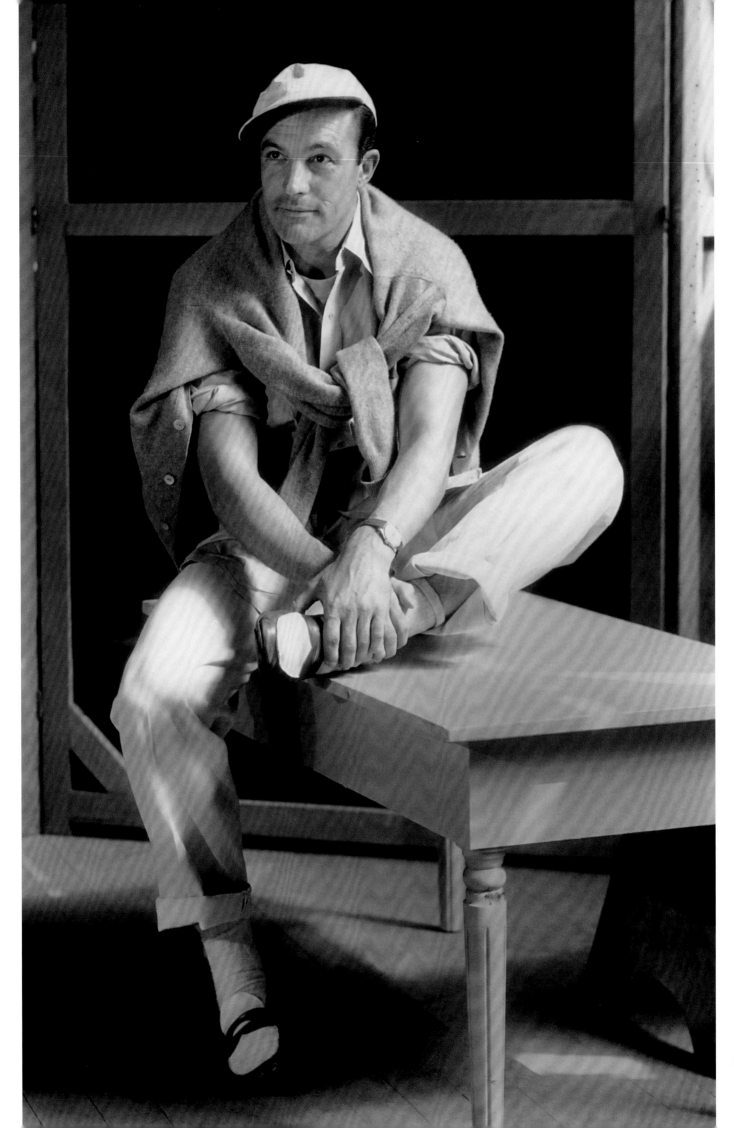

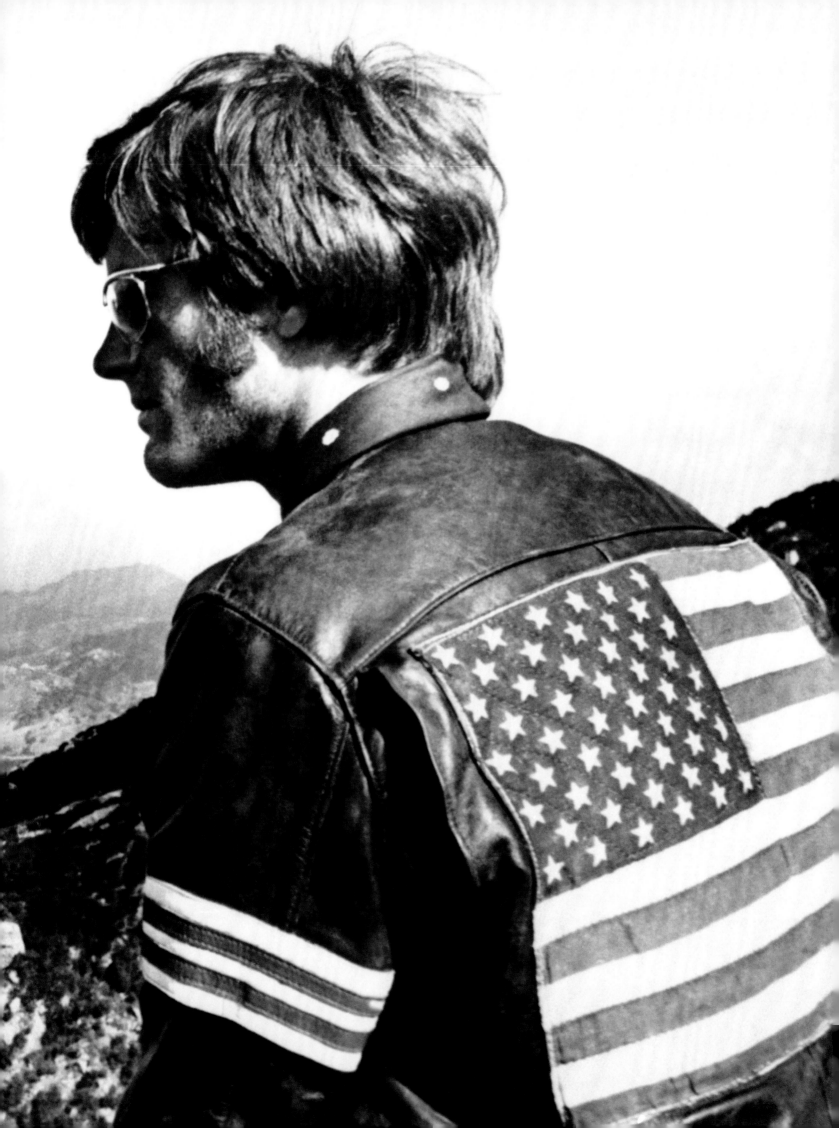

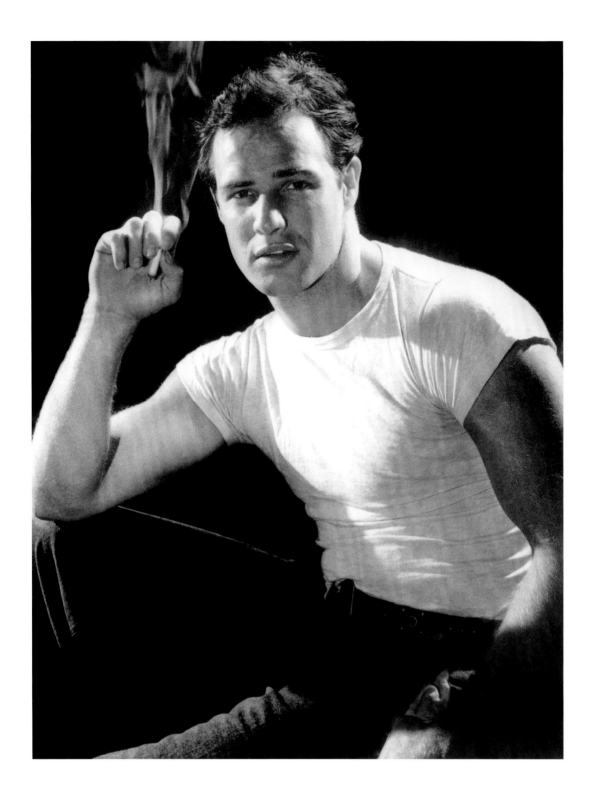

Marlon Brando in the film *A Streetcar Named Desire*, 1951

Above Stelllaaa! Marlon Brando created the role of the tight white T-shirt–wearing rebel Stanley Kowalski in both the stage and film versions of Tennessee Williams's *A Streetcar Named Desire*.

Buckler for Andrew Buckler, 2004

Opposite The actor Adrien Brody is equally at home in a black dress shirt and a tuxedo or in Andrew Buckler's Western shirt and jeans, worn here with the requisite hipster hat.

Peter Fonda in the film *Easy Rider*, 1969

Previous pages The rebels of the 1950s became the countercultural icons of the 1960s in *Easy Rider*, starring Peter Fonda in this iconic black leather jacket emblazoned with an American flag.

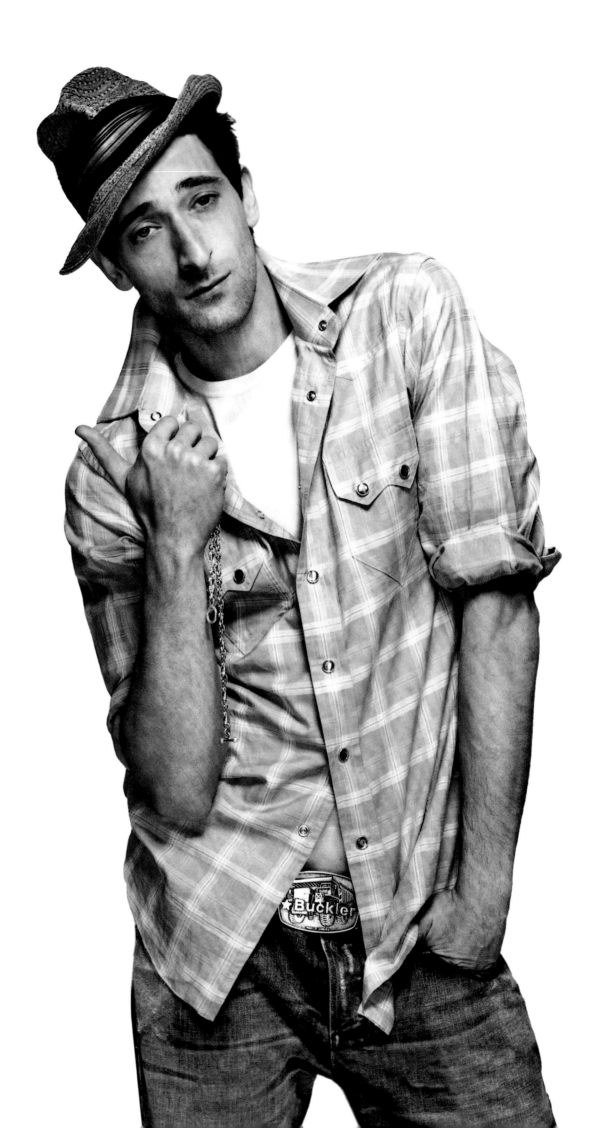

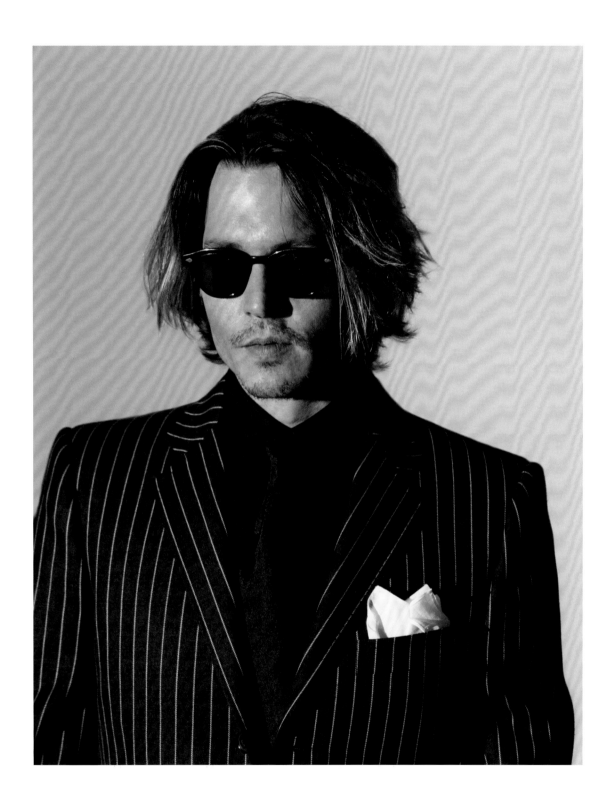

Johnny Depp, 2004

Above Johnny Depp has taken rebel wear into unexpected territory, paying homage to the sharply dressed gangster rebels of 1940s Hollywood.

Warren Beatty in the film *Shampoo*, 1975

Opposite In this film, Warren Beatty plays the rebel-as-hairdresser, with a foppish, hippie-chic style that puts Carrie Fisher, Julie Christie, and Goldie Hawn at his mercy.

Marc Jacobs, 2006

Following pages, left A pair of models in Hollywood-inspired clothing by Marc Jacobs. The designer continues to influence style on and off the red carpet.

Brad Pitt and George Clooney, 2007

Following pages, right Brad Pitt and George Clooney, icons of today's Hollywood royalty, looking casually chic at Grauman's Chinese Theatre. Both transform their sharp suits—Pitt with a T-shirt, and Clooney with a black open-collar shirt.

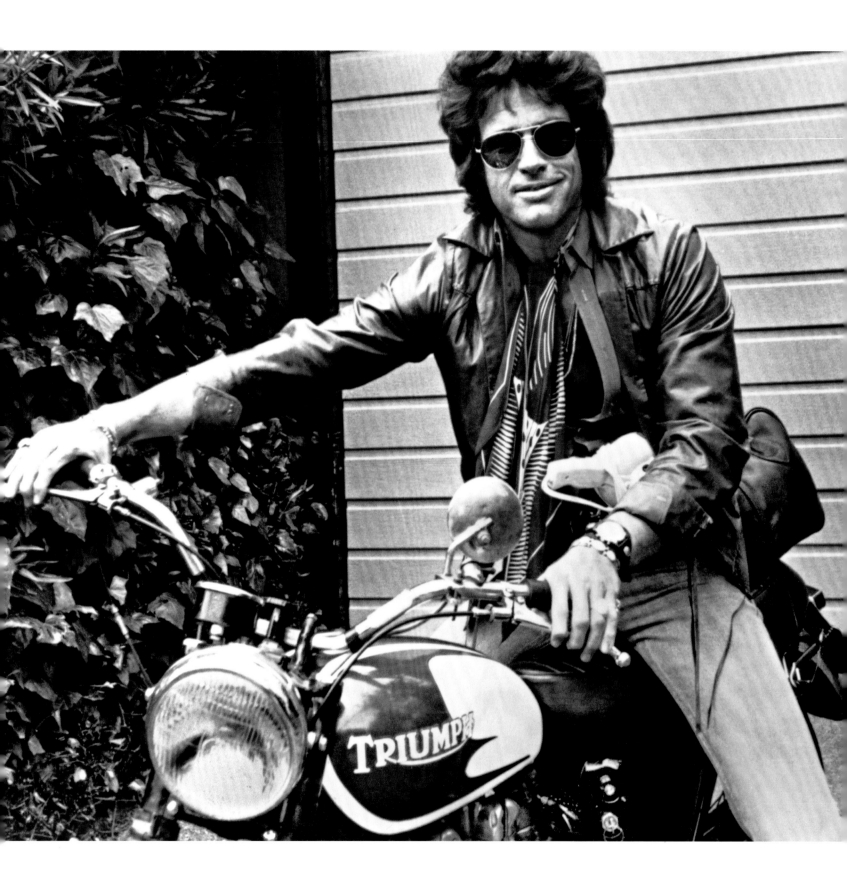

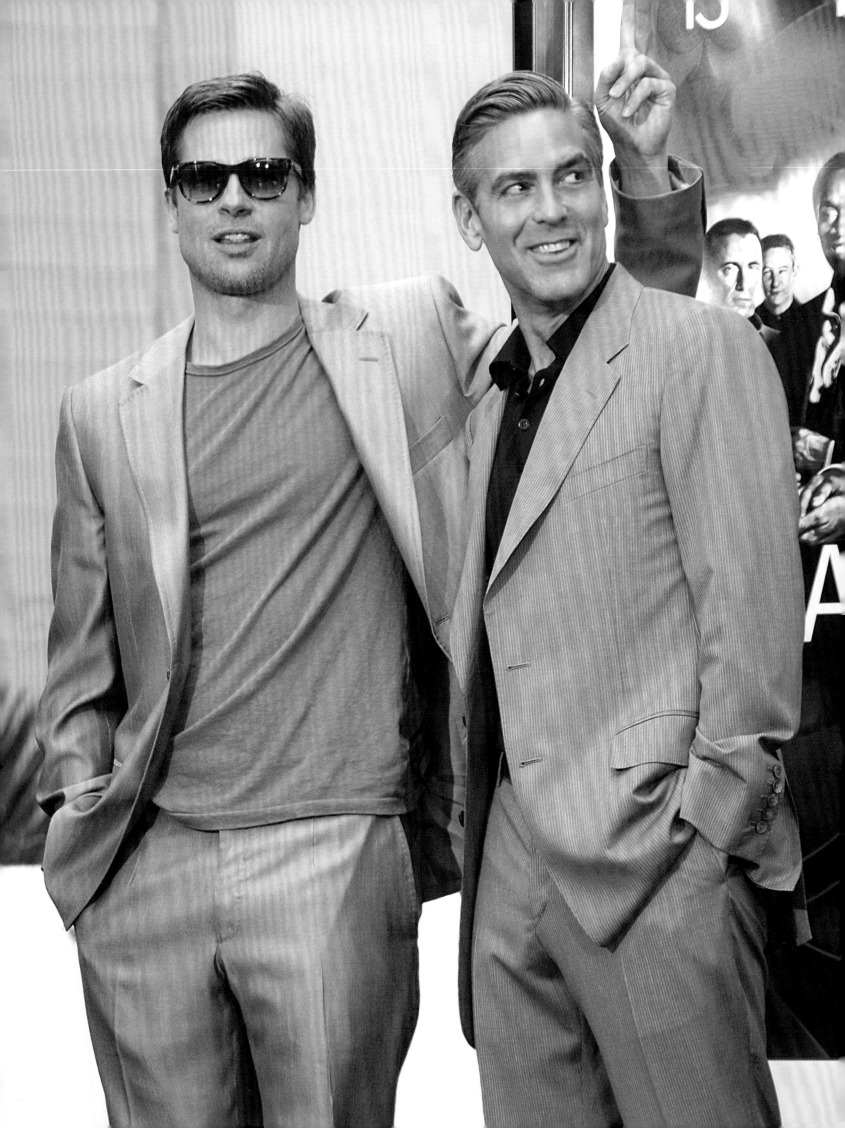

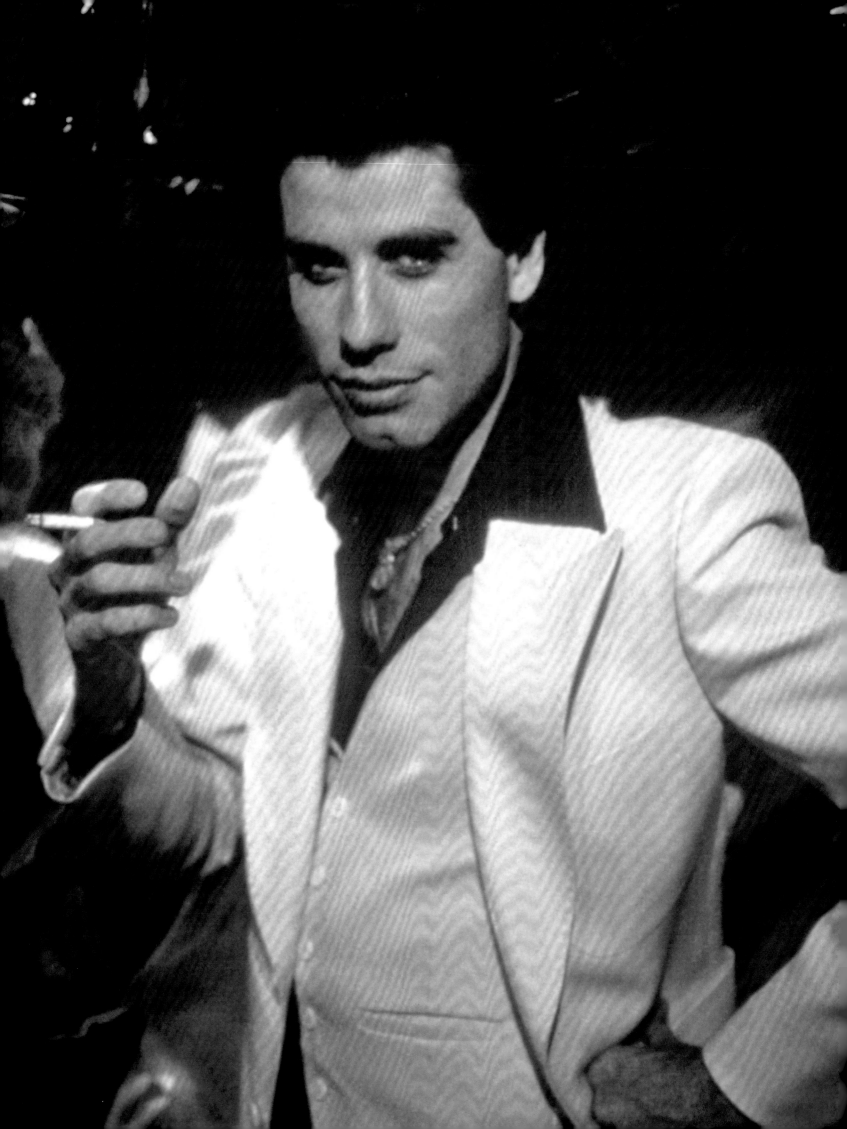

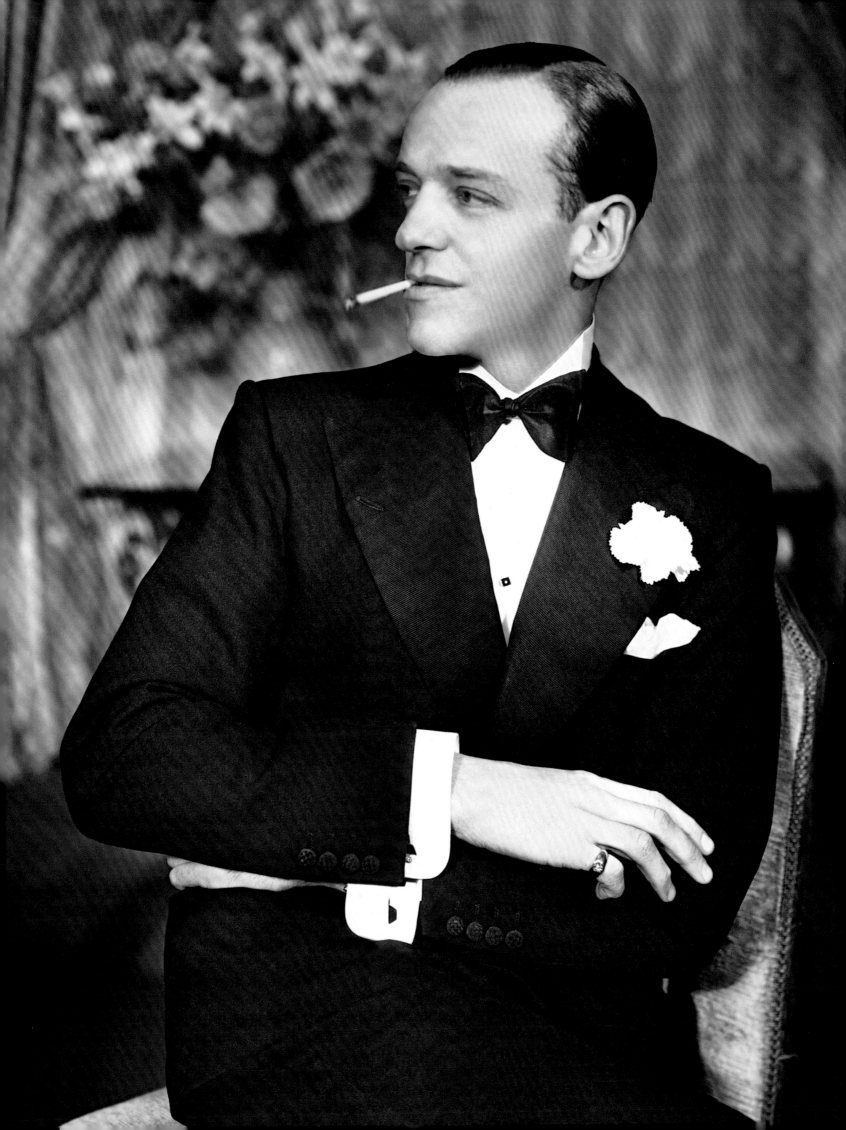

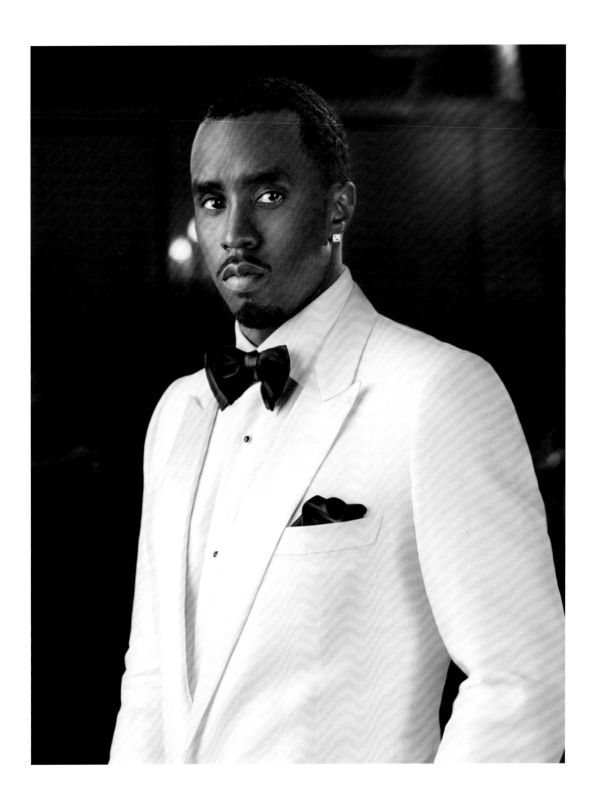

Sean "Diddy" Combs, 2008

Above Hip-hop impresario and designer Sean "Diddy" Combs was at the helm of the trend toward sharply tailored dressing, as seen in this impeccable white dinner jacket and black bow tie.

Fred Astaire in the play *Gay Divorce*, 1933

Opposite Legendary fashion plate and dancer Fred Astaire is synonymous with formalwear.

Errol Flynn, 1938

Previous pages, left The swashbuckling matinee idol had a colorful private life and a personal style to match, as this debonair sport jacket, open shirt, and casually flared collar suggest.

John Travolta in the film *Saturday Night Fever*, 1977

Previous pages, right As Tony Manero, John Travolta wore what would become the most famous suit of the 1970s—a white, three-piece disco ensemble with an open-collar shirt. Both he and the suit became stars overnight.

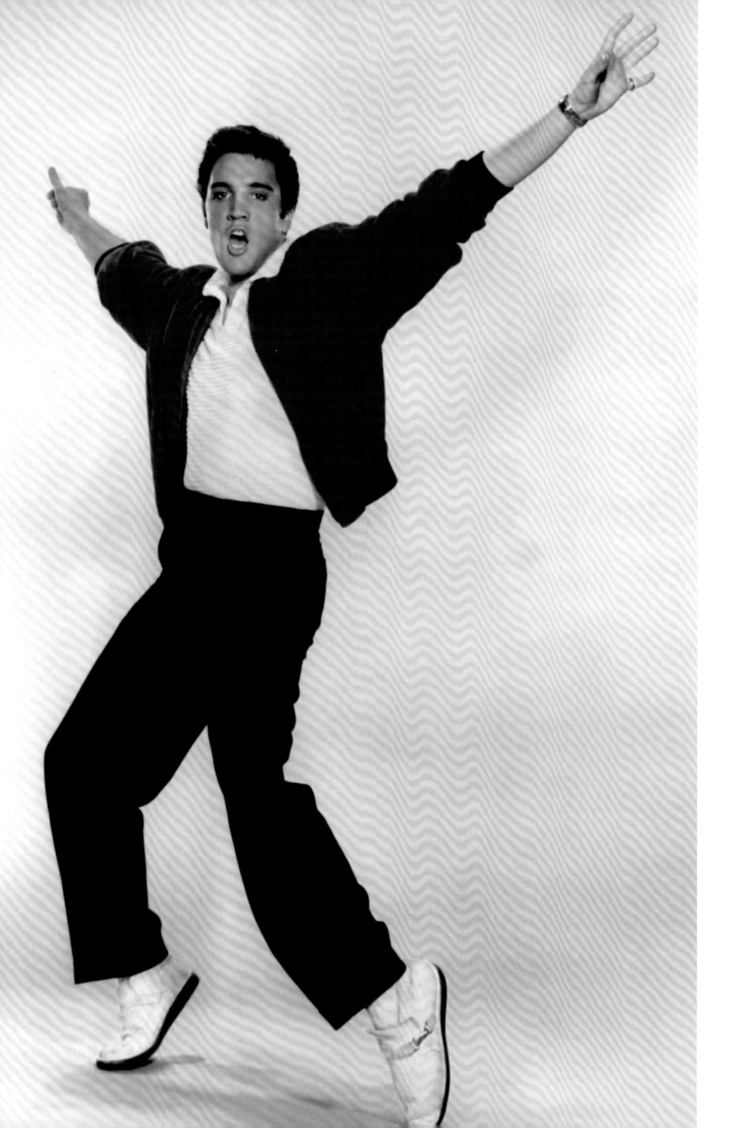

Music

{ *Rock-star style is at the core of American fashion.*

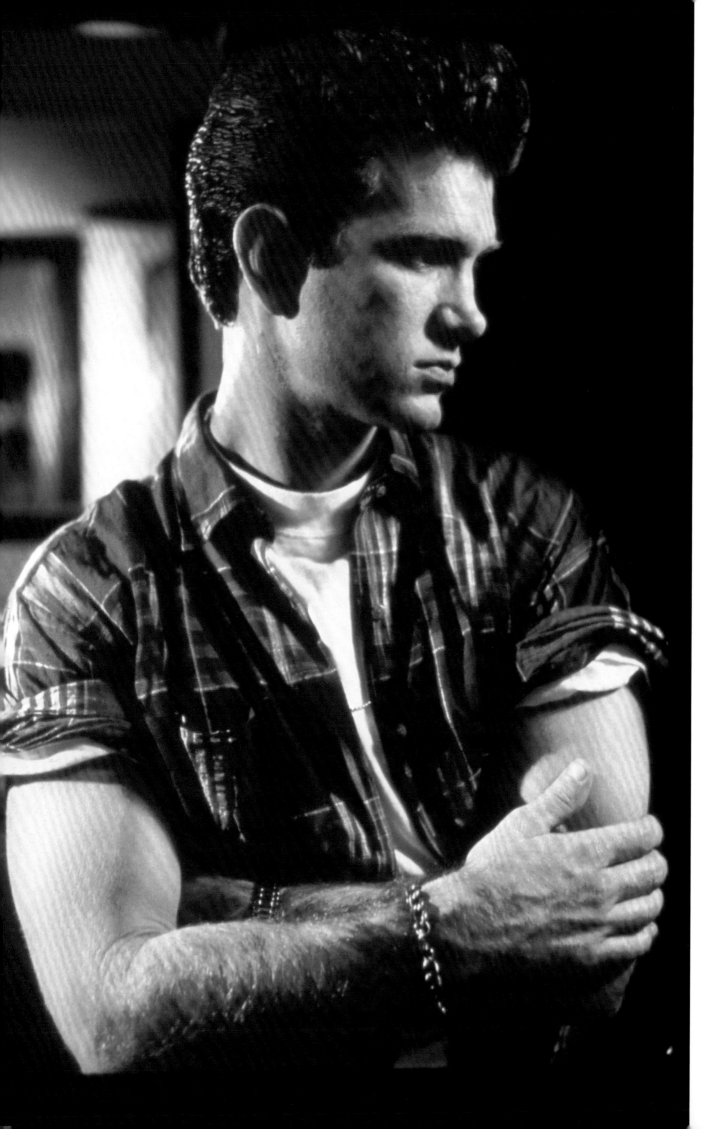

ROCK
STYLE

"No change in musical style will survive unless it is accompanied by a change in clothing style. Rock is to dress up to."

FRANK ZAPPA

Fashion and rock music are inextricably linked: clothing creates the rocker's image, and the rocker in turn embodies "the look" in the most dramatic way possible—onstage. When Elvis first shook up Ed Sullivan's stuffy variety show in September 1956, his Beale Street style, pompadour hair, sharp sports jacket, and black pants were as instrumental to his success as his singing and his swiveling hips. The man responsible for Elvis's attire was Bernard Lansky, a stylist before the term was coined and owner of Lansky Brothers, Presley's favorite Memphis clothing store. In the years to come, Elvis always gave credit where it was due, and Lansky's business benefited royally from his endorsements. This was just the beginning of a give-and-take love affair between the worlds of rock and fashion that has only strengthened through the years—and has become quite literal, with the proliferation of celebrity couples, from Mick Jagger and supermodel Jerry Hall to Pete Doherty of Babyshambles and Kate Moss.

The birth of rock and roll, however, was not just a product of Elvis, but a synergy of many diverse elements: millions of teenagers searching for a fresh, new identity; the emergence of rockabilly and rhythm and blues at exactly the right time to satisfy those needs; and, perhaps most important, the growth of television in the 1950s, a medium ideally suited to spread the dynamic style across the country. Beyond variety shows like Ed Sullivan's, there were teen programs (notably *American Bandstand*) and a plethora of local TV rock-and-roll parties featuring all the latest dance steps and fashion trends. Youth looked to each other and to the rock stars they admired on television for fashion guidance. A dress code on *Bandstand* prohibited jeans and open collars, but the guys still looked pretty cool in their drape-cut jackets and skinny ties—and why not? This was how their idols Buddy Holly, Jerry Lee Lewis, and Eddie Cochran dressed.

Elvis Presley, ca. 1950s *Previous pages* The King exploded onto the American scene via *The Ed Sullivan Show* and shook up white-bread America with his flashy style—and swiveling hips. **Chris Isaak, 1988** *Opposite* Alexander Julian's madras sport shirt is as right for Chris Isaak's fifties rocker look as the crooner's T-shirt, rolled cuffs, and pompadour hairdo.

In the fifties, many rock stars performed in expensive, flashy suits and ties to demonstrate their financial success and dazzle their fans. In this respect, Elvis may have gone further than any other with his legendary gold lamé suit, a stunner from the famed "Rodeo Tailor," Nudie Cohn. But this extreme statement was more the exception than the rule; generally speaking, it was African American R & B performers who consistently dressed to impress. Vocal groups like the Coasters, the Imperials, and the Flamingoes wore matching, impeccably tailored suits and tuxedoes in shiny fabrics like sharkskin, silk, and mohair. Then there were the individual performers such as Ray Charles, Chuck Berry, and especially the dynamic and eccentric Little Richard. The man also known as Richard Penniman wore his hair piled high in a pomaded pompadour, with conspicuous makeup (he was glamorous well before glam rock), a pencil mustache, and an extreme drape-cut suit coordinated with a monochromatic white shirt and white tie. Former Rolling Stones manager Andrew Loog Oldham rhapsodized, "That gray shot silk, loose gray wonder of a suit he wore in [the film] *The Girl Can't Help It* is all Macon Armani/ Pittsburgh Paul Smith; the look is energy, svelte freedom, and forever." Little Richard's performance was equally wild: standing, bouncing, pounding the piano keys, resting his shoe on the keyboard, punctuating his lyrics with rhythmic screams. James Brown, who emulated Little Richard's extremely slick style and energetic stage manner, praised him for first putting "the funk in the rock and roll beat," while Paul McCartney, Jimi Hendrix, and David Bowie all cited Little Richard as an early inspiration, both musically and sartorially.

The bands that made up the 1960s' British Invasion were equally natty, albeit in a mod, shrunken-suit style—a precursor to Thom Browne's twenty-first-century silhouette. In 1962, when Beatles manager Brian Epstein wanted to give the boys a new image, he commissioned show business tailor Dougie Millings to make four snug, collarless suits inspired by the designs of Pierre Cardin—and thus the Beatles were born. Later Millings, who also made suits for American artists Bill Haley & His Comets, the Everly Brothers, and even the Beach Boys, went on to create a wardrobe of skinny-lapelled mod designs for the Beatles' 1964 American tour, making music and fashion history.

After the uninhibited flamboyance of the late sixties and seventies, many rockers were ready to get back to basics. The time was ripe for a return to tailoring. Enter the new wavers and bands like Blondie, who dressed for their 1978 *Parallel Lines* album cover in slim black suits, simple white shirts, and skinny black ties—a look that found another expression more than two decades later with post-post-punk New York City bands like the Strokes.

The Beach Boys, 1962 *Previous pages* The band originally known as the Pendletones rode the crest of the surfing wave to stardom, turning their beach-functional, Pendleton plaid overshirts into fashion.

With the coming of the new millennium, sharp suits were ready for a major comeback in videos, concerts, and on the red carpet. Hip-hop performers such as Diddy and Jay-Z, tired of bling-bling combined with super-sized gangsta jeans and sweatshirts, started dressing for performances and awards ceremonies in tailored three-piece suits and elegant, perfectly accessorized tuxedos—a shout-out to early R & B performers and their aspirational clothing. These trendsetters were soon joined by a host of others, including Kanye West, André 3000, and Ne-Yo, whose 2008 album *Year of the Gentleman* summed up the fashion scene. Epitomizing this dapper mood, "Rap Pack" members West, Lil Wayne, Jay-Z, and T. I. performed "Swagga Like Us" at the 2009 Grammy Awards dressed in matching tuxes, bow ties, and cummerbunds. Broadcast in black and white, they recalled nothing so much as a dapper 1950s vocal group. Not to be outdone, rock and pop performers also turned to bespoke suits; note Brandon Flowers of the Killers and Justin Timberlake dressed in black tuxedos coordinated with black shirts and ties.

In another fashion/rock merger, musical performers of all genres opened their own fashion companies. Russell Simmons, known as the godfather of hip-hop fashion, moved from producing and managing seminal rappers like Run DMC and the Beastie Boys to founding his own clothing brand, Phat Farm. Now nearly every rapper worth his salt has his own line, from Diddy's Sean John and Jay-Z's Rocawear to LL Cool J's collection for Sears. In the twenty-first century, rockers are joining the designing ranks of rappers, including Justin Timberlake with William Rast, the Stone Temple Pilots' Scott Weiland with English Laundry, and Gene Simmons of Kiss under his own name—as if there weren't already enough solidly rock-centric lines like Rock & Republic, Rag & Bone, and Slinky Vagabond.

The role of the musician as a driving force in fashion—rather than just another kind of dandy—was created by those ragged, rebellious rock forefathers of the 1960s. By the 1967 "Summer of Love," elements including the British invasion, Vietnam war protests, hippie flower power, psychedelia, unisex dressing, long hair, and peace and love all came together, igniting an explosion of street style. For the first time, there were clothing stores solely devoted to "groovy gear" the kids wanted, including New York boutiques like the Different Drummer and Limbo Clothes, not to mention a host of jeans-focused stores such as Merry-Go-Round located in malls across America.

By the late sixties, rock groups were following the lead of the Rolling Stones, each member expressing his own dynamic style. The presentation of the whole band became greater than the sum of its parts. Initially, the look was a hip, free-spirited mix of Edwardian jackets, wide paisley ties, turtlenecks,

stovepipe pants and jeans, suede CPO jackets, and blue denim shirts worn with open vests—overall a style that seems remarkably contemporary now.

The performer who truly embodied all of these converging trends was Jimi Hendrix. When he electrified the crowd, burning his Stratocaster guitar at the 1967 Monterey Pop Festival (named one of the greatest performances of all time by *Rolling Stone*), he wore a large Afro hairdo bound with a gypsy headband, a billowy yellow crepe blouse with cascading ruffles, a gold braid-trimmed black leather vest, red leather bell-bottoms, and high-heeled boots, further accessorized with rings on his fingers and a large beaded folkloric necklace. And this was just one of many wild costumes for Hendrix, who dressed differently for virtually every performance. (Prince, in the eighties, and Lenny Kravitz, in the nineties, were both indebted to this seminal rock fashion plate.) Hendrix's wardrobe choices brought together the styles of other performers of the era: gold trimmed band jackets, Middle Eastern embroidered shearling vests, tie-dye or Indian-paisley print gauze shirts, tunics adorned with foot-long fringe, conch silver belts, purple velvet bell-bottoms, granny glasses, rumpled felt hats, and multiple flowing scarves, all carefully uncoordinated in vivid clashing colors. A Hendrix biopic to be directed by Quentin Tarantino has been on hold since 2006—apparently they just can't find anyone to fill his snakeskin boots.

As peacock-inspired street style grew increasingly bizarre, even rivaling what was worn on stage, the fans demanded something more from a concert than just music and colorful hippie regalia. Concerts became theatrical experiences, with outrageous sets, lighting, and costumes. Glam rock was the first high-concept style: Marc Bolan of T. Rex and Gary Glitter pioneered it in England, and in America it was the New York Dolls. The Dolls' David Johansen explored this over the top performance art starting in 1971, a year before Bowie's Ziggy Stardust was born. Their decidedly camp fashion trademarks were spandex leopard-print leggings, black leather jackets, floppy oversized bows, lengthy scarves and feather boas, dangerously high platform shoes, teased hair, plenty of makeup and, perhaps most unsettling, fey mannerisms befitting a drag queen. Having gone as far as humanly possible, rock style had no alternative but to change direction.

At the other extreme, formative punk rock bands like New York's Ramones created their own particular kind of non-fashion fashion based on black leather and ripped jeans. As Legs McNeil, a cofounder of *Punk* magazine, described an early performance: "They were all wearing these black leather jackets. And they counted off this song . . . and it was just this wall of noise. They looked so striking. These guys were not hippies. They were something completely new."

The more convincingly antifashion "Boss," Bruce Springsteen, has made a blue-collar image for himself by wearing simple T-shirts, black jeans, plaid flannel, and chambray work shirts consistent with the gravitas of his socially conscious songs. Likewise, folk singer Bob Dylan (before he went electric) dressed in a nondescript way. But the outstanding example of this unpretentious attitude was the Seattle-based grunge movement, popularized by bands such as Pearl Jam, Nirvana, and Soundgarden. Like reputed grunge founding father Neil Young, their wardrobe consisted of layered thrift store clothing, cardigans, untucked plaid flannel shirts, message T-shirts, ripped jeans, and ratty sneakers. But it took New Yorker Marc Jacobs, designing for Perry Ellis in 1992, to magically transform this hodgepodge into runway fashion and, in the process, establish his name. More recently, grunge has returned to favor, particularly in the comfy, untucked, multilayered collections of Yigal Azrouël, Michael Bastian, and even Jacobs again.

Fashion Rocks, an annual television special begun in 2004 that features stars of both music and style, illustrates this intimate yet totally open relationship—everything is out of the fashion closet, and everyone knows exactly who's wearing what. Fashion has always played a crucial part in rock magic, but lately there's no longer even a pretense of rebellious rockers making their own dangerous fashion choices, or breaking all the rules. In fact, many musicians have gone from calling the shots to being slaves of celebrity fashion stylists! But realistically speaking, it's been nearly sixty years since the birth of rock and roll—how long could this "rebel outlaw" illusion last? As long as rock stars look great, does it really matter if they get by with a little help from their designer friends? So rockers like Iggy Pop, Alice Cooper, Chris Cornell of Soundgarden, and the band Franz Ferdinand appear in advertisements for designer John Varvatos, while he in turn dresses them to perfection. And when punk's historic birthplace CBGB's closed, rather than let it become yet another bank branch, Varvatos preserved it as a rock museum with fashion. The designer is convinced that "every guy has a rock-god fantasy." Certainly he himself does, as does another longtime fan, designer Tommy Hilfiger. Hilfiger's love affair with rock began long before he first rubbed shoulders with rappers in the early nineties, dressing them in XXL all-American looks like the red, white, and blue rugby shirt Snoop Dogg famously wore on *Saturday Night Live*. Since then, stars like Sting and David Bowie have appeared in Hilfiger advertisements, and the designer has sponsored numerous concert series and even backed the "Rock Style" exhibition at the Metropolitan Museum of Art. Varvatos, Hilfiger, and their best and brightest colleagues have demonstrated over and over that, in Hilfiger's words, "music is the best source of fashion inspiration in the world."

Little Richard in the film *The Girl Can't Help It*, 1956 *Following pages, left* The dynamic, madcap performer Little Richard shrieked and pounded the piano even when the cameras weren't rolling. For *The Girl Can't Help It*, he worked his signature moves in this sharp zoot suit and skinny white tie. **Rag & Bone, 2008** *Following pages, right* Contemporary fashion, like this Rag & Bone ensemble, echoes the skinny ties and narrow lapels of late-1950s rock style.

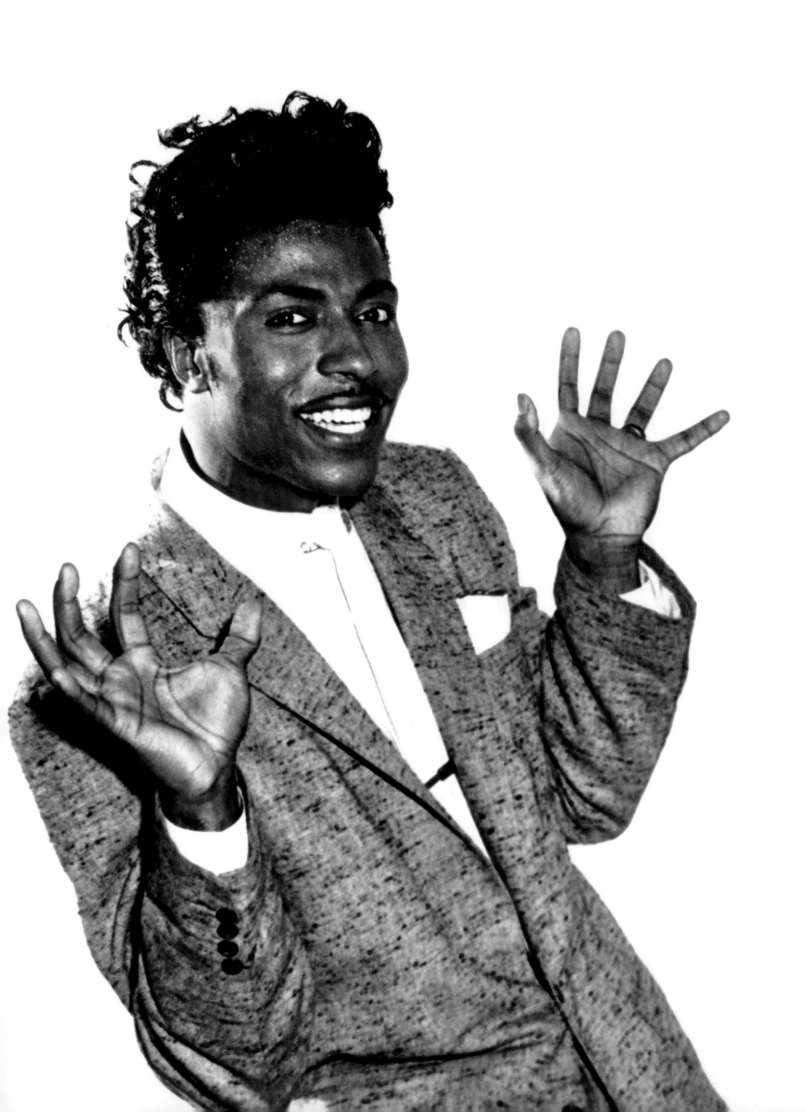

Bob Dylan, 1965
Left The young Dylan had an unpretentious, grungy style, in keeping with his down-to-earth, folk-singing roots.

Shipley & Halmos, 2008
Opposite Shipley & Halmos spearheaded the movement toward sophisticated downtown chic with tailored jackets; suspender-held, high-waisted trousers; and layered knits.

Jim Morrison, 1968
Previous pages, left Mythic singer and sex symbol Jim Morrison, front man for the Doors, loved leather—the preferred material of rock musicians everywhere. Here, he performs in a leather suit before a psychedelic projection.

Chrome Hearts, 2002
Previous pages, right Leather pants and a striking silver-buckled belt: It's a look Morrison would have coveted.

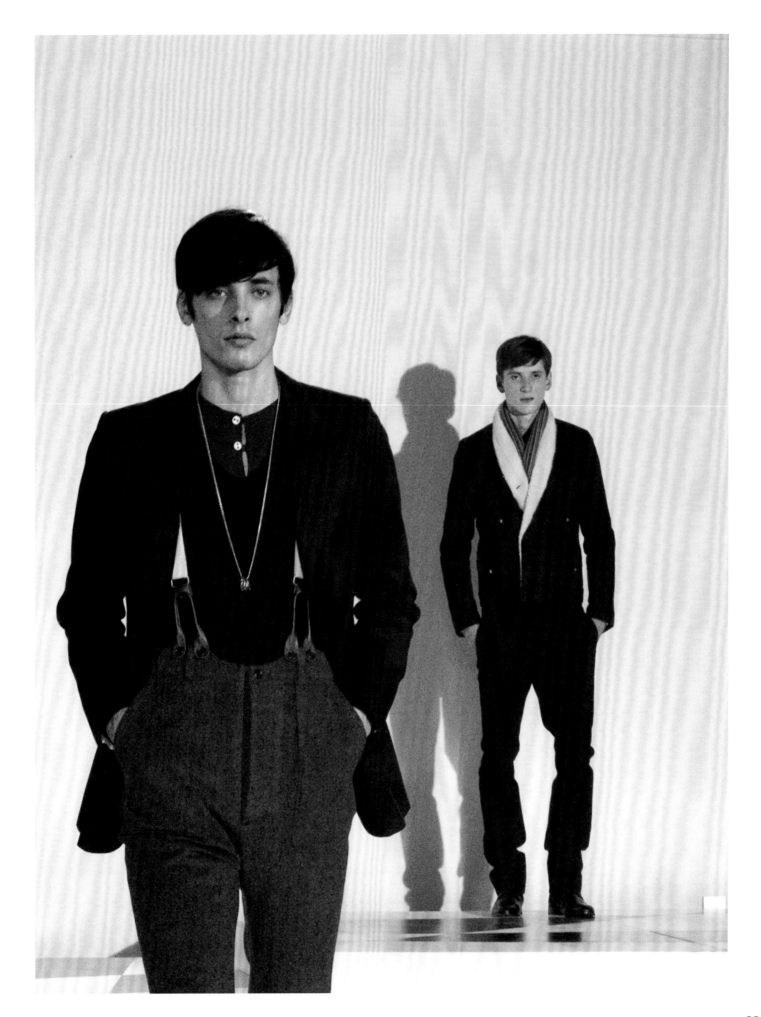

Jimi Hendrix, 1967

Above The epitome of hippie chic, Hendrix burns his guitar at the 1967 Monterey Pop Festival. It was a definitive moment in rock-and-roll history.

Todd Oldham, 1994

Opposite Photographer Satoshi Saikusa worked with Oldham to evoke every kind of rock dandy, from glam to hip-hop, in this fur-topped ensemble from the November 1994 *L'Uomo Vogue.*

The Ramones, ca. 1970

Previous pages, left The founding fathers of punk, the New York–based Ramones wear ripped jeans and T-shirts with official rock outerwear: black leather motorcycle jackets.

Keanan Duffty, 2007

Previous pages, right Rock-influenced designer Keanan Duffty's sketch of his punky "Bowie Zowie" T-shirt.

Stephen Burrows, 1970

Following pages, left The adventurous women's wear designer, experimented with menswear early on for sale at New York's legendary "O" boutique, as seen in this leather and nickel "dog" collar worn by pioneering African-American model, Renauld White.

Earth, Wind & Fire, ca. mid-1970s

Following pages, right Members of the R & B band Earth, Wind & Fire show off their flamboyant outfits in this mid-1970s celebration of funky colors, bell-bottoms, vests, and platform footwear.

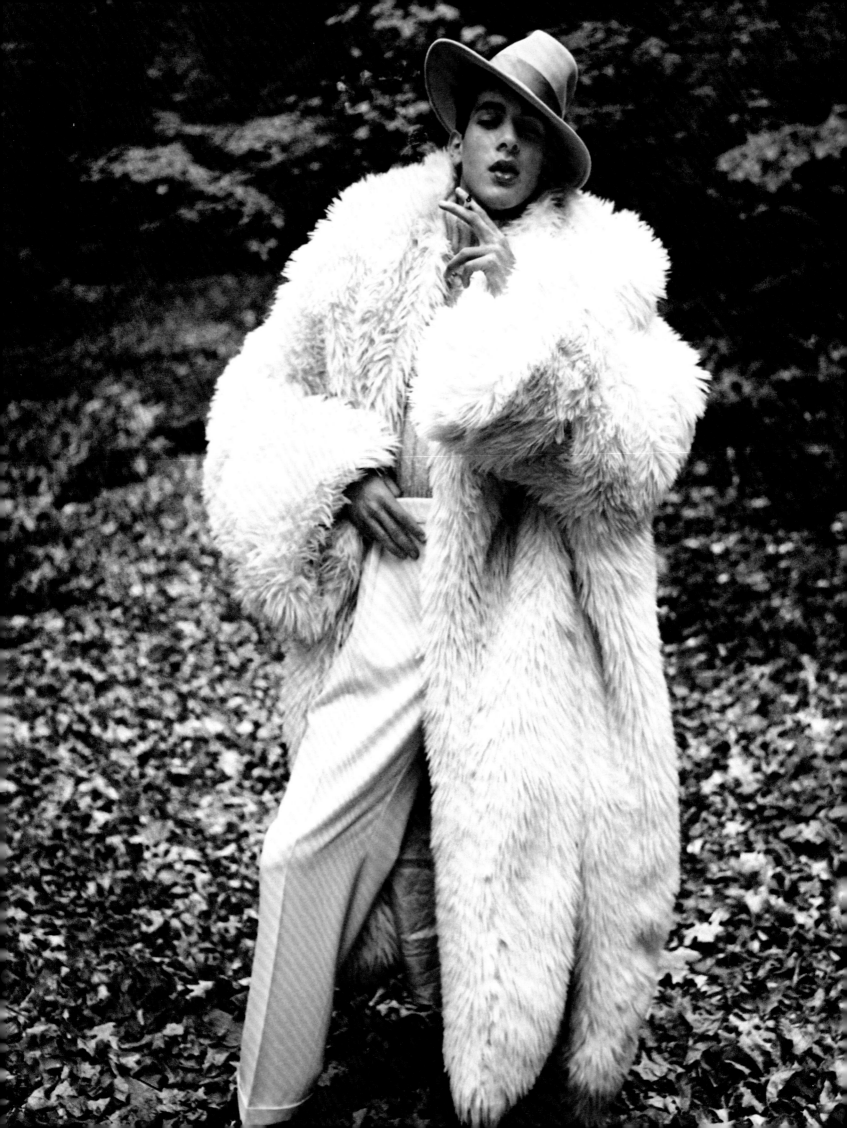

Patchwork snakeskin, 1972

Opposite This patchwork snakeskin jacket featured in the February 1972 issue of *L'Uomo Vogue* is a perfect example of hippie-chic gone haute.

Michael Kors, 2005

Right The tradition of exotic snakeskin jackets lives on in this 2005 Michael Kors python blazer.

The Clash, 1977

Left The English punk band the Clash influenced the look of new wave with red and white leather jackets and tight, heavily zippered pants.

Rag & Bone, 2009

Following pages, far left Rock for all seasons and all ages: Rag & Bone revive punk and new wave fashion for Spring 2009.

Buckler for Andrew Buckler, 2009

Following pages, center left Also for Spring 2009, Buckler shows the classic black leather jacket and tight jeans with a grungy plaid shirt.

Rock & Republic, 2009

Following pages, center right Rock & Republic lives up to its name for Spring 2009 with a black blazer, a white T-shirt, and skinny, sanded jeans.

Ron Chereskin, 2005

Following pages, far right Chereskin began his career with novelty neckwear; here, he shows the early-21st century's loosened tie and untucked shirt.

241

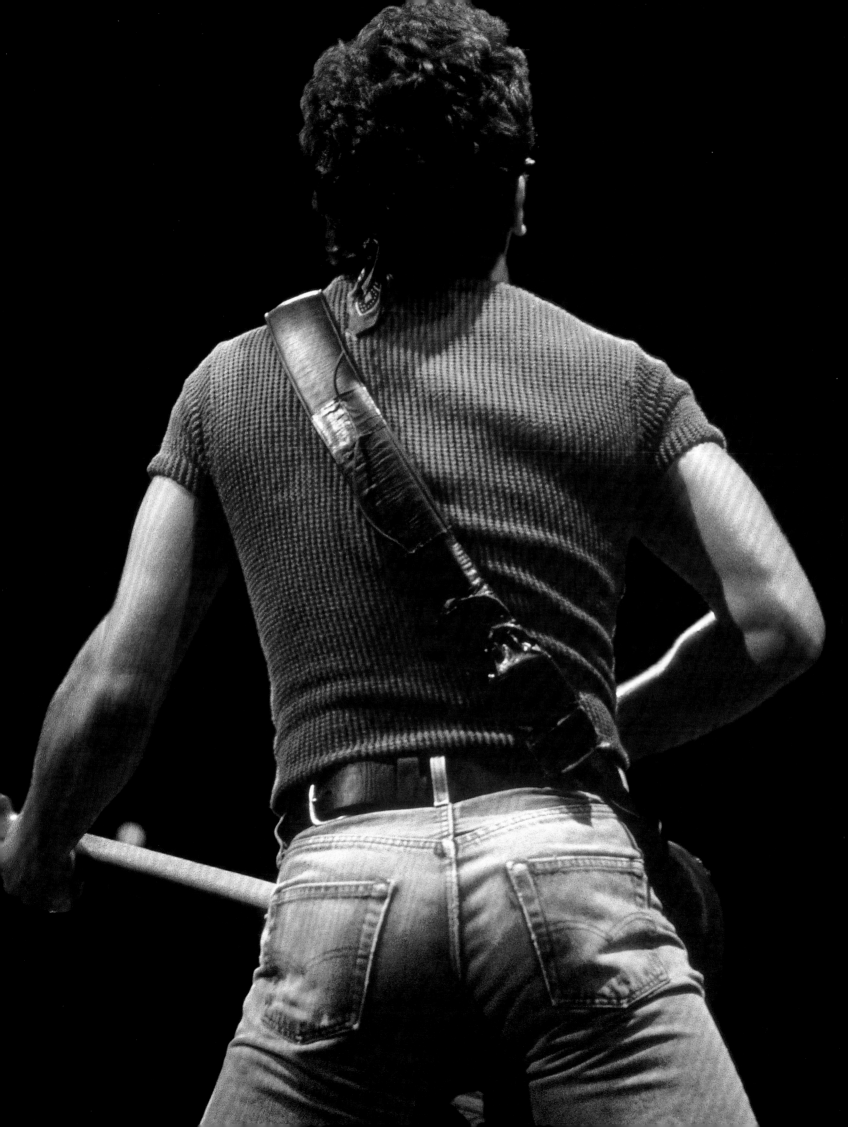

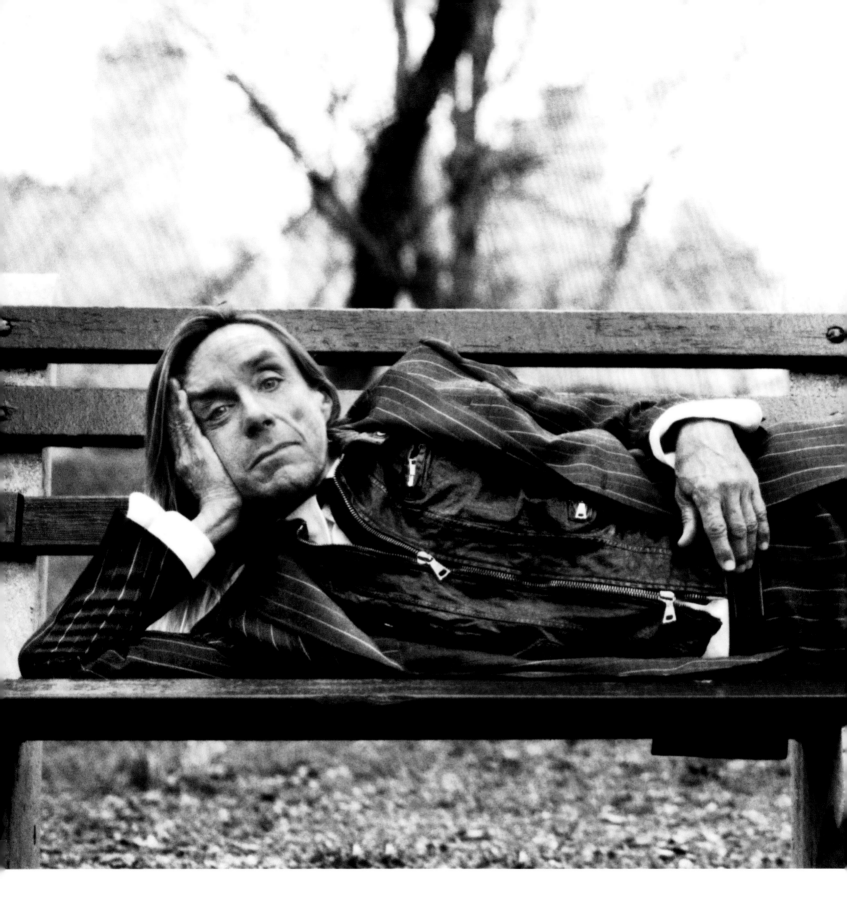

John Varvatos, 2006

Above Longtime music fan John Varvatos used the legendary rocker Iggy Pop in this offbeat 2006 campaign.

Robert Comstock, 2000

Previous pages, left Comstock, known for his rugged outerwear, strikes a dressy note with this deerskin jacket and jeans.

Bruce Springsteen, 1985

Previous pages, right Working-class rocker Bruce Springsteen makes his statement on style—best seen from the rear.

Stephen Sprouse, 1987

Following pages, left "Hardcore Boy," a Fall 1987 sketch, shows the edgy designs, Day-glo colors, and wild prints for which Stephen Sprouse is so justly celebrated.

Marc Ecko, 2004

Following pages, right Music and fashion impresario Marc Ecko launched his hip-hop–flavored Cut & Sew collection in fall 2004.

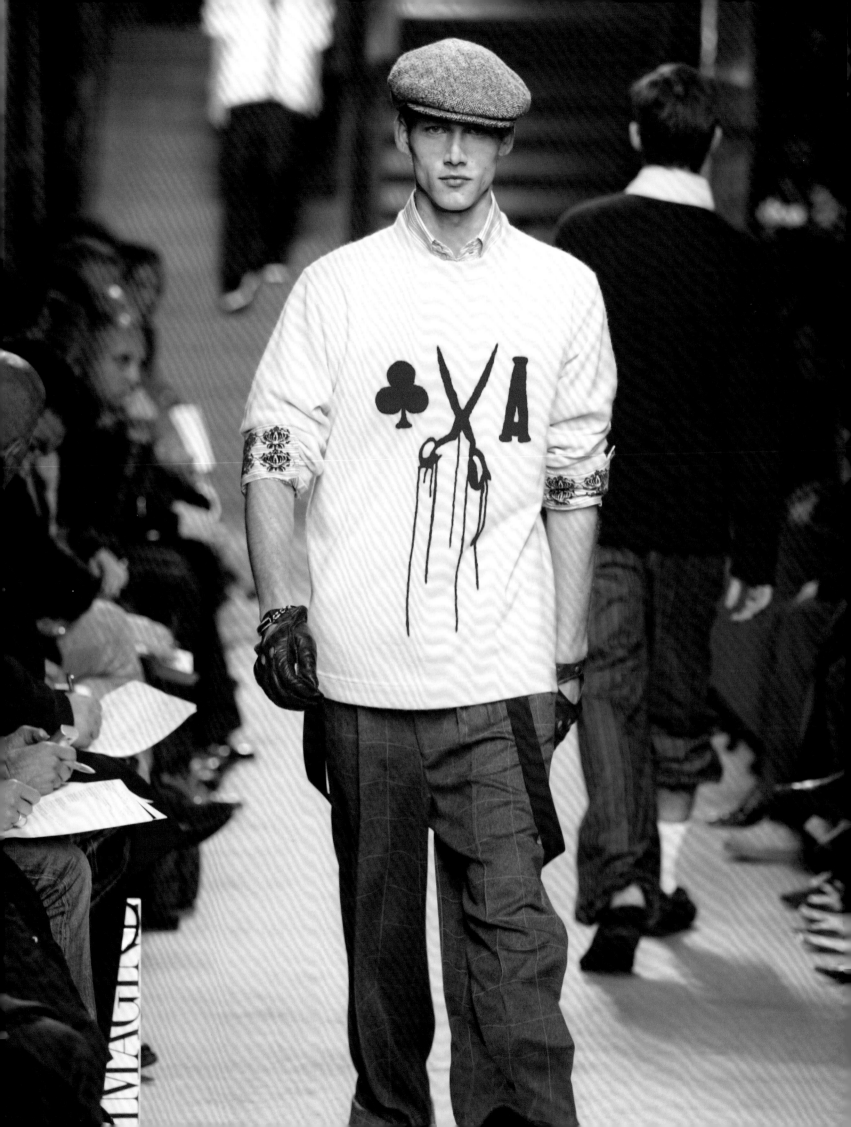

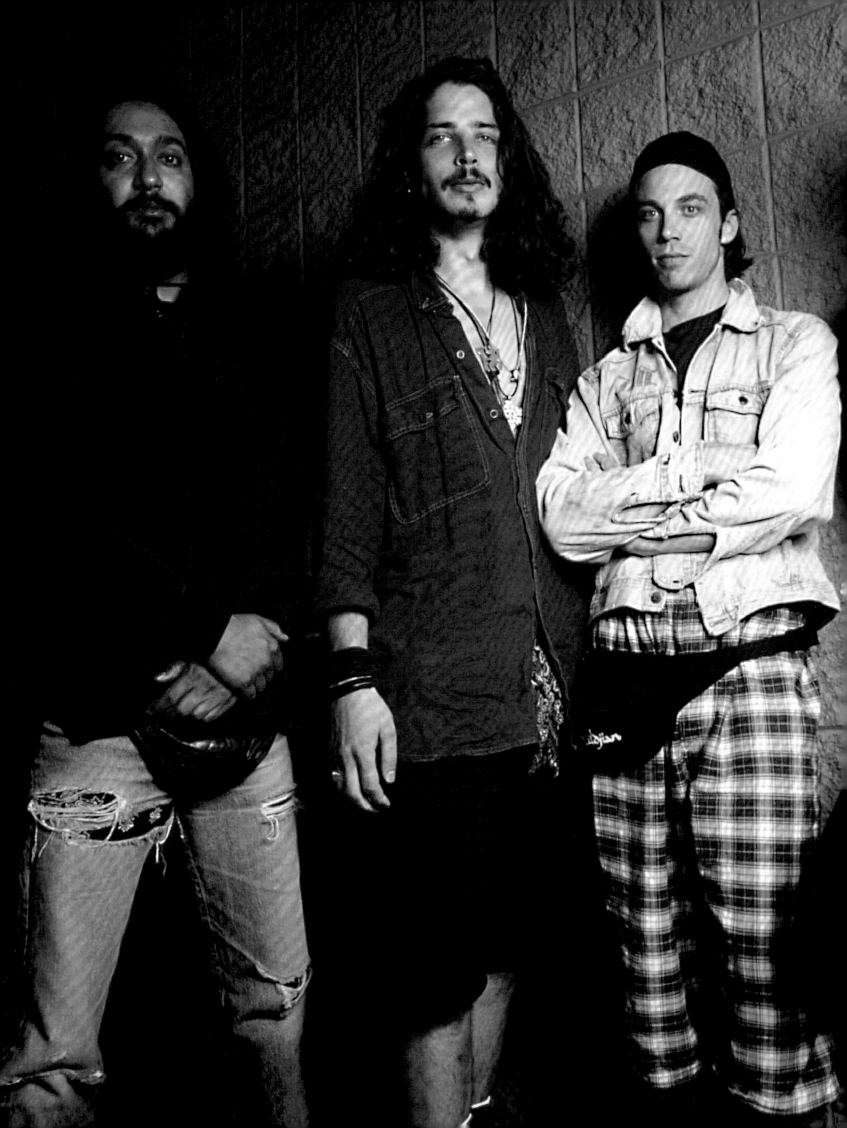

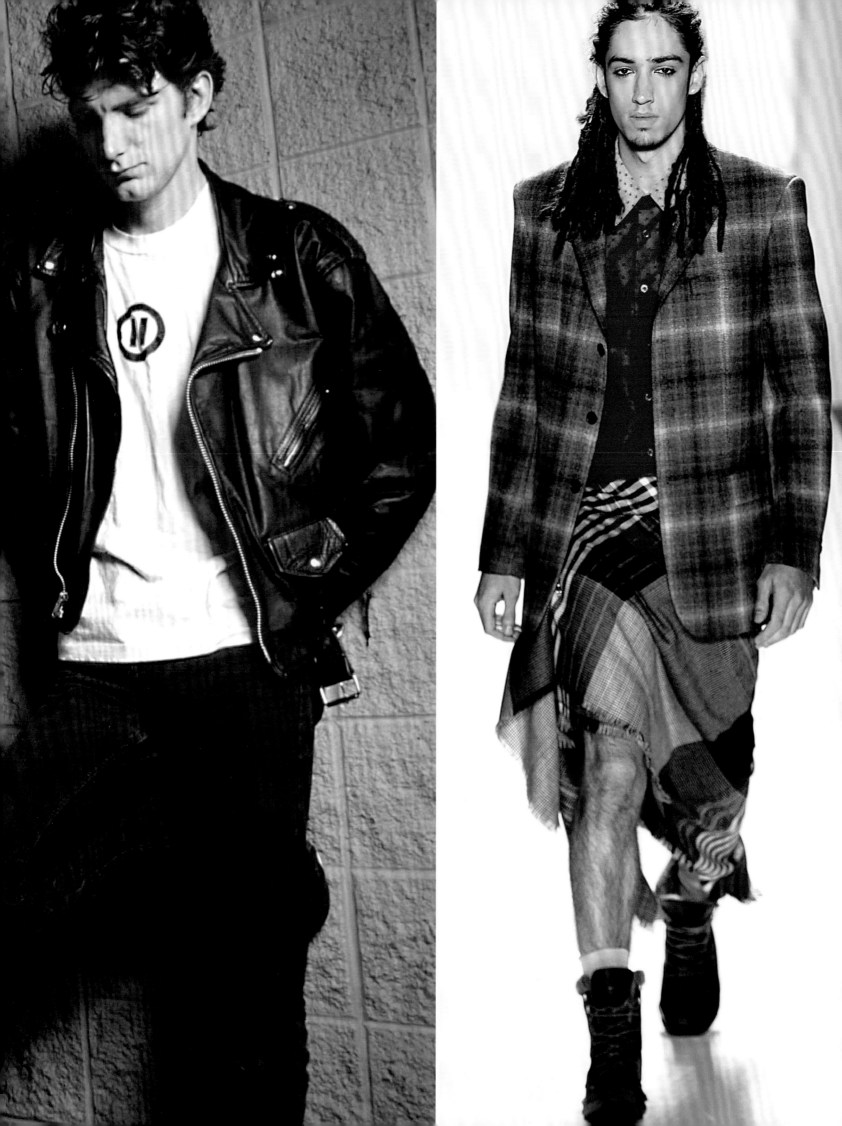

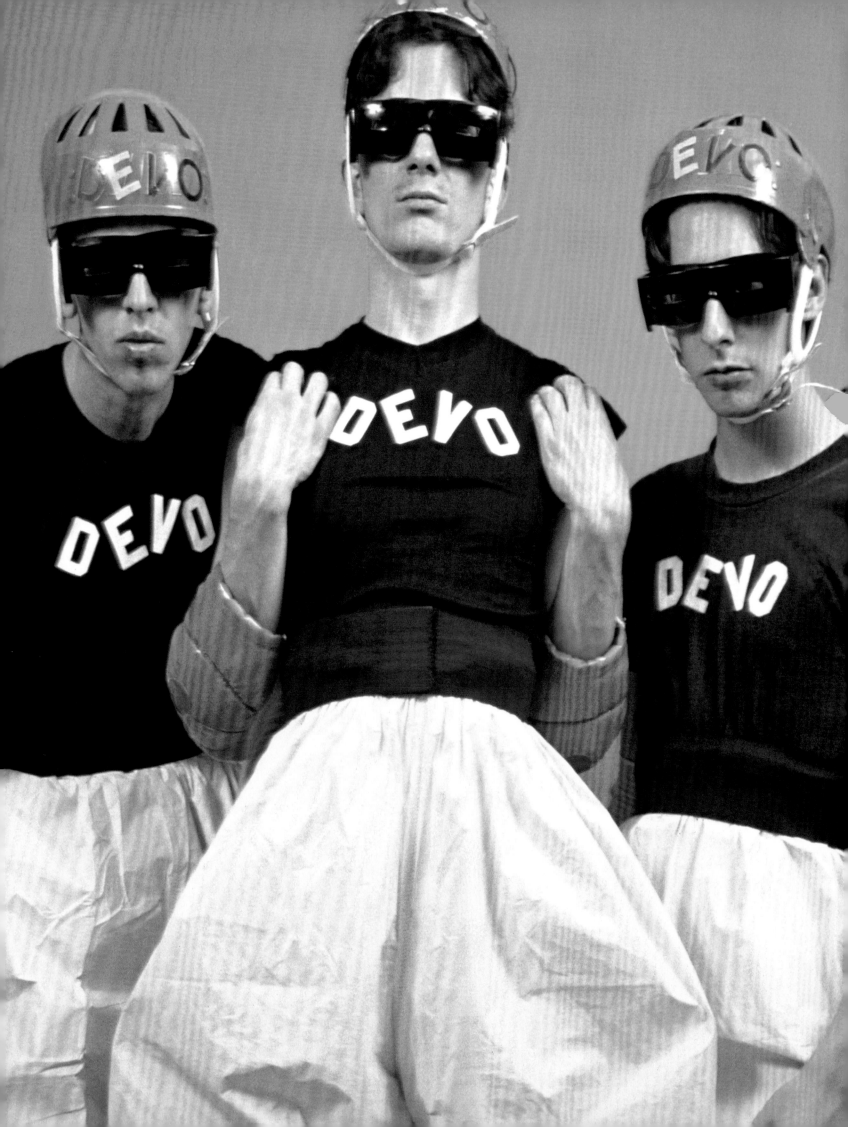

Duckie Brown, 2009

Right Steven Cox and Daniel Silver's highly "technical" Duckie Brown collection for Spring 2009 was based around synthetics and dramatically contrasting proportions.

Devo, 1978

Opposite New wave marked the commercialization of punk, as demonstrated by Devo, in bright yellow plastic balloon pants and orange helmets.

Soundgarden, ca. 1990s

Previous page, left Like their fellow early-1990s Seattle grunge bands Nirvana and Pearl Jam, Soundgarden band members prided themselves on their thrift-shop–style, a hodgepodge of plaids, T-shirts, and ripped jeans.

R. Scott French, 2008

Previous pages, right R. Scott French recaptures the spirit of grunge with a Pendleton-inspired plaid jacket and a signature shirt wrapped around the waist.

John Varvatos, 2009

Following pages, left Varvatos pays tribute to the military influence on rock style, a classic look since the Beatles' 1967 album *Sgt. Pepper's Lonely Hearts Club Band*.

Michael Jackson, 1984

Following pages, right Riding high after the success of his "Thriller" video, Michael Jackson attended the 1984 Grammy Awards in full military regalia.

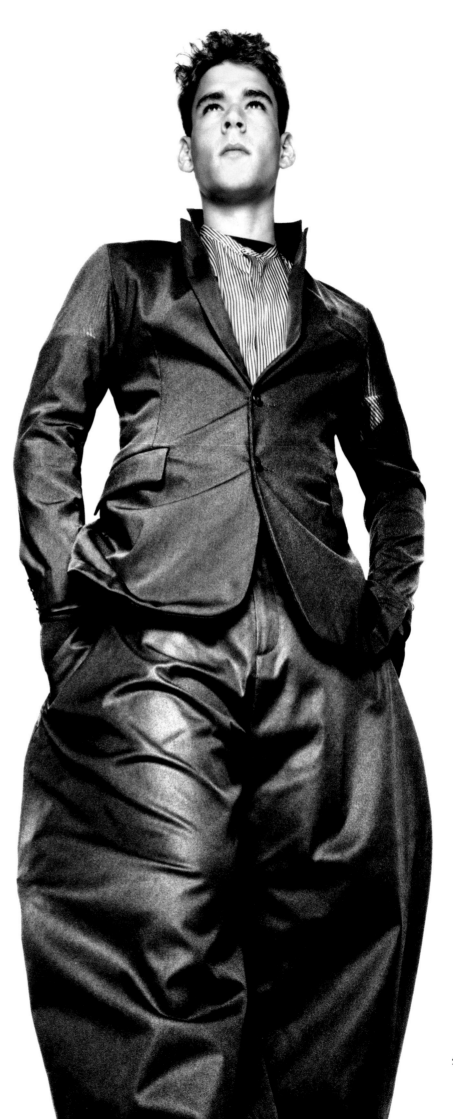

251

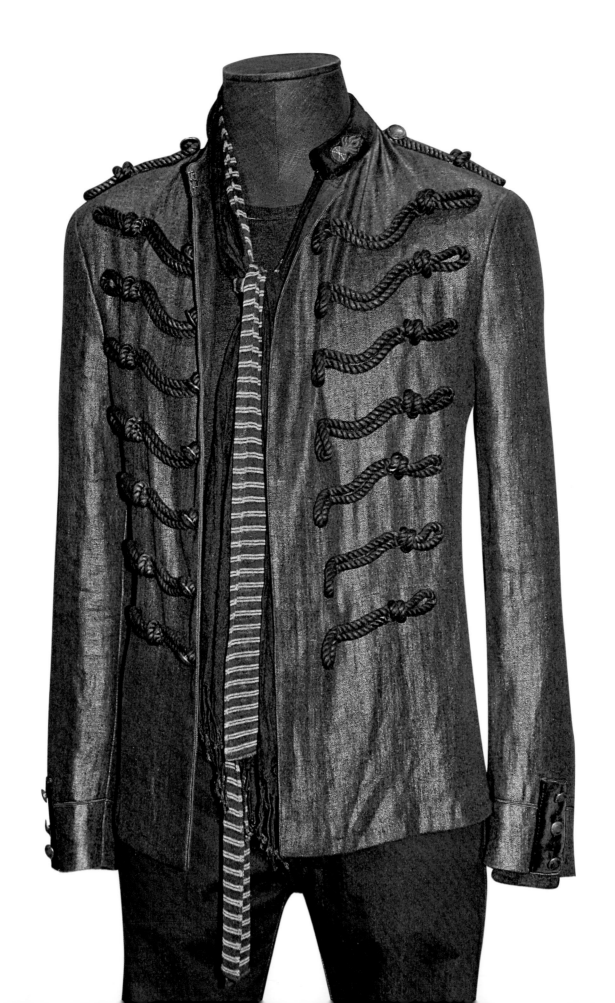

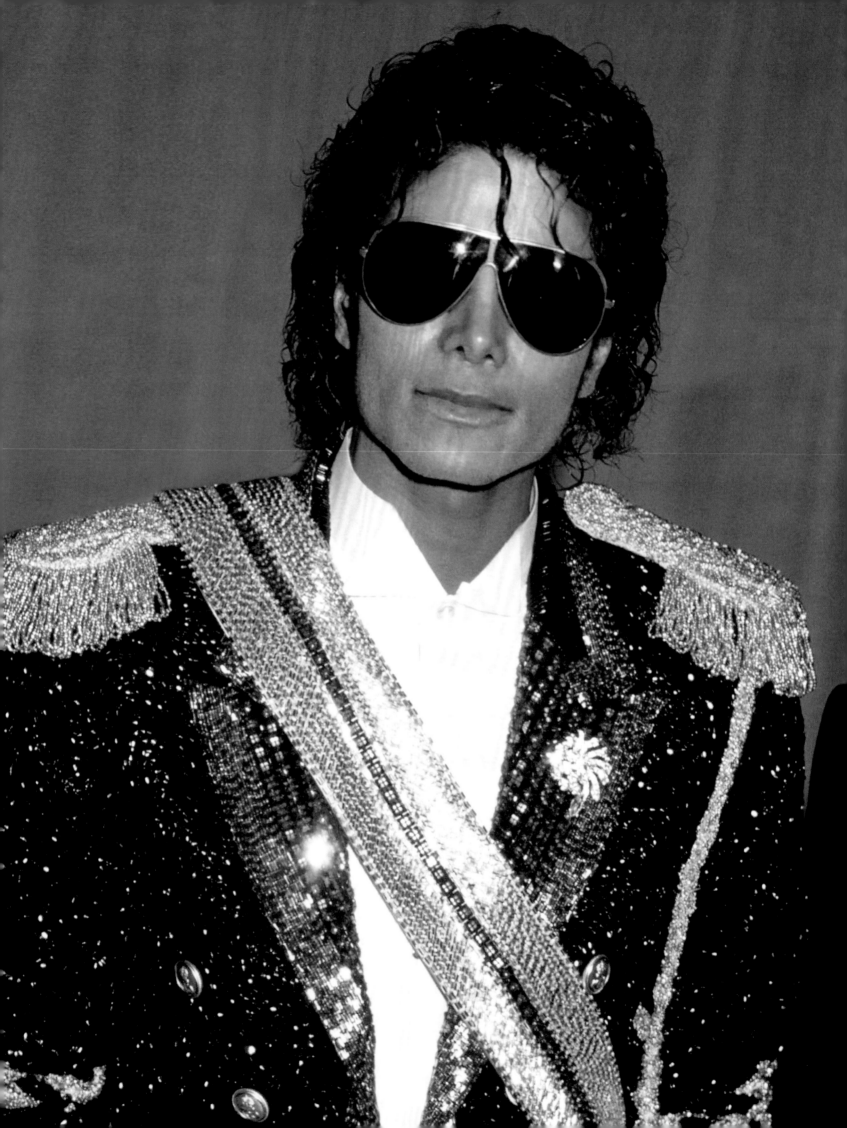

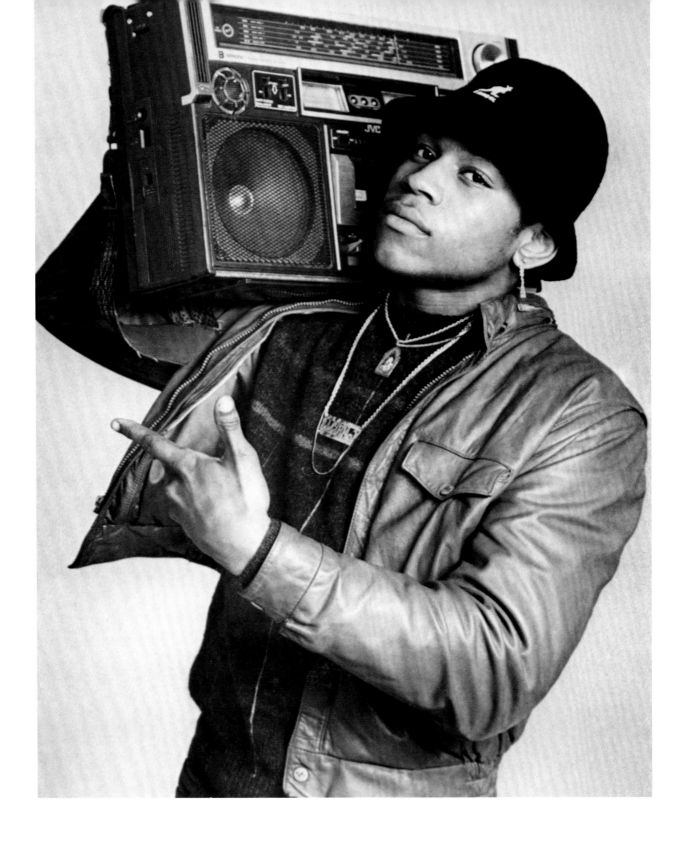

LL Cool J, 1985

Above The early hip-hop-to-pop crossover LL Cool J, with a boom box on his shoulder, wears a Kangol hat, leather jacket, necklaces, and earrings.

Eugenia Kim, 2008

Opposite Headwear designer Eugenia Kim created this trendy bowler.

Chrome Hearts, 2006

Following pages, left These white-gold and diamond bracelets from Chrome Hearts recall the extravagant, bling-heavy wardrobes of turn-of-the-millennium rappers.

Barry White, 1992

Following pages, right "The Sultan of Smooth Soul," Barry White, made his name in the 1970s disco era with the Love Unlimited Orchestra but was clearly enjoying a comeback here, resplendent in the November 1992 *L'Uomo Vogue*.

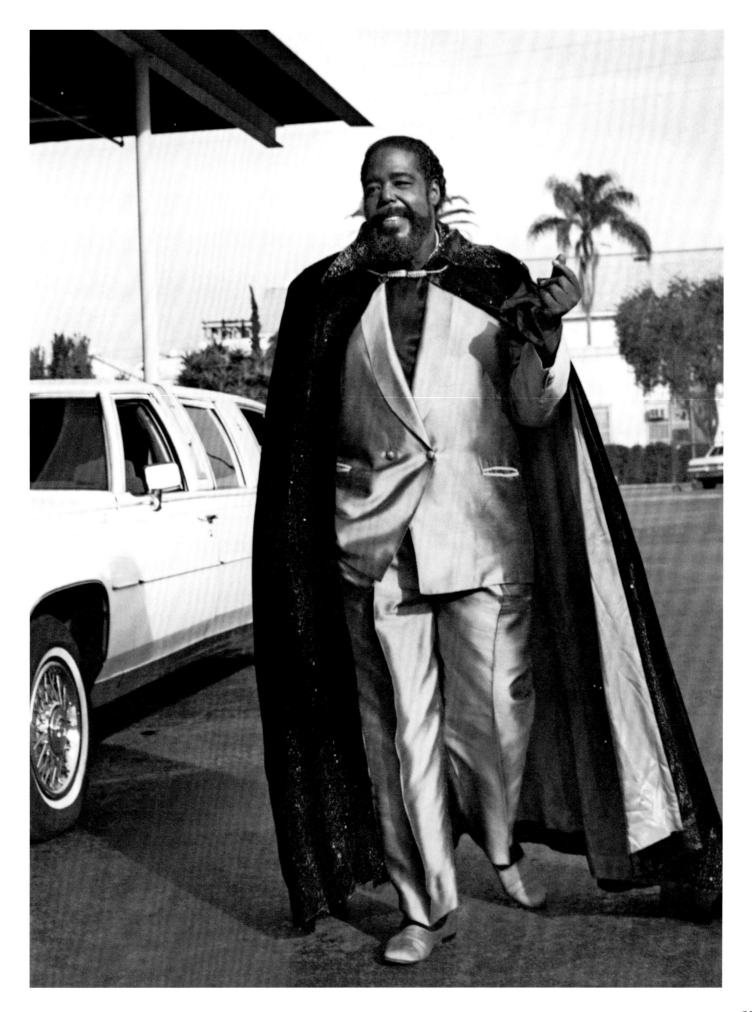

Tim Hamilton, 2009

Left Tim Hamilton's inspiration may have been Vienna circa 1910 (think Egon Schiele), but the result is pure rock, with a shrunken jacket, knitted jodphurs, and streamlined combat boots, all in black.

Brandon Flowers, 2005

Opposite Decadent, chic, and sophisticated: Brandon Flowers of the Killers accessorizes with a glittering brooch and flattering eye makeup, all in the best rock tradition.

The Jonas Brothers, 2008
Above Disney's latest boy toys show how a good stylist can transform typical teenagers into urbane rock stars.

Italo Zucchelli for Calvin Klein Collection, 2008
Opposite Paging Brandon Flowers: This streamlined silver suit from the pages of *Flaunt* magazine would be a perfect fit for a rocker with flash.

Kenneth Cole, 2008
Previous pages, left A hoodie peeking out from under a suit jacket lends instant hipster credibility.

Eminem in the film *8 Mile*, 2002
Previous pages, right Detroit rapper Eminem dressed in an understated hoodie and a denim jacket for *8 Mile*, which was based on his own rise to fame.

Ne-Yo, 2008

Left R & B performer Ne-Yo was living the title of his album *Year of the Gentleman* when he showed off this well-tailored look at the 2008 American Music Awards.

Justin Timberlake, 2008

Opposite 21st-century fashion icon Justin Timberlake wore a white dinner jacket from his own William Rast collection for the Fall 2008 *Fashion Rocks*.

CURRENT CFDA MEMBERSHIP ROSTER

1	Joseph Abboud	58	Doo-Ri Chung	113	Mossimo Giannulli
2	Amsale Aberra	59	Carol Cohen	114	Justin Giunta
3	Reem Acra	60	Meg Cohen	115	Nicholas Graham
4	Carey Adina	61	Peter Cohen	116	Cindy Greene
5	Adolfo	62	Anne Cole	117	Henry Grethel
6	Simon Alcantara	63	Kenneth Cole	118	George Gublo
7	Linda Allard	64	Liz Collins		
8	Carolina Amato	65	Michael Colovos	119	Everett Hall
9	Ron Anderson	66	Nicole Colovos	120	Jeff Halmos
10	John Anthony	67	Sean Combs	121	Douglas Hannant
11	Nak Armstrong	68	Rachel Comey	122	Cathy Hardwick
12	Brian Atwood	69	Maria Cornejo	123	John Hardy
13	Max Azria	70	Esteban Cortazar	124	Karen Harman
14	Yigal Azrouël	71	Francisco Costa	125	Dean Harris
		72	Victor Costa	126	Johnson Hartig
15	Mark Badgley	73	Jeffrey Costello	127	Sylvia Heisel
16	Michael Ball	74	Erica Courtney	128	Joan Helpern
17	Jeffrey Banks	75	James Coviello	129	Stan Herman
18	Leigh Bantivoglio	76	Steven Cox	130	Lazaro Hernandez
19	Jhane Barnes	77	Keren Craig	131	Carolina Herrera
20	John Bartlett	78	Philip Crangi	132	Tommy Hilfiger
21	Victoria Bartlett			133	Carole Hochman
22	Dennis Basso	79	Sandy Dalal	134	Janet Howard
23	Michael Bastian	80	Robert Danes		
24	Bradley Bayou	81	Erica Davies	135	Marc Jacobs
25	Richard Bengtsson	82	Oscar de la Renta	136	Henry Jacobson
26	Dianne Benson	83	Donald Deal	137	Eric Javits, Jr.
27	Magda Berliner	84	Louis Dell'Olio	138	Lisa Jenks
28	Alexis Bittar	85	Pamela Dennis	139	Betsey Johnson
29	Sherrie Bloom	86	Kathryn Dianos	140	Alexander Julian
30	Kenneth Bonavitacola	87	Keanan Duffty		
31	Sully Bonnelly	88	Randolph Duke	141	Gemma Kahng
32	Monica Botkier	89	Henry Dunay	142	Norma Kamali
33	Marc Bouwer	90	Holly Dunlap	143	Donna Karan
34	Bryan Bradley	91	Stephen Dweck	144	Lance Karesh
35	Barry Bricken			145	Kasper
36	Thom Browne	92	Marc Ecko	146	Ken Kaufman
37	Dana Buchman	93	Libby Edelman	147	Jenni Kayne
38	Andrew Buckler	94	Sam Edelman	148	Rod Keenan
39	Sophie Buhai	95	Mark Eisen	149	Pat Kerr
40	Tory Burch	96	Melinda Eng	150	Naeem Khan
41	Stephen Burrows			151	Eugenia Kim
		97	Steve Fabrikant	152	Calvin Klein
42	Anthony Camargo	98	Carlos Falchi	153	Michael Kors
43	Pamela Capone	99	Pina Ferlisi	154	Fiona Kotur-Marin
44	Pierre Carrilero	100	Andrew Fezza	155	Reed Krakoff
45	Liliana Casabal	101	Patricia Ficalora	156	Regina Kravitz
46	Edmundo Castillo	102	Cheryl Finnegan	157	Devi Kroell
47	Salvatore Cesarani	103	Eileen Fisher	158	Blake Kuwahara
48	Richard Chai	104	Dana Foley		
49	Julie Chaiken	105	Tom Ford	159	Steven Lagos
50	Amy Chan	106	Istvan Francer	160	Derek Lam
51	Charles Chang-Lima	107	Isaac Franco	161	Richard Lambertson
52	Natalie Chanin	108	R. Scott French	162	Adrienne Landau
53	Georgina Chapman	109	Carolee Friedlander	163	Liz Lange
54	Ron Chereskin			164	Ralph Lauren
55	Wenlan Chia	110	James Galanos	165	Eunice Lee
56	David Chu	111	Nancy Geist	166	Judith Leiber
57	Eva Chun	112	Geri Gerard	167	Larry Leight

192

17

136

341

143

132

292

87

16

54

41

23

168	Nanette Lepore	226	Robin Piccone	286	Peter Speliopoulos
169	Michael Leva	227	Mary Ping	287	Michael Spirito
170	Monique Lhuillier	228	Linda Platt	288	Laurie Stark
171	Phillip Lim	229	Tom Platt	289	Richard Stark
172	Adam Lippes	230	Alexandre Plokhov	290	Cynthia Steffe
173	Elizabeth Locke	231	Laura Poretzky	291	Sue Stemp
174	Tina Lutz	232	Zac Posen	292	Scott Sternberg
		233	Lilly Pulitzer	293	Robert Stock
175	Bob Mackie	234	James Purcell	294	Steven Stolman
176	Jeff Mahshie			295	Jay Strongwater
177	Catherine Malandrino	235	Jessie Randall	296	Jill Stuart
178	Maurice Malone	236	David Rees	297	Anna Sui
179	Colette Malouf	237	Tracy Reese		
180	Isaac Manevitz	238	William Reid	298	Robert Tagliapietra
181	Robert Marc	239	Robin Renzi	299	Elie Tahari
182	Mary Jane Marcasiano	240	Mary Ann Restivo	300	Vivienne Tam
183	Lana Marks	241	Brian Reyes	301	Rebecca Taylor
184	Lisa Mayock	242	Kenneth Richard	302	Yeohlee Teng
185	Jessica McClintock	243	Judith Ripka	303	Gordon Thompson
186	Jack McCollough	244	Patrick Robinson	304	Monika Tilley
187	Mary McFadden	245	Loree Rodkin	305	Zang Toi
188	Mark McNairy	246	David Rodriguez	306	Isabel Toledo
189	David Meister	247	Narciso Rodriguez	307	Rafe Totengco
190	Andreas Melbostad	248	Jackie Rogers	308	John Truex
191	Gilles Mendel	249	Alice Roi	309	Trina Turk
192	Gene Meyer	250	Lela Rose	310	Mish Tworkowski
193	Carlos Miele	251	Kara Ross		
194	Malia Mills	252	Christian Roth	311	Patricia Underwood
195	Nicole Miller	253	Cynthia Rowley	312	Kay Unger
196	James Mischka	254	Rachel Roy		
197	Richard Mishaan	255	Ralph Rucci	313	Carmen Marc Valvo
198	Isaac Mizrahi	256	Kelly Ryan	314	Koos van den Akker
199	Paul Morelli			315	Nicholas Varney
200	Robert Lee Morris	257	Gloria Sachs	316	John Varvatos
201	Miranda Morrison	258	Jamie Sadock	317	Joan Vass
202	Rebecca Moses	259	Selima Salaun	318	Adrienne Vittadini
203	Kate Mulleavy	260	Angel Sanchez	319	Diane von Furstenberg
204	Laura Mulleavy	261	Behnaz Sarafpour	320	Patricia von Musulin
205	Sandra Muller	262	Janis Savitt		
206	Matt Murphy	263	Arnold Scaasi	321	Marcus Wainwright
		264	Jordan Schlanger	322	Tom Walko
207	Gela Nash-Taylor	265	Anna Corinna Sellinger	324	Vera Wang
208	Josie Natori	266	Ricky Serbin	325	Cathy Waterman
209	Charlotte Neuville	267	Christopher Serluco	326	Heidi Weisel
210	David Neville	268	Ronaldus Shamask	327	Stuart Weitzman
211	Rozae Nichols	269	George Sharp	328	Carla Westcott
212	Lars Nilsson	270	Marcia Sherrill	329	John Whitledge
213	Roland Nivelais	271	Sam Shipley	330	Edward Wilkerson
214	Vanessa Noel	272	Kari Sigerson	331	Gary Wolkowitz
215	Charles Nolan	273	Daniel Silver	332	Angela Wright
216	Maggie Norris	274	Howard Silver	334	Sharon Wright
217	Peter Noviello	275	Michael Simon		
		276	George Simonton	335	Araks Yeramyan
218	Sigrid Olsen	277	Paul Sinclaire	336	Gerard Yosca
219	Luca Orlandi	278	Pamela Skaist-Levy	337	Jean Yu
220	Rick Owens	279	Amy Smilovic	338	David Yurman
		280	Michelle Smith		
221	Thakoon Panichgul	281	Maria Snyder	339	Gabriella Zanzani
222	Marcia Patmos	282	Mimi So	340	Katrin Zimmermann
223	Edward Pavlick	283	Peter Som	341	Italo Zucchelli
224	Christina Perrin	284	Kate Spade		
225	James Perse	285	Gunnar Spaulding		

153

151

172

1

310

215

20

63

316

321
210

230

114

47.

25

271

171

165

164

140

244

238

14

299

329

309

108

155

120

271

76
273
288
100
38
289
48

274

92

19

105

253

135

36

275

CFDA Fashion Award Winners 1981–2008

2008

Womenswear Designer of the Year *Francisco Costa for Calvin Klein*

Menswear Designer of the Year *Tom Ford*

Accessory Designer of the Year *Tory Burch*

Swarovski Award for Womenswear *Kate & Laura Mulleavy for Rodarte*

Swarovski Award for Menswear *Scott Sternberg for Band of Outsiders*

Swarovski Award for Accessory Design *Philip Crangi*

Eugenia Sheppard Award *Candy Pratts Price*

International Award *Dries Van Noten*

Geoffrey Beene Lifetime Achievement Award *Carolina Herrera*

Board of Directors' Special Tribute *Mayor Michael R. Bloomberg*

2007

Womenswear Designer of the Year *Oscar de la Renta and Lazaro Hernandez & Jack McCollough for Proenza Schouler (tie)*

Menswear Designer of the Year *Ralph Lauren*

Accessory Designer of the Year *Derek Lam*

Swarovski Award for Womenswear *Phillip Lim*

Swarovski Award for Menswear *David Neville & Marcus Wainwright for Rag & Bone*

Swarovski Award for Accessory Design *Jessie Randall for Loeffler Randall*

Eugenia Sheppard Award *Robin Givhan*, Fashion Editor, *Washington Post*

International Award *Pierre Cardin*

Geoffrey Beene Lifetime Achievement Award *Robert Lee Morris*

Eleanor Lambert Award *Patrick Demarchelier*

Board of Directors' Special Tribute *Bono & Ali Hewson*

American Fashion Legend Award *Ralph Lauren*

2006

Womenswear Designer of the Year *Francisco Costa for Calvin Klein*

Menswear Designer of the Year *Thom Browne*

Accessory Designer of the Year *Tom Binns*

Swarovski's Perry Ellis Award for Womenswear *Doo-Ri Chung*

Swarovski's Perry Ellis Award for Menswear *Jeff Halmos, Josia Lamberto-Egan, Sam Shipley & John Whitledge for Trovata*

Swarovski's Perry Ellis Award for Accessory Design *Devi Kroell*

Eugenia Sheppard Award *Bruce Weber*

International Award *Olivier Theyskens*

Lifetime Achievement Award *Stan Herman*

Eleanor Lambert Award *Joan Kaner*

Board of Directors' Special Tribute *Stephen Burrows*

2005

Womenswear Designer of the Year *Vera Wang*

Menswear Designer of the Year *John Varvatos*

Accessory Designer of the Year *Marc Jacobs for Marc Jacobs*

Swarovski's Perry Ellis Award for Womenswear *Derek Lam*

Swarovski's Perry Ellis Award for Menswear *Alexandre Plokhov for Cloak*

Swarovski's Perry Ellis Award for Accessory Design *Anthony Camargo & Nak Armstrong for Anthony Nak*

Eugenia Sheppard Award *Gilles Bensimon*

International Award *Alber Elbaz*

Lifetime Achievement Award *Diane von Furstenberg*

Award for Fashion Influence *Kate Moss*

Board of Directors' Special Tribute *Norma Kamali*

2004

Womenswear Designer of the Year *Carolina Herrera*

Menswear Designer of the Year *Sean Combs for Sean John*

Accessory Designer of the Year *Reed Krakoff for Coach*

Swarovski's Perry Ellis Award for Ready-to-Wear *Zac Posen*

Swarovski's Perry Ellis Award for Accessory Design *Eugenia Kim*

Eugenia Sheppard Award *Teri Agins*

International Award *Miuccia Prada*

Lifetime Achievement Award *Donna Karan*

Fashion Icon Award *Sarah Jessica Parker*

Eleanor Lambert Award *Irving Penn*

Board of Directors' Special Tribute *Tom Ford*

2003

Womenswear Designer of the Year *Narciso Rodriguez*

Menswear Designer of the Year *Michael Kors*

Accessory Designer of the Year *Marc Jacobs for Marc Jacobs*

Swarovski's Perry Ellis Award for Ready-to-Wear *Lazaro Hernandez & Jack McCollough for Proenza Schouler*

Swarovski's Perry Ellis Award for Accessory Design *Brian Atwood*

Eugenia Sheppard Award *André Leon Talley*

International Award *Alexander McQueen*

Lifetime Achievement Award *Anna Wintour*

Fashion Icon Award *Nicole Kidman*

Eleanor Lambert Award *Rose Marie Bravo*

Board of Directors' Special Tribute *Oleg Cassini*

2002

Womenswear Designer of the Year *Narciso Rodriguez*

Menswear Designer of the Year *Marc Jacobs*

Accessory Designer of the Year *Tom Ford for Yves Saint Laurent Rive Gauche*

Perry Ellis Award *Rick Owens*

Eugenia Sheppard Award *Cathy Horyn*

International Award *Hedi Slimane for Dior Homme*

Lifetime Achievement Award *Grace Coddington*

Lifetime Achievement Award *Karl Lagerfeld*

Fashion Icon Award *C. Z. Guest*

Creative Visionary Award *Stephen Gan*

Eleanor Lambert Award *Kal Ruttenstein*

2001

Womenswear Designer of the Year *Tom Ford*

Menswear Designer of the Year *John Varvatos*

Accessory Designer of the Year *Reed Krakoff for Coach*

Perry Ellis Award for Womenswear *Daphne Gutierrez & Nicole Noselli for Bruce*

Perry Ellis Award for Menswear *William Reid*

Perry Ellis Award for Accessories *Edmundo Castillo*

International Designer of the Year *Nicolas Ghesquière for Balenciaga*

Lifetime Achievement Award *Calvin Klein*

Eugenia Sheppard Award *Bridget Foley*

Humanitarian Award *Evelyn Lauder*

Eleanor Lambert Award *Dawn Mello*

Special Award *Bernard Arnault* for his Globalization of the Business of Fashion with Style

Special Award *Bob Mackie* for his Fashion Exuberance

Special Award *Saks Fifth Avenue* for their Retail Leadership of Fashion Targets Breast Cancer

2000

Womenswear Designer of the Year *Oscar de la Renta*

Menswear Designer of the Year *Helmut Lang*

Accessory Designer of the Year *Richard Lambertson & John Truex*

Perry Ellis Award for Womenswear *Miguel Adrover*

Perry Ellis Award for Menswear *John Varvatos*

Perry Ellis Award for Accessories *Dean Harris*

International Designer of the Year *Jean-Paul Gaultier*

Lifetime Achievement Award *Valentino*

Humanitarian Award *Liz Claiborne for the Liz Claiborne and Art Ortenenberg Foundation*

Most Stylish Dot.com Award *PleatsPlease.com*

Special Award The Dean of American Fashion *Bill Blass*

Special Award The American Regional Press presented to *Janet McCue*

Special Award *The Academy of Motion Picture Arts & Sciences* for Creating the World's Most Glamorous Fashion Show

1998/1999

Womenswear Designer of the Year *Michael Kors*

Menswear Designer of the Year *Calvin Klein*

Accessory Designer of the Year *Marc Jacobs*

Perry Ellis Award for Womenswear *Josh Patner and Bryan Bradley for Tuleh*

Perry Ellis Award for Menswear *Matt Nye*

Perry Ellis Award for Accessories *Tony Valentine*

International Designer of the Year *Yohji Yamamoto*

Lifetime Achievement Award *Yves Saint Laurent*

Eugenia Sheppard Award *Elsa Klensch*

Humanitarian Award *Liz Tilberis*

Special Award *Betsey Johnson* for her Timeless Talent

Special Award *Simon Doonan* for his Windows on Fashion

Special Award *InStyle Magazine* for Putting the Spotlight on Fashion and Hollywood

Special Award *Sophia Loren* for a Lifetime of Style

Special Award *Cher* for her Influence on Fashion

1997

Womenswear Designer of the Year *Marc Jacobs*

Menswear Designer of the Year *John Bartlett*

Accessory Designer of the Year *Kate Spade*

Perry Ellis Award for Womenswear *Narciso Rodriguez*
Perry Ellis Award for Menswear *Sandy Dalal*
International Designer of the Year *John Galliano*
Lifetime Achievement Award *Geoffrey Beene*
The Stiletto Award *Manolo Blahnik*
Special Award *Anna Wintour* for her Influence on Fashion
Dom Pérignon Award *Ralph Lauren*
Special Award *Elizabeth Taylor* for a Lifetime of Glamour
Special Tributes *Gianni Versace & Princess Diana*

1996
Womenswear Designer of the Year *Donna Karan*
Menswear Designer of the Year *Ralph Lauren*
Accessory Designer of the Year *Elsa Peretti for Tiffany & Co.*
Perry Ellis Award for Womenswear *Daryl Kerrigan for Daryl K.*
Perry Ellis Award for Menswear *Gene Meyer*
Perry Ellis Award for Accessories *Kari Sigerson and Miranda Morrison for Sigerson Morrison*
International Designer of the Year *Helmut Lang*
Lifetime Achievement Award *Arnold Scaasi*
Eugenia Sheppard Award *Amy Spindler*
Dom Pérignon Award *Kenneth Cole*
Special Award *Richard Martin & Harold Koda*

1995
Womenswear Designer of the Year *Ralph Lauren*
Menswear Designer of the Year *Tommy Hilfiger*
Accessory Designer of the Year *Hush Puppies*
Perry Ellis Award for Womenswear *Marie-Anne Oudejans for Tocca*
Perry Ellis Award for Menswear *Richard Tyler / Richard Bengtsson & Edward Pavlick for Richard Edwards (tie)*
Perry Ellis Award for Accessories *Kate Spade*
International Designer of the Year *Tom Ford for Gucci*
Lifetime Achievement Award *Hubert de Givenchy*
Eugenia Sheppard Award *Suzy Menkes*
Special Award *Isaac Mizrahi & Douglas Keeve for* Unzipped
Special Award *Robert Isabell*
Special Award *Lauren Bacall*
Dom Pérignon Award *Bill Blass*

1994
Womenswear Designer of the Year *Richard Tyler*
Perry Ellis Award for Womenswear *Victor Alfaro and Cynthia Rowley (tie)*
Perry Ellis Award for Menswear *Robert Freda*
Accessory Award for Women *Robert Lee Morris*
Accessory Award for Men *Gene Meyer*
Lifetime Achievement Award
Carrie Donovan/Nonnie Moore/Bernadine Morris
Eugenia Sheppard Award *Patrick McCarthy*
Special Award *Elizabeth Tilberis*
Special Award *The Wonderbra*
Special Award *Kevyn Aucoin*
Special Tribute *Jacqueline Kennedy Onassis*

1993
Womenswear Designer of the Year *Calvin Klein*
Menswear Designer of the Year *Calvin Klein*
Perry Ellis Award for Womenswear *Richard Tyler*
Perry Ellis Award for Menswear *John Bartlett*
Lifetime Achievement Award *Judith Leiber/Polly Allen Mellen*
International Award for Accessories *Prada*
Eugenia Sheppard Award *Bill Cunningham*
Special Awards *Fabien Baron/Adidas/Converse/Keds/Nike/Reebok*
Industry Tribute *Eleanor Lambert*

1992
Womenswear Designer of the Year *Marc Jacobs*
Menswear Designer of the Year *Donna Karan*
Accessory Designer of the Year *Chrome Hearts*
Perry Ellis Award *Anna Sui*
International Award *Gianni Versace*
Lifetime Achievement Award *Pauline Trigère*
Special Awards *Steven Meisel/Audrey Hepburn/ The Ribbon Project/Visual AIDS*

1991
Womenswear Designer of the Year *Isaac Mizrahi*
Menswear Designer of the Year *Roger Forsythe*
Accessory Designer of the Year *Karl Lagerfeld for House of Chanel*
Perry Ellis Award *Todd Oldham*
Lifetime Achievement Award *Ralph Lauren*
Eugenia Sheppard Award *Marylou Luther*
Special Awards *Marvin Traub/Harley Davidson/Jessye Norman/ Anjelica Huston/Judith Jamison*

1990
Womenswear Designer of the Year *Donna Karan*
Menswear Designer of the Year *Joseph Abboud*
Accessory Designer of the Year *Manolo Blahnik*
Perry Ellis Award *Christian Francis Roth*
Lifetime Achievement Award *Martha Graham*
Eugenia Sheppard Award *Genevieve Buck*
Special Awards *Emilio Pucci/Anna Wintour*
Special Tribute *Halston*

1989
Womenswear Designer of the Year *Isaac Mizrahi*
Menswear Designer of the Year *Joseph Abboud*
Accessory Designer of the Year *Paloma Picasso*
Perry Ellis Award *Gordon Henderson*
Lifetime Achievement Award *Oscar de la Renta*
Eugenia Sheppard Award *Carrie Donovan*
Special Award *The Gap*
Special Tribute *Giorgio di Sant'Angelo/Diana Vreeland*

1988
Menswear Designer of the Year *Bill Robinson*
Perry Ellis Award *Isaac Mizrahi*
Lifetime Achievement Award *Richard Avedon/Nancy Reagan*

Eugenia Sheppard Award *Nina Hyde*
Special Award *Geoffrey Beene/Karl Lagerfeld for House of Chanel/Grace Mirabella/Judith Peabody/The Wool Bureau Inc.*

1987
Best American Collection *Calvin Klein*
Menswear Designer of the Year *Ronaldus Shamask*
Perry Ellis Award *Marc Jacobs*
Eugenia Sheppard Award *Bernadine Morris*
Lifetime Achievement Award *Giorgio Armani, Horst, Eleanor Lambert*
Special Awards *Arnell/Bickford Associates and Donna Karan/ Manolo Blahnik/Hebe Dorsey/FIT/Giorgio di Sant'Angelo/ Arnold Scaasi/Vanity Fair*
Special Tribute *Mrs. Vincent Astor*

1986
Perry Ellis Award *David Cameron (first recipient)*
Lifetime Achievement Award *Bill Blass/Marlene Dietrich*
Special Awards *Geoffrey Beene/Dalma Callado/Elle magazine/ Etta Froio/Donna Karan/Elsa Klensch/Christian Lacroix/ Ralph Lauren*

1985
Lifetime Achievement Award *Katharine Hepburn/ Alexander Liberman*
Special Tribute *Rudi Gernreich*
Special Awards *Geoffrey Beene/Liz Claiborne/Norma Kamali/ Donna Karan/Miami Vice/Robert Lee Morris/Ray-Ban Sunglasses/"Tango Argentino"*

1984
Lifetime Achievement Award *James Galanos*
Special Tribute *Eugenia Sheppard*
Special Awards *Astor Place Hair Design/Bergdorf Goodman/ Kitty D'Alessio/ John Fairchild/Annie Flanders/Peter Moore of NIKE/ Robert Pittman of MTV/Stephen Sprouse/Diana Vreeland/Bruce Weber*

1983
Jeff Aquilon/Giorgio Armani/Diane De Witt/Perry Ellis/Calvin Klein/Antonio Lopez/Issey Miyake/Patricia Underwood/ Bruce Weber

1982
Bill Cunningham/Perry Ellis/Norma Kamali/Karl Lagerfeld/ Antonio Lopez

1981
Jhane Barnes/Perry Ellis/Andrew Fezza/Alexander Julian/Barry Kieselstein-Cord/Calvin Klein/Nancy Knox/Ralph Lauren/ Robert Lighton/Alex Mate & Lee Brooks/Yves Saint Laurent/ Fernando Sanchez

CREDITS

P. 4: photo by Kurt Markus, courtesy Bill Robinson Estate; p. 6: courtesy Polo Ralph Lauren; p. 8: © The Granger Collection; p. 14: © Peter Miller, courtesy Howard Greenberg Gallery, New York; p. 16: © Bill Steele; p. 18–19: © Oliviero Toscani; p. 21: © 2009 National Museum of American Illustration™, Newport, R.I., www.americanillustration.org, courtesy Bill Hargreaves; p. 25: courtesy John Bartlett; p. 26–27: © 2009 National Museum of American Illustration™, Newport, R.I., www.americanillustration.org; p. 28: photo by Paola Kudacki; p. 29: photo by Richard Phibbs, courtesy John Varvatos; p. 30: photo by Susan Shacter, courtesy Rafael; p. 31: © Hulton Archive/Getty Images; p. 32: courtesy Sean John Combs; p. 33: © 2009 National Museum of American Illustration™, Newport, R.I., www.americanillustration.org; p. 34: © Condé Nast Archive/Corbis; p. 35: courtesy Coach; p. 36: © 20th Century Fox Film Corp., all rights reserved/Everett Collection; p. 37: photo by Getty Images, courtesy Henry Jacobson LLC; p. 38: © Levi Strauss & Co.; p. 39: photo by Tyler Boye/DNR, © Condé Nast Publications; p. 40: photo by Jimi Celeste, courtesy Tony Melillo; p. 41: photo by Harry De Zitter; p. 42: © Norman Rockwell Family Agency; p. 43: © Bettmann/Corbis; p. 44: © Laura Wilson; p. 45: © 2008 Robert Rausch, courtesy Billy Reid; p. 46: © Woolrich Woolen Mills; p. 47: © Herb Ritts; p. 48: © Philippe Bialobos; p. 49: courtesy Coach; p. 50: © Bruce Weber; p. 51: courtesy Tommy Hilfiger; p. 52: © Robert E. Bryan Personal Collection; p. 54: © Arnaldo Anaya Lucca; p. 56: © 2009 National Museum of American Illustration™, Newport, R.I., www.americanillustration.org; p. 57: © Jeannette Montgomery Barron; p. 60–61: © George Silk/Time Life Pictures/Getty Images; p. 62: © Julian Broad; p. 63: photo by Kevin Hatt, courtesy Unis; p. 64–65: © John Whitledge; p. 66: photo by Pamela Hanson, courtesy Tommy Hilfiger; p. 67: © Polo Ralph Lauren; p. 68: photo by Kyle Ericksen, © Condé Nast Publications; p. 69: courtesy Joseph Abboud; p. 70: photo by Kyle Ericksen, © Condé Nast Publications; p. 71: © Trovata; p. 72: photo by Dan Lecca, courtesy Marc Jacobs; p. 73: photo by Dan Lecca, courtesy Yigal Azrouël (left); courtesy Gant Limited Edition (right); p. 74: photo by Dan Lecca, courtesy Gap; p. 75: © Bettmann/Corbis; p. 76: courtesy Thom Browne; p. 77: courtesy Coach; p. 78–79: © Bruce Weber; p. 80: © Hy Peskin/Time Life Pictures/Getty Images; p. 82: photo by J. R. Duran, courtesy Jhane Barnes; p. 86: © Bettmann/Corbis; p. 87: photo by Dan Lecca, courtesy Gap; p. 88: courtesy Joseph Abboud; p. 89: photo by Dan Lecca, courtesy Michael Kors; p. 90: © 2009 National Museum of American Illustration™, Newport, R.I., www.americanillustration.org; p. 91: © Peter Lindbergh; p. 92: © Edwin Levick/Hulton Archive/Getty Images; p. 93: © www.firstVIEW.com (left), courtesy Charles Nolan (right); p. 94: illustration by Ken Dallison, all rights reserved; p. 95: courtesy Bill Blass; p. 96: © Nina Leen/Time & Life Pictures/Getty Images; p. 97: courtesy Michael Kors; p. 98: © Bruce Weber; p. 99: photo by Richard Reed, courtesy Sal Cesarani; p. 100: © All rights reserved; p. 101: photo by Nancy Brown, courtesy Alexander Julian; p. 102: courtesy Perry Ellis; p. 103: © Craig McDean/Art + Commerce; p. 104: photo by Robert Rausch, courtesy Billy Reid; p. 105: courtesy Kenneth Cole; p. 106–107: photo by Terry Richardson, courtesy Elie Tahari; p. 108: © All rights reserved; p. 109: photo by Jonathon Skow, courtesy Trina Turk; p. 110–111: photo by Dan Lecca, courtesy Richard Chai; p. 112: © Everett Collection; p. 114: © Terry Richardson; p. 119: photo by Giles Price; p. 120: © Bruce Weber; p. 121: courtesy Alan Flusser; p. 122–123: © Frank Driggs Collection/Getty Images; p. 124: courtesy Bill Blass; p. 125: © Richard Burbridge/Art + Commerce; p. 126: © Everett Collection; p. 127: photo by Perry Hagopian/*Brides*, © Condé Nast Publications; p. 128: illustration by L. Fellows, all rights reserved; p. 129: photo by Robert Rausch, courtesy Billy Reid; p. 130: © Everett Collection; p. 131: © Herb Ritts; p. 132–133: © Paola Kudacki; p. 134: © 2009 National Museum of American Illustration™, Newport, R.I., www.americanillustration.org p. 135: courtesy Alexandre Plokhov; p. 136: courtesy Brooks Brothers; p. 137: photo by Dan Lecca, courtesy Calvin Klein (left), photo by Dan Lecca, courtesy Gene Meyer (right); p. 138: © H. Armstrong Roberts/Retrofile/Getty Images; p. 139: © Peter Lindbergh; p. 140–141: © Dewey Nicks/Trunk Archives; p. 142: © Nathaniel Goldberg/Art + Commerce; p. 143: photo by Eric Ray Davidson/*GQ*, © Condé Nast Publications; p. 144: © Carlo Allegri/Getty Images; p. 146: photo by Robert Rausch, courtesy Billy Reid; p. 148–149: © The Cole Porter Collection, The American Musical

Theatre Collection, Yale University Music Library; p. 152: © 2009 National Museum of American Illustration™, Newport, R.I., www.americanillustration.org; p. 153: © Nancy Kaszerman/Zuma/Corbis; p. 154: © Slim Aarons/Getty Images; p. 155: © Giovanni Aponte; p. 156: © Condé Nast Archive/Corbis; p. 157: © Michael Oldford, courtesy Mish; p. 158: © John Rogers/Getty Images; p. 159: courtesy Alan Flusser; p. 160: © Deborah Feingold/Corbis; p. 161: © Lynn Goldsmith; p. 162: © Patrick McMullan; p. 163: © Photofest; p. 164: © Gjon Mili/Time Life Pictures/Getty Images; p. 165: © Gregory Pace/Corbis; p. 166: © Michael O'Neill; p. 167: courtesy the Geoffrey Beene Archives; p. 168: photo by Platon, courtesy Duckie Brown; p. 169: © Horst P. Horst/Art + Commerce; p. 170–171: © Bruce Weber; p. 172: © Bruce Weber; p. 173: © Paramount Pictures/courtesy Getty Images; p. 174: © Diego Uchitel, courtesy Thom Browne; p. 175: photo by Dan King, courtesy Tim Hamilton (left), photo by Dan Lecca, courtesy Robert Geller (right); p. 176: © photo by C. S. Bull/www.mptvimages.com; p. 178: © 1978, Eugene R. Richee/www.mptvimages.com; p. 180–181: © Everett Collection; p. 185: © Terry O'Neill/Getty Images; p. 186: © United Artists/The Kobal Collection; p. 190: photo by Richard Reed, courtesy Sal Cesarani; p. 191: © www.mptvimages.com; p. 192: photo by Dan Lecca, courtesy Michael Kors; p. 193: © Bettmann/Corbis; p. 194: © 20th Century Fox Film Corp, all rights reserved/courtesy Everett Collection; p. 195: courtesy Band of Outsiders; p. 196: © All rights reserved; p. 197: © Chiun-Kai Shih, courtesy Buckler; p. 198: © John Kobal Foundation/Getty Images; p. 199: © 1978, John Engstead/www.mptvimages.com; p. 200: courtesy Cynthia Rowley; p. 201: © Warner Bros./The Kobal Collection; p. 202–203: © Bettmann/Corbis; p. 204: © Everett Collection; p. 205: photo by Matt Jones; p. 206: © Lisa O'Connor/Zuma/Corbis; p. 207: © Everett Collection; p. 208: courtesy Marc Jacobs; p. 209: © Stewart Cook/Rex USA, courtesy Everett Collection; p. 210, 211: © Everett Collection; p. 212: © Hulton-Deutsch Collection/Corbis; p. 213: photo by Anders Overgaard, courtesy Sean John Combs; p. 214: © Everett Collection; p. 216: photo by Elliot Erwitt, courtesy Alexander Julian; p. 218–219: © Michael Ochs Archives/Getty Images; p. 224: © Everett Collection; p. 225: photo by Morgan Howland, © www.tobi.com; p. 226: © Yale Joel/Time Life Pictures/Getty Images; p. 227: photo by Laurie Lynn Stark, courtesy Chrome Hearts; p. 228: © Jerry Schatzberg/Corbis; p. 229: courtesy Shipley & Halmos; p. 230: © Michael Ochs Archives/Getty Images; p. 231: courtesy Keanan Duffty; p. 232: © Eddie Caraeff; p. 233: © Satoshi Saïkusa; p. 234: photo by Owen Brown, Choker by Bobby Breslau for Stephen Burrows (model: Renauld White); p. 235: © Michael Ochs Archives/Getty Images; p. 236: © Oliviero Toscani; p. 237: photo by Dan Lecca, courtesy Michael Kors; p. 238–239: photo by Adrian Boot, © UrbanImage Photo Archive; p. 240: photo by Dan Lecca, courtesy Rag & Bone (left), photo by Randy Brooke, courtesy Buckler (right); p. 241: photo by www.firstVIEW.com, courtesy Rock & Republic (left), photo by Howard Goldfarb, courtesy Ron Chereskin (right); p. 242: photo by Daniel O'Neill, courtesy Robert Comstock; p. 243: © Dave McGough/DMI/Time & Life Pictures/Getty Images; p. 244–245: photo by Danny Clinch, courtesy John Varvatos; p. 246: By Stephen Sprouse, courtesy the Sprouse Family Archives; p. 247: courtesy Marc Ecko; p. 249: © Paul Natkin/WireImage/Getty Images; p. 249: courtesy R. Scott French; p. 250: © Lynn Goldsmith/Corbis; p. 251: photo by Platon, courtesy Duckie Brown; p. 252: photo by Giovanni Giannoni/DNR, © Condé Nast Publications; p. 253: © Ron Galella/WireImage/Getty Images; p. 254: © Janette Beckman/Getty Images; p. 255: photo by Nico Iliev, courtesy Eugenia Kim; p. 256: photo by Thierry Bearzatto, courtesy Chrome Hearts; p. 257: © Michel Comte; p. 258: © Dan King, courtesy Tim Hamilton; p. 259: © Kevin Pletcher; p. 260: courtesy Kenneth Cole; p. 261: © Universal/courtesy Everett Collection; p. 262: © Joshua Jordan/Jed Root, Inc.; p. 263: © Scott Gries/Getty Images; p. 264: © M. Brown/Getty Images for AMA; p. 265: © Craig McDean/Art + Commerce.

All designers' portraits are courtesy the designers, except Tom Ford's portrait, © Sølve Sundsbø / Art + Commerce.

Every possible effort has been made to identify legal claimants; any errors and omissions brought to the publisher's attention will be corrected in future editions.

ACKNOWLEDGMENTS

When I first saw Robert Bryan, I was struck by his impeccable sense of style. I didn't know who he was, but then he was introduced to me as a skilled writer, stylist, and historian on men's fashion. It all added up. He was the real deal. As we began to plan for *American Fashion Menswear*—the CFDA's third book in the popular series that includes *American Fashion* and *American Fashion Accessories*—I knew he was the only person to take the helm. The CFDA is forever indebted to him for the care and brilliance that he brought to this project.

Next, I leaned on CFDA member Jeffrey Banks to help make this book a success. One of the most active members of the CFDA, Jeffrey is—in his own right—not only one of America's best menswear designers, but also an accomplished author. His opinions, research, and contributions can be seen throughout the book. He is a good friend to the organization, and I thank him.

The CFDA has now worked with Assouline on five books. The relationship has grown to a true partnership. I am proud of CFDA's work with Assouline, and I am always so appreciative of Martine and Prosper Assouline. They believe in only the best. Esther Kremer, CFDA's book editor, remains a constant supporter of the CFDA and our publishing efforts. We could not have completed any of these books without her. Thank you also to Perrine Scherrer for her design ideas and work on *American Fashion Menswear*.

A special thanks to the members of the CFDA. Publishing these books is not only a way to showcase the membership but also a way to demonstrate what a formidable force American fashion is in today's world.

These books would not be possible without the detailed organization and hard work of Nicole Borel-Saladin. Thank you to Nicole, Lisa Smilor, CaSandra Diggs, Karen Peterson, Katie Campion, Danielle Billinkoff, Rachel Shechtman, Amy Walbridge, Sara Maniatty, and Keenya Trancoso. The CFDA staff is the best.

Thank you to the photographers, agents, magazines, and models for sharing your work with us. You made this book possible.

Every day at CFDA is inspiring thanks to the vision and leadership of CFDA President Diane von Furstenberg. We consider ourselves extremely fortunate to stand beside her and to work with her to help and promote American designers.

And thank you to the great Ralph Lauren for his introduction to *American Fashion Menswear*. It is an honor to have him support this book. If any designer exemplifies men's American fashion it is Ralph.

STEVEN KOLB
Executive Director

This book would not have been possible without the help and participation of a great many generous and talented people. First of all I must thank Steven Kolb of the CFDA for trusting and honoring me with this great opportunity; namely the charge of documenting the illustrious history of American menswear. His advice, support, and encouragement all along the way have been invaluable. Further, the publication would not have been possible without the entire staff of Assouline, especially Martine Assouline, who runs a very tight ship indeed, and her superb editor Esther Kremer, who wisely guided my research and writing from first to last. I owe a debt of gratitude to my very close friends, Sharon Graubart, trend forecaster extraordinaire, and Condé Nast photographer Kyle Ericksen, who were more than generous with their time and carefully considered opinions throughout the writing process. Without their highly constructive criticism of my various chapter introductions, this book would not have turned out half so well.

Regarding picture research and selection, I am likewise beholden to another old friend, noted designer and CFDA menswear authority Jeffrey Banks who worked with me tirelessly on this project for weeks on end. His taste, knowledge, and consideration were fundamental ingredients in this very complex process. Contributing to this same endeavor, Nicole Borel-Saladin of the CFDA and her temporary substitute, Stephanie Pate, industriously performed the essential tasks of tracking pictures and securing the rights to publication from a host of America's finest designers, magazines, photographers, and historical archives. In addition, I greatly appreciate the creative efforts of Assouline's photo director Perrine Scherrer, who combined all of these elements in a way that perfectly balances logic and aesthetics, and those of art director Camille Dubois. Last but certainly not least, I want to thank Ralph Lauren for writing the foreword to this book. Truly there is no one better suited to this task, or indeed more deserving of that honor.

Hopefully our book will demonstrate once and for all that America has contributed far more to men's style than Western wear alone, however admirable that in itself may be.

ROBERT E. BRYAN